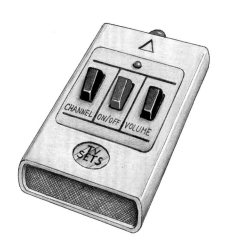

BEHIND THE SCREENS

Illustrated Floor Plans and Scenes from the Best TV Shows of All Time

IÑAKI ALISTE LIZARRALDE

WITH NEAL E. FISCHER

CHRONICLE BOOKS

SAN FRANCISCO

CONTENTS

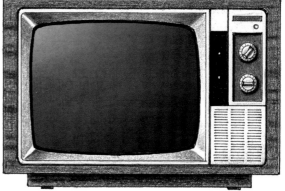

INTRODUCTION

We love TV.

We love TV so much that we designed a special reclining chair made for the sole purpose of comfortably watching as much TV as humanly possible. We've gone from 3-inch screens to 100-inch screens, manual to remote control, wide-screen to flat-screen, SD to 3D to 4K, and beyond. We've added new words to the *Oxford English Dictionary* like *binge-watch* because of how much TV we consume. It helps raise us, teaches us, comforts us, and becomes part of our everyday conversation. When we meet new people or catch up with old friends, the conversation inevitably turns to "What are you watching right now?" Even if you don't watch TV, the fact that you don't has become a statement and a part of your identity. And let's be honest, if you don't watch TV, you're probably not reading this book, but you totally *should* because these pages capture some of the most beloved shows in history across a wide range of genres and subgenres (classics, family, mystery, etc.), featuring programs that amassed legions of dedicated fans and broke records and glass ceilings.

It's not hyperbole to say that TV changed the world. It transformed the way we get information; delivered the excitement of a play, movie, or sporting event into our living room; and brought us closer together. Compared to books, theater, and film, television is considered relatively young at nearly one hundred years old, yet it has become the most popular and influential medium in history. It is also responsible for a piece of our cultural canon unlike any other: the sitcom. Born in part from the vaudevillian radio shows of the 1950s and earlier, no other medium gives viewers the opportunity to immerse themselves visually in a story half-hour after half-hour, week after week, and year after year. You grow up, change, and adapt with characters that are experiencing on-screen the same love, heartbreak, tragedy, and everyday moments as you. While television has evolved in different ways throughout the decades with the addition of reality television, live sports, and cinematic premium cable, the sitcom will always be ubiquitous in television. And like TV, the sitcom evolved, too, eventually finding footing with modern audiences by increasing the complexity of the story lines, deepening the emotional range of the characters, and mixing genres to create a diverse, multifaceted, boundary-pushing body of work at our fingertips with the click of a remote.

As we learn to love the characters and storytelling on-screen, there is one character that doesn't make the top billing but is ever present—the set. TV show sets are the places where characters and plotlines converge to create worlds so captivating they make us sit on the edge of our seat, laugh

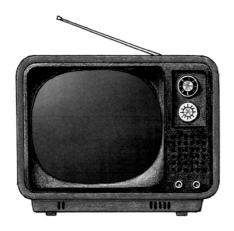

until we cry, and binge-watch season after season. They give characters a tangible space for their stories to exist; they are the homes that welcome viewers into their favorite fictional worlds, and the playgrounds where actors create on-screen magic. They are the "sixth man" of any TV show and, in some cases, become even more iconic than the shows themselves.

Have you ever wondered about the layout of the Simpsons' home? Bert and Ernie's apartment from *Sesame Street*? Or the cubicles of Dunder Mifflin from *The Office*? Or maybe the wildly expensive Greenwich Village apartment that is somehow affordable for TV's most famous friends? Think you can find Norm's stool from *Cheers*, Sheldon's spot from *The Big Bang Theory*, Walter White's rogue pizza from *Breaking Bad*, or the lanai from *The Golden Girls* without checking an episode?

If you answered yes to any of those questions, then you're in the right place. This book honors all that is holy about television and the worlds that have been created. Within these pages Iñaki Aliste Lizarralde brings you a celebration and carefully curated collection of beloved television shows from the past and present, both all-time and soon-to-be classics, with beautifully hand-rendered artwork representing the iconic sets and props that made them unforgettable. While some landmark shows in TV history may not be included, these shows have a strong sense of place, often have plotlines that are contained to just one place for the duration of the episode, and are so iconic they can be recognized by many with just a single quote.

Alongside hilarious TV moments, Easter eggs, and behind-the-scenes trivia, *Behind the Screens* imagines what famous TV apartments, houses, and offices would look like if they were to exist beyond the studio lots and soundstages where they were filmed. You may be a superfan of a certain show (you know who you are and we love you) and notice that one detail is not as you remember, but a set is different from a technical floor plan in that it asks the audience to use their imagination to fill in the spaces not shown on screen—Iñaki has done just that.

Feel free to put the remote down, find your comfiest spot, grab a beverage or snack, and enjoy a little walk-through of TV history. And while you're reading this book, you might be disappointed by the fact that in real life you don't have a laugh track playing after every zinger or a documentary crew following you around for every reaction, but that's okay. Because TV does have all those glorious things, and that's why we love it.

Roll incredibly catchy theme song . . .

ARTIST'S NOTE

When I started drawing floor plans and blueprints of iconic television sets, I intended it to be a hobby just for me. I am an architectural design illustrator first—taking abstract interior design ideas and conceiving them as blueprints using a traditional hand-drawn technique—and a television and film fan second. It was an exciting experiment to figure out how everything fit together in these fictional worlds, and I approached these drawings as I do in my work drafting real building and architecture plans. After sharing my drawings online, thinking only people with select design interests would be compelled by them, I learned quickly that the immense community of television lovers and cinephiles was equally, if not more, enthusiastic about my work. Fans, and even set designers from the shows I drew, were eager to see on-screen worlds transformed on paper, giving the shows a new life and deepening their relationships with the stories they loved.

With this project, my intention was to reinterpret the scenography of a TV show and capture the essence of these imaginary spaces as if they could be real places. Of course, these sets were in fact "real" in the sense that they existed on a soundstage on a film lot, but my goal was to create homes, offices, and buildings that you could envision existing in your neighborhood or town. By closing the fourth wall, which on a set would be absent so the camera could move around unobstructed, I created tangible spaces as livable as your own house.

The first task I embarked on was perhaps the most important: watching hours and hours of TV. You name it, I watched it. But this task was not

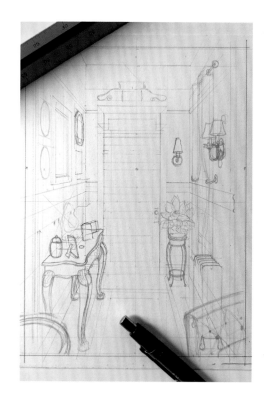

The Process

Each illustration is hand drawn: Here is a glimpse into the process from sketch to final product. Do you recognize this closet?

merely pressing a button on the remote and letting the show play; from my viewing I gleaned every wall, detail, and piece of furniture you see in this book. Every set design or new angle that appeared in the background of an episode gave me another clue to putting it all together—eventually joining these puzzle pieces to create a cohesive floor plan.

Numerous challenges present themselves when trying to represent on paper what I saw on-screen. In order to make these structures plausible in our world, I made adjustments and took small liberties to make sense of each space. Additionally, sets don't often include every room, hallway, and closet in a house; the crew builds only what they need to film. In those cases, I filled in the blanks or completed hallways that led to nowhere. Throughout a show's season, the spaces and decorations change for a myriad of reasons—budget fluctuations, staff transitions, plotlines introducing new characters who need bedrooms—and these changes can often contradict each other or appear and disappear without explanation. This makes it impossible to capture the whole life span of a show in just one floor plan. What you see throughout *Behind the Screens* are my interpretations of the pivotal sets and moments that stood out to me. It is my hope that this book brings you the same joy you had on your first viewing (or your hundredth viewing) of your favorite TV show.

Thank you for tuning in,

Iñaki Alliste Lizarralde

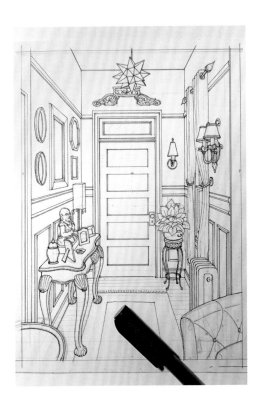
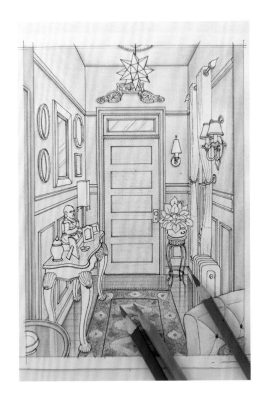
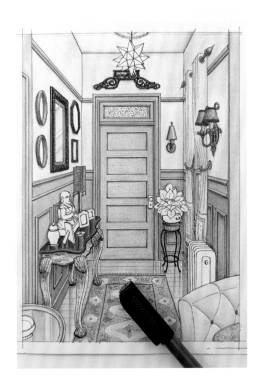

OLDIES BUT GOODIES

This is my opportunity to
be immortalized forever in
a classic work of art.
—BLANCHE

That's exactly what she said
when that shoe salesman took
Polaroids of her in the back
seat of his Volare.
—DOROTHY

The Golden Girls

What makes something a "classic" television show? Is it the time period it was released? The stars who made it famous? Or its impact on pop culture? In the early days of sitcoms, when television started to compete with movies as a preferred form of entertainment, thanks to how simple and convenient it was, there weren't two hundred channels and a vast collection of streaming services like we have now. TV was indeed an event. It became an appointment on a family's calendar. Junior would grab the TV trays, Sis would turn the dial to one of three channels, and Mom and Dad would bring out the hot plates. Together they would collectively laugh at the antics of the Brady children, sit on the edge of their plastic-covered couches watching Magnum make yet another harrowing escape, clink cocktail glasses on their lanai while watching the Golden Girls lounge on theirs, and shed a tear for what plagued the Ingalls family.

Sitcoms technically started broadcasting in America in 1947 with shows like *Mary Kay and Johnny* and *The Morey Amsterdam Show*, but they did not really *begin* until 1951 with the premiere of *I Love Lucy*, thanks to its groundbreaking influence in front of and behind the camera. Once the format was proven successful by *Lucy*, an influx of copycats made TV predictable and indistinguishable. Programs eventually evolved with new techniques, story lines, and formats into the complex, genre-crossing, movie-like shows we see today. However, between then and now, these few special shows became classics not for their ratings, Twitter engagement, or awards, but because they were simply good television. While *classic* can mean many things, for television it should mean a show that's as fresh and relevant today as the day it aired, that has left an indelible mark on pop culture history, and that has changed the format for the better.

I LOVE LUCY

CREATED BY: Desi Arnaz and Lucille Ball	**CHANNEL:** CBS
SERIES RUN: 6 seasons; 180 episodes; 1951–1957	
FILM LOCATION: Live studio audience at General Service Studios (seasons 1–2), Desilu Cahuenga Studios (seasons 3–5)	

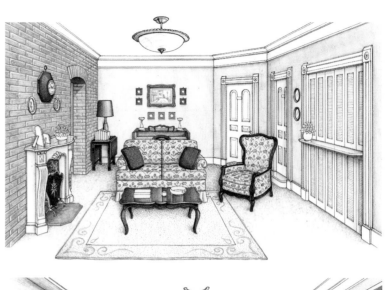

When we discuss sitcom pioneers, *I Love Lucy* stands above the rest. This groundbreaking series followed Lucy Ricardo, a housewife with an undeserved zeal for stardom who constantly bombarded her husband, Ricky Ricardo, a singer/bandleader, to appear on his show to help her advance in show business. Together with their best friends and landlords, Fred and Ethel Mertz, Lucy and Ricky navigated life as a married couple in middle-class America. *I Love Lucy* was adapted from Lucy's successful radio show *My Favorite Husband*, a weekly program from 1948 about a well-off, happily married society couple. When CBS offered Ball a pilot for *I Love Lucy*, Ball said she'd only do it if her real-life husband, Desi Arnaz, could play her TV husband. In the eyes of the network, there was only one problem—he was Cuban and there hadn't been an interracial couple like theirs on TV ever before. According to the network, no one would believe a redheaded American was married to a Cuban (despite the fact they had already been married for a decade). Proving the network wrong, the couple went on tour performing a comedy act that thrilled audiences and forced the hands of the ignorant executives. *I Love Lucy* became the most-watched show in the United States during four of its six seasons, and it was the first show to end its run at the top of the ratings, winning Emmys for Ball, Vivian Vance (Ethel), and the show.

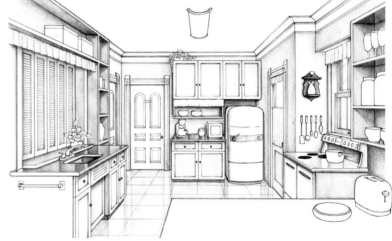

I Love Lucy was a true innovator in the way sitcoms were filmed, with several techniques still used to this day. Wanting to move away from the blurry kinescope process popular at the time, Ball and Arnaz lobbied to shoot the show on 35 mm film. *I Love Lucy*'s Oscar-winning cinematographer Karl Freund, known for directing classics like *The Mummy* (1932) and acting as a cinematographer on others like *Metropolis* (1927) and *Dracula* (1931), combatted the significant challenges of shooting with multiple cameras, and lighting setups, by pioneering the "flat lighting" system (used by virtually every traditional sitcom even now), which reduced contrast and softened shadows, allowing actors to perform anywhere on the set like a play. Additionally, it was one of the first shows to move production to the West Coast, which helped cement Los Angeles as the new capital of broadcasting.

Ultimately, *I Love Lucy*'s more efficient production garnered better performances and allowed genuine laughter to fuel the actors, creating a tidal wave of shows imitating its success. The show became a beacon for ambitious female entertainers who, like Ball, wanted control of their careers in front of and behind the camera. For almost seventy-five years, every sitcom that has aired since—from a creative, technical, and business standpoint—owes a debt of gratitude to Lucy, Ricky, Ethel, and Fred.

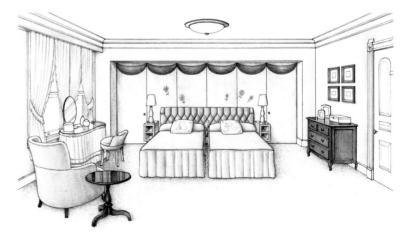

Ricky and Lucy Ricardo's Apartment

ADDRESS: 623 East Sixty-Eighth Street, Apartment 4A (and later 3D),
New York, New York

For $125 a month Lucy and Ricky lived in this charming Upper East Side apartment with an address that, in reality, would be located squarely in the East River. After Little Ricky was born, the apartment became so cramped that Lucy was forced to keep sugar in the bathroom.

Vitameatavegamin

A comedic performance for the ages—Lucy grew increasingly drunk off an alcohol-laced "health tonic" while rehearsing a commercial in the episode "Lucy Does a TV Commercial" (ranked number 4 on *TV Guide*'s "100 Greatest Episodes of All Time").

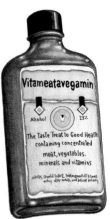

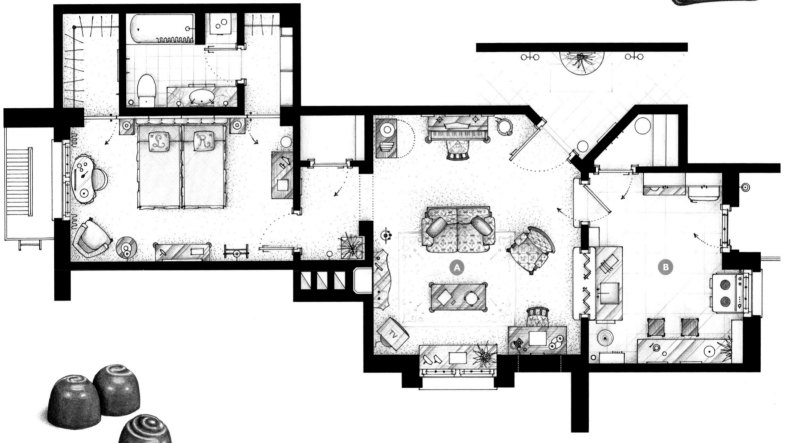

"Job Switching"

Ricky and Fred comically fail at being homemakers while Lucy and Ethel work at a candy factory with a wily conveyor belt in one of the show's most iconic episodes.

Ⓐ "Lucy Goes to the Hospital"

Comedic chaos ensued when Ricky, Fred, and Ethel rehearsed how to get Lucy to the hospital to give birth. Coincidentally, Lucille Ball gave birth to her son on the night this episode aired.

Ⓑ "Pioneer Women"

Remember when Lucy and Ethel made a monstrous loaf of bread? Lucille Ball insisted the enormous loaf be real bread and not a prop.

The Ricardo Country Home

LOCATION: Westport, Connecticut

Fed up with life in the city, Lucy daydreamed about life in the country with its clean, fresh air and homegrown food. Ricky surprised Lucy for their anniversary by purchasing a quaint, old, early-American house in Westport, Connecticut. Though memorable, the house's location was only actually used for about a dozen episodes before the show came to an end.

GROUND FLOOR

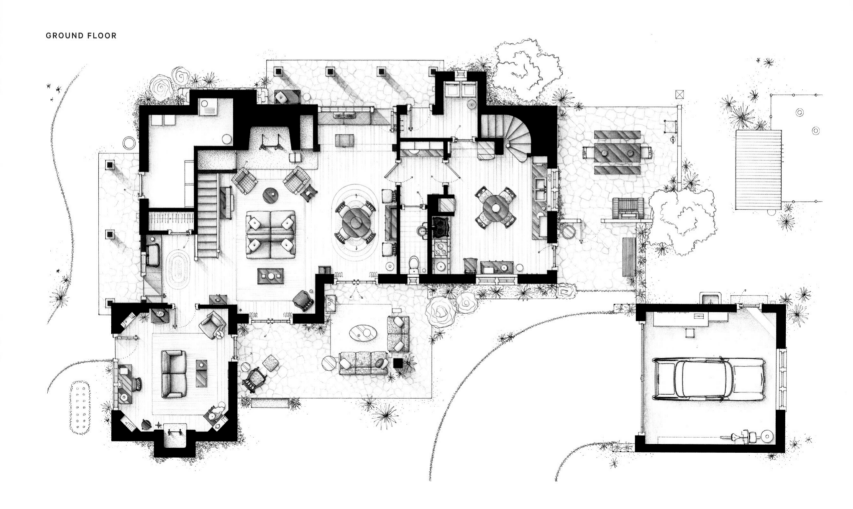

Yankee Doodle Dud

In what became the final episode of the series, "The Ricardos Dedicate a Statue," Lucy accidentally breaks a minuteman statue poised to be unveiled at the Yankee Doodle Day celebration. After failing to put it back together, Lucy tries posing as the statue, complete with body paint, but Fred the dog blows her cover.

UPPER FLOOR

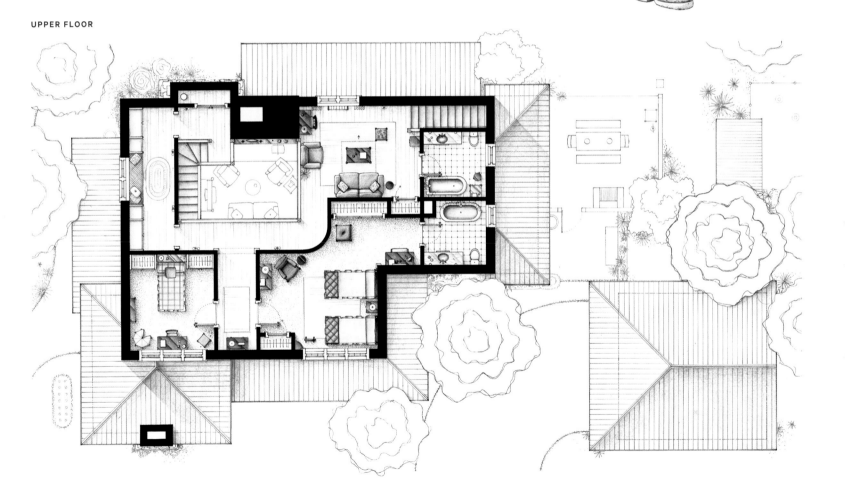

THE BRADY BUNCH

CREATED BY: Sherwood Schwartz	**CHANNEL:** CBS
SERIES RUN: 5 seasons; 117 episodes; 1969–1974	
FILM LOCATION: Paramount Studios in Hollywood, California	

Here's the story . . . Three words, four syllables, and a B-D-E-D on the musical scale that, once heard, immediately resonates as one of the most iconic and catchy theme songs of all time. A theme song that transports you back to a different era with a blended family that was way ahead of their time. You'd be hard-pressed to find a list of American cultural icons that doesn't have *The Brady Bunch* firmly placed on it. The show fits the list, just like Johnny Bravo fits the suit. Premiering in 1969 on ABC, *The Brady Bunch* was created by Sherwood Schwartz (*Gilligan's Island*) after he read an article in the *Los Angeles Times* that said 30 percent of marriages have a child or children from a previous marriage.

The show's premise was simple: Mike, a widower with three boys, marries Carol, a mother with three girls. *The Brady Bunch* was not the first but is perhaps the most famous show about a blended family from two different worlds coming together to live under one roof. Their home had no shortage of hilarious hijinks, life lessons, and heartfelt moments that generations of families have grown up with. The titular bunch included eldest son, leader, and future "Casanova of Clinton Avenue," Greg; fun-loving middle son, Peter; mischievous youngest son, Bobby; confident and overachieving eldest daughter, Marcia; insecure and absent-minded middle daughter, Jan; and the youngest daughter in curls, Cindy. Not to be forgotten is the family housekeeper, Alice Nelson, who kept the house running smoothly with her dependable sky blue uniform, smile, and occasional self-deprecating joke, as well as Tiger the loyal dog.

While not a massive hit at first, with just five seasons on the air, the show found its footing in syndication and for more than fifty years hasn't left the airwaves. It displayed themes of awkward adjustments, gender and sibling rivalry, puppy love, teenage angst, self-image, and responsibility. *The Brady Bunch* also became the gold standard of branching out to remain relevant with countless spin-offs, sequels, variety series, cartoons, studio albums, television movies and specials, stage plays, and even a few satirical film adaptations in the '90s.

The Brady Bunch surely had a nose for longevity as it consistently ranks as one of the best television shows of all time, with Mike and Carol Brady also appearing on lists of television's best moms and dads. We watched them travel to ghost towns, the Grand Canyon, King's Island amusement and water park, and, of course, Hawai'i, but the bread and butter of the show was seeing the Brady kids playfully fighting and causing mischief before eventually hugging it out after learning a lesson from Mom and Dad in their iconic mid-century modern home. The final line of that catchy theme song states, "That's the way we became the Brady Bunch," and just as much as we felt like we became part of their family, they became an even bigger part of ours.

Tabu Tiki Idol

In a trio of treasured episodes, the Bradys took a family trip to Hawai'i, where this cursed Tiki idol caused havoc for the family. Bobby was almost crushed by wall decor, Greg wiped out while surfing, Alice hurt her back doing the hula, and Peter had a run-in with a tarantula.

A Goat Named Raquel

Greg steals Coolidge High School's mascot and unsuccessfully tries to hide it in the busy Brady household. When caught, his punishment is a 5,000-word essay on the evils of mascot stealing.

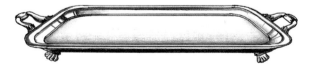

The Silver Platters

The kids bought an anniversary platter for their parents and were fifty-six dollars short after Jan misunderstood the cost. To make extra cash, they secretly entered the Pete Stern Amateur Hour as "The Silver Platters" and performed their famous renditions of "It's a Sunshine Day" and "Keep On."

The Brady Family Home

ADDRESS: 4222 Clinton Way (possibly Santa Monica, California, though never confirmed)

Exteriors were filmed at the residence of 11222 Dilling Street, North Hollywood, California. In 2018, HGTV outbid several parties, including superfan Lance Bass of *NSYNC, to rehab and expand the home so all the interiors would match what fans know and love. Thanks to devotees of America's favorite blended family, it was reported that for many years this home was the second most photographed after the White House.

A Very Brady Stairs

The floating grand staircase was easily the most recognizable and iconic area of the home. Atop the credenza in front of it were the white horse statue, appearing in every episode, and Carol's favorite vase that met its demise at the bounce of Peter's basketball. "She always says, 'Don't play ball in the house.'" —Bobby

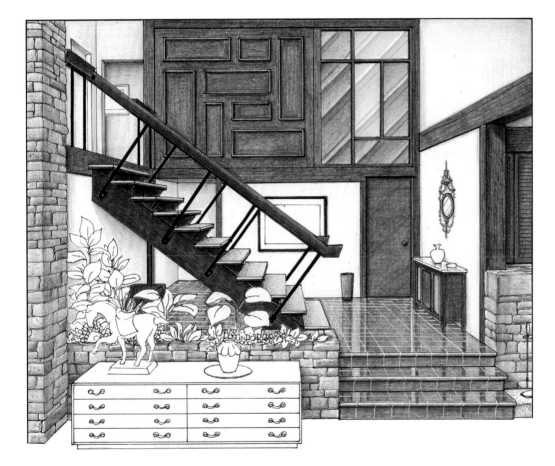

"My volcano worked!" —Peter

"Yeah, like Mount Vesuvius." —Alice

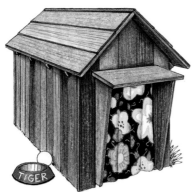

Tiger's Doghouse

This set piece surprisingly had no furry tenant for most of the show—according to Barry Williams (Greg), the empty doghouse remained to help cover holes in the AstroTurf caused by an accidentally fallen stage light.

(A) "Marcia, Marcia, Marcia!"

One of the series' most well-known quotes, was surprisingly only uttered once in the series, during "Her Sister's Shadow" from season 3.

GROUND FLOOR

B Upstairs Jack-and-Jill Bathroom

Several of the show's funniest sitcom squabbles between the Brady kids took place in this blue Jack-and-Jill bathroom. However, unlike this plan, fans may notice the on-set version of the bathroom lacked one crucial element: a toilet.

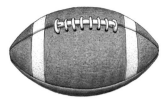

"Oh, my nose!" —Marcia

UPPER FLOOR

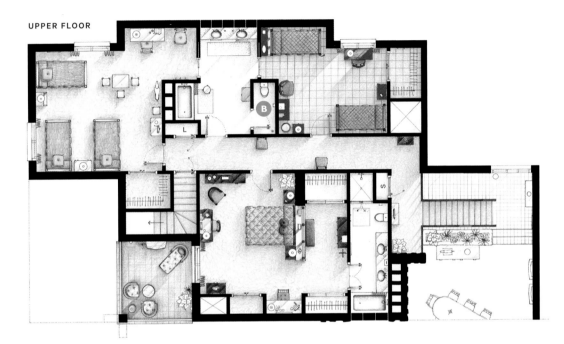

ATTIC

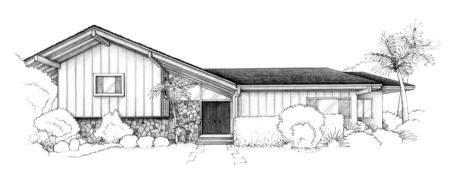

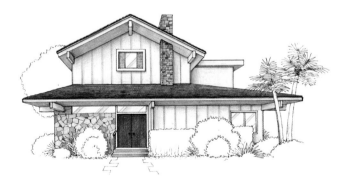

Fiction versus Reality

The above designs illustrate what the Brady exterior looked like on the show (left) and what it would look like if the exterior matched the interiors we're used to seeing on TV.

MAGNUM P.I.

CREATED BY: Donald P. Bellisario	CHANNEL: CBS
SERIES RUN: 6 seasons; 180 episodes; 1980–1988	
FILM LOCATION: Hawai'i Film Studio in Honolulu, O'ahu, Hawai'i; on location in and around Hawai'i	

The '80s were a decade in entertainment when muscles were oiled, biceps were bulging, and for action stars, sheer physical size was likely more important than the quality of acting skills. Breaking these trends (with a *little* oil and some majestic body hair) was *Magnum P.I.*, which followed Thomas Magnum, a former Navy SEAL and Vietnam War veteran hired by a mysterious millionaire pulp writer to be head of security for his estate. In exchange for his services, Magnum lived on the property rent free and had access to a Ferrari, which he took on cases as a private investigator along with the help of his friends TC and Rick. Magnum's exploits were often a thorn in the side of the estate's caretaker, Higgins, an ex-British army sergeant major, who, along with "the Lads" (his two Doberman pinschers), attempted to keep Magnum in check.

After it premiered, the show quickly became a phenomenon, serving as the breakout role for Tom Selleck, whose relatable rendition of an action hero immediately resonated with audiences. So much so, in fact, that his signature wardrobe and accessories became fashion symbols almost overnight. Cocreated by Donald P. Bellisario (a former marine), *Magnum P.I.* helped change the way the Vietnam War was viewed in popular culture and was applauded by veterans for being one of the first examples of a TV show depicting a Vietnam veteran as a hero and human being.

The show was also an easy green light for CBS, who didn't want to waste the production facilities already built for *Hawaii Five-O*. In each of its first five seasons, *Magnum P.I.* ranked in the top twenty of ratings, and the show's series finale in 1988 ranks as the sixth highest-rated series finale of all time, narrowly behind *Friends*. The Mustache Hall of Fame inducted Tom Selleck into their ranks for his iconic upper lip companion, and if that's not the indicator of how *Magnum P.I.* clearly left an impact on pop culture, then what is?

Thomas Magnum's Apartment

ADDRESS: 1541 Kalakaua Avenue, North Shore, O'ahu, Hawai'i

Magnum resided in the guest house of "Robin's Nest," the massive Hawaiian beachfront estate of Robin Masters. Like Charlie Townsend's in *Charlie's Angels*, the face of Robin Masters was never shown. His voice, heard in five episodes, was provided by none other than legendary actor and director Orson Welles.

GROUND FLOOR

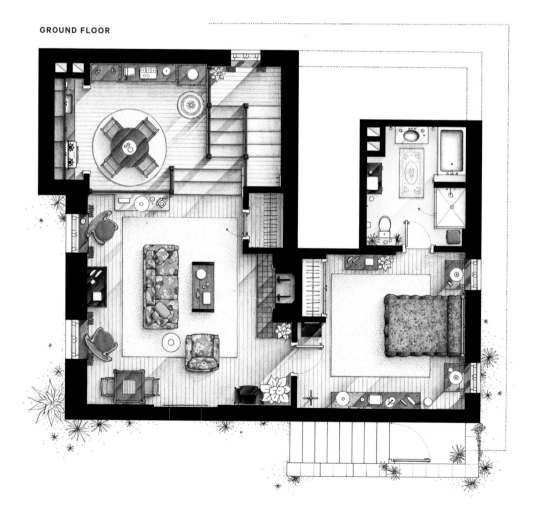

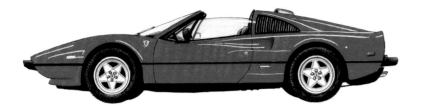

Riding in Style

Capturing the hearts of millions, and the pocketbooks of a select few, this bright red Ferrari 308 GTS (though several models were used throughout the seasons), with license plate ROBIN 1, was Thomas Magnum's preferred mode of transportation. Thanks to *Magnum P.I.*'s success, it became Ferrari's bestselling model of the 1980s. You also might recognize it as the car Christie Brinkley drove in *National Lampoon's Vacation*.

TERRACE

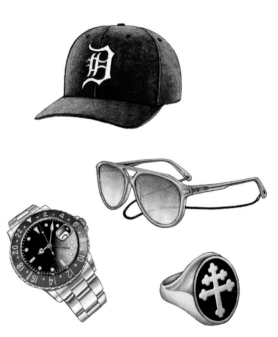

Magnum P.I. Starter Kit

No private detective will ever be as disarmingly cool as Thomas Sullivan Magnum IV. But amateur sleuths can take inspiration from this P.I. starter kit, and they'll be solving cases on the shores of O'ahu in no time.

1. Hawaiian shirt
2. Detroit Tigers baseball cap
3. Rolex watch
4. Cross of Lorraine team ring
5. Vuarnet sunglasses
6. Mustache

LITTLE HOUSE ON THE PRAIRIE

DEVELOPED BY: Blanche Hanalis, based on *Little House on the Prairie* by Laura Ingalls Wilder	**CHANNEL:** NBC
SERIES RUN: 9 seasons; 200 episodes and 4 specials; 1974–1982	
FILM LOCATION: Paramount Studios in Hollywood, California; on location in and around California	

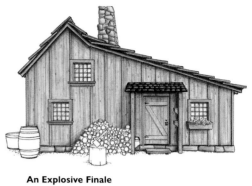

An Explosive Finale

During the official series finale, Walnut Grove citizens learned a land baron was taking their town. Laura inspired residents to protest by blowing up the town (they can have the land, but not what's on it), and the show ended with a literal bang. This story line was added by Michael Landon and the show's writers/producers due to their anger and heartbreak that the series was canceled without warning.

Based on the bestselling Little House series of children's novels by Laura Ingalls Wilder that chronicled her childhood on the American prairie, and creatively spearheaded by actor/writer/director Michael Landon (*Bonanza*, *Highway to Heaven*), *Little House on the Prairie* premiered in 1974 on NBC and soon became a cultural phenomenon. The historical drama loosely based on the books followed the Ingalls family of Charles "Pa" Ingalls; Caroline "Ma" Ingalls; eldest daughter, Mary Ingalls; middle daughter, Laura "Half-Pint" Ingalls; and youngest daughter, Carrie Ingalls, as they departed their home in the woods of Wisconsin and traveled by covered wagon toward Kansas. They eventually settled in Plum Creek near the town of Walnut Grove, Minnesota.

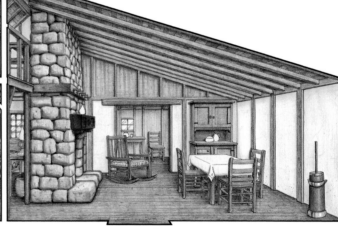

The show was immediately accepted by audiences who fell in love with the pioneer fashion, depiction of a simpler time, and history lessons wrapped in near soap-operatic drama. The show was lighthearted at times but didn't shy away from leaning into serious themes such as addiction, adoption, prejudice, and more. Before streaming and the advent of binging, *Little House* became event-TV with such story lines as the presumed death of Jack, the family watchdog; the stove Laura bought as a Christmas gift for Ma after selling her beloved horse; Carrie falling down a mine shaft (which eerily predated the real-life rescue of "Baby Jessica"); and the episode "I'll Be Waving as You Drive Away," which was about Mary going blind and which *TV Guide* ranked in 1997 as number 97 on its "100 Greatest Episodes of All Time" list. The show also featured memorable characters like Nellie Oleson, the antagonist and chief rival to Laura Ingalls.

The character is big in France, where the show has a cult following that doesn't consider Nellie mean—just French. But no role was as important to the show as Charles, the hardworking, reliable, and honorable father and husband, who is still consistently ranked as one of the best TV dads of all time, thanks to Michael Landon's performance.

Little House was nominated for sixteen Emmy Awards, winning four, and served as a launching pad for young talent such as Melissa Gilbert (future Screen Actors Guild president), Sean Penn (uncredited in his first role directed by his dad, Leo Penn), and Jason Bateman. The show is still popular, with reruns and streaming owing to its classic storytelling, beautiful visuals, and life lessons. *Little House on the Prairie* taught us that you can overcome just about anything life throws at you if you're surrounded by the right people.

The Ingalls Family Home

LOCATION: Plum Creek (near Walnut Grove), Minnesota

After the events of the feature-length pilot where the Ingalls traversed several states to find a new home, they settled down in Walnut Grove in the first episode, "Harvest of Friends," where "Pa" built them a house in between work at the mill. Interiors were filmed at Paramount Studios, stages 30 and 31 (the same stages as *The Godfather* and *Star Trek*).

GROUND FLOOR

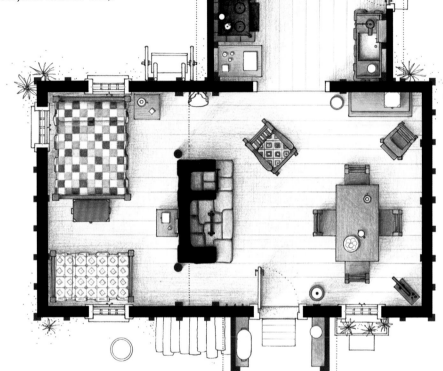

LOFT

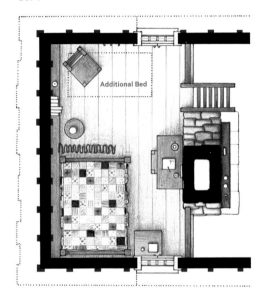

Additional Bed

Walnut Grove

Exteriors of the Ingalls home and the rest of Walnut Grove were mainly filmed at Big Sky Ranch in Simi Valley, California.

"Home is the nicest word there is." —Laura

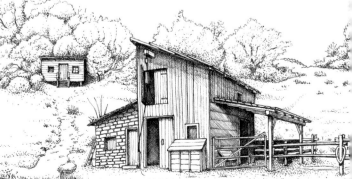

THE GOLDEN GIRLS

CREATED BY: Susan Harris	**CHANNEL:** NBC
SERIES RUN: 7 seasons; 180 episodes; 1985–1992	
FILM LOCATION: Live studio audience at Red Studios Hollywood (formerly Ren-Mar Studios and Desilu Cahuenga Studios) in Hollywood, California	

Picture it. Miami. 1985. A TV show premiered. It was unlike anything seen before—four older, single women (three widows and a divorcée), living in the same home, collectively experiencing the joys and angst of their golden years. The show's concept was inspired by a sketch at NBC's 1984 *All-Star Hour*, featuring Doris Roberts (*Everybody Loves Raymond*) and Selma Diamond (*Night Court*) and poking fun at *Miami Vice*. Executives loved it and immediately began developing a show featuring older women as the leads. Created by Susan Harris, and premiering on NBC, *The Golden Girls* followed new roommates Dorothy Zbornak, a smart, cynical, and sarcastic substitute teacher from Brooklyn; Rose Nylund, an earnest, dim-witted former housewife from St. Olaf, Minnesota; Blanche Devereux, a self-absorbed southern belle and relentless flirt; and Sophia Petrillo, Dorothy's uncensored and brazen Sicilian mother, as they lived together in Blanche's iconic Miami home.

The Golden Girls, on top of its pitch-perfect writing and performances, was groundbreaking in the subjects it tackled. Two examples—the wedding of Blanche's brother Clayton to Doug, nearly twenty-five years before nationwide marriage equality would be passed, and Rose (played by the incomparable Betty White) dealing with an HIV scare and being told by Blanche, "AIDS is not a bad person's disease, Rose. It is not God punishing people for their sins"—among many more demonstrate the bravery *The Golden Girls* showed in its storytelling. Thanks to its inclusivity and celebration of queer relationships, the show earned a massive following in the LGBTQ+ community when young gay viewers heard a very Catholic and very Sicilian Sophia on network TV say, "I'll tell you the truth, Dorothy. If one of my kids was gay, I wouldn't love him one bit less. I would wish him all the happiness in the world."

Just like Blanche at an Argentinian cowboy convention, when *The Golden Girls* debuted, it was a bona fide hit. While it may not have won the high honor of St. Olaf Butter Queen, *The Golden Girls* received critical acclaim, picking up eleven Emmy Awards, including two awards for Outstanding Comedy Series and a statue apiece for Bea Arthur, Betty White, Rue McClanahan, and Estelle Getty, making *The Golden Girls* one of four sitcoms (along with *All in the Family*, *Will & Grace*, and *Schitt's Creek*) where the main cast all received an Emmy. It spawned three spin-offs (*Empty Nest*, *Nurses*, and *The Golden Palace*) and has been adapted over a dozen times.

As Rose said in the series finale, "What can you say after seven years of fights, laughter, secrets, cheesecake?" The answer is clear: While there is a sea of classic sitcoms that have *not* aged well, *The Golden Girls* became what is widely considered an example of one that, in fact, did.

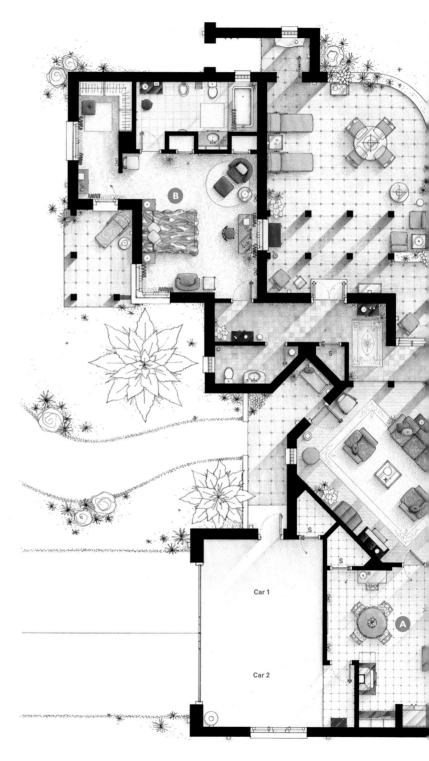

Blanche Devereux's House

ADDRESS: 6151 Richmond Street, Miami, Florida

Three thousand miles away from Miami, the exteriors of Blanche's house were filmed in the Los Angeles neighborhood of Brentwood, just a mile down the road from *The Fresh Prince of Bel-Air*'s Banks Mansion. The designer of *The Golden Girls* set, Emmy Award–winning production designer and art director John Shaffner, was also responsible for the sets of *Friends*, *Two and a Half Men*, *The Big Bang Theory*, *Roseanne*, and *Dharma & Greg*.

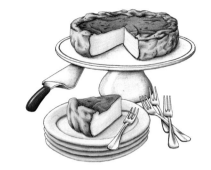

The Cheesecake

The Golden Girls proved that every problem can be solved with cheesecake. Bestselling chef and author George Geary used to manage a grocery store near Paramount Studios and baked every cheesecake seen on the show.

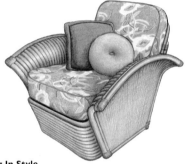

Lounging In Style

A mainstay of the living room was this chic 1930s rattan fan arm lounge chair that provided tropical comfort to the bright and flowery interior design of the house.

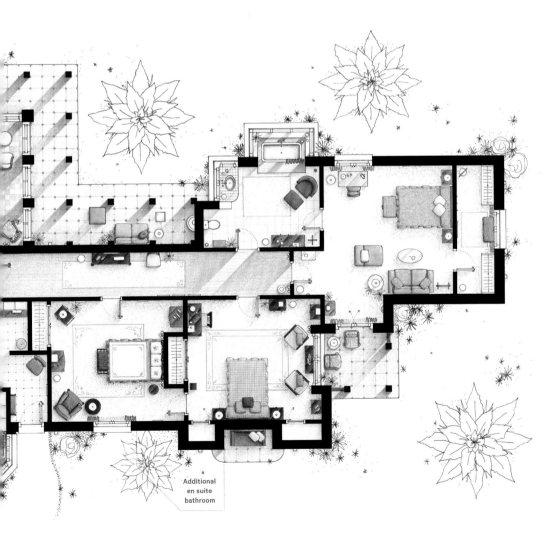

Additional en suite bathroom

A Kitchen Leftovers

The kitchen set was added last-minute thanks to late-stage script revisions to the pilot, which contributed to an overall house layout that fans, and even the designers, agree is confusing and illogical. To help save time, the production team used a kitchen set leftover from the short-lived sitcom *It Takes Two*, also created by Susan Harris.

B Blanche's Boudoir

Perfectly suited for Blanche and featuring the iconic bedspread and matching banana-leaf wallpaper—in season 2, Blanche gifted the girls each a calendar called "The Men of Blanche's Boudoir." As a behind-the-scenes prank, the calendars were filled with pictures of crew members—the cast loved them so much they kept them.

THE MARY TYLER MOORE SHOW

CREATED BY: James L. Brooks and Allan Burns	**CHANNEL:** CBS
SERIES RUN: 7 seasons; 168 episodes; 1970–1977	
FILM LOCATION: Live studio audience at CBS Studio Center in Studio City, California	

After playing the loveable stay-at-home mom on *The Dick Van Dyke Show*, Mary Tyler Moore could have taken a break and rested on the popularity of her character Laura Petrie, but instead, she decided to start her own production company, MTM Enterprises, and helped bring to life one of the most influential and groundbreaking sitcoms of all time. Premiering in 1970, *The Mary Tyler Moore Show* followed Mary Richards, a single, independent, thirtysomething woman who relocated to Minneapolis after a broken engagement and took a job at WJM-TV, the city's lowest-rated news station. Ready to start fresh, she met her gruff but loveable boss, Lou Grant; wisecracking head writer, Murray Slaughter; incompetent anchorman, Ted Baxter; man-chaser Sue Ann Nivens; landlord Phyllis Lindstrom; and best friend and upstairs neighbor, Rhoda Morgenstern. *The Mary Tyler Moore Show* rebelled against the typical sitcom setup of domesticity and showed that single women could happily live alone (in bachelorette pads), date men without worrying about marriage, and stand up to a male-dominated industry—all while simultaneously, unwittingly revolutionizing a new subgenre of television sitcom revolving around the workplace.

Airing in the middle of the second wave of feminism, the program reflected on the ideals and struggles of women in the real world. The series made an impact culturally and creatively that cannot be overstated. Moore ensured her television show nail the voice of modern women by hiring a slew of female writers to write for it. At one point, twenty-five of seventy-five writers on the show were women, which at the time was an anomaly. Without *The Mary Tyler Moore Show*, there would be no *Cheers* or *Murphy Brown*, no Liz and Jack (*30 Rock*), Leslie and Ron (*Parks and Recreation*), and no Oprah Winfrey—that's right, the queen of daytime

TV and history's first female African American billionaire has said that Mary Tyler Moore and her spunky on-screen alter ego had more influence on her career than any other person.

The Mary Tyler Moore Show was no stranger to the awards circuit, receiving sixty-seven Emmy Award nominations and winning twenty-nine times. It holds the record for most acting wins for a comedy series at sixteen. The show spawned three spin-offs for its

supporting characters, including the more dramatic *Lou Grant* (1977–1982), *Phyllis* (1975–1977), and *Rhoda* (1974–1978), which famously featured Rhoda's wedding, the second-most-watched television episode of all time. *The Mary Tyler Moore Show* is still considered the benchmark of workplace comedies. And its star, Mary Tyler Moore, was indeed a cultural icon and role model who inspired generations of young women to live free and independent on *their* terms.

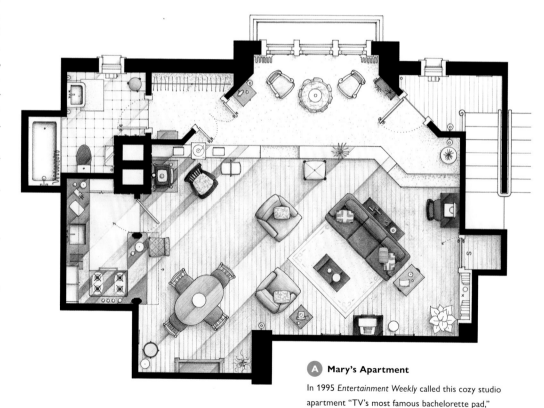

A Mary's Apartment

In 1995 *Entertainment Weekly* called this cozy studio apartment "TV's most famous bachelorette pad," thanks to its unforgettable shag carpet, comfy sleeper sofa, Palladian windows, and kitschy overall design.

The Lindstrom Household

ADDRESS: 119 North Weatherly Avenue, Minneapolis, Minnesota

Home to Mary, Rhoda, and Phyllis, this Queen Anne Victorian used for exterior shots is still located in the Kenwood neighborhood of Minneapolis. The original owner of the house became so overwhelmed with tourists and fans that she placed several "Impeach Nixon" signs in the windows, which prevented producers from filming. They eventually moved Mary into a high-rise apartment.

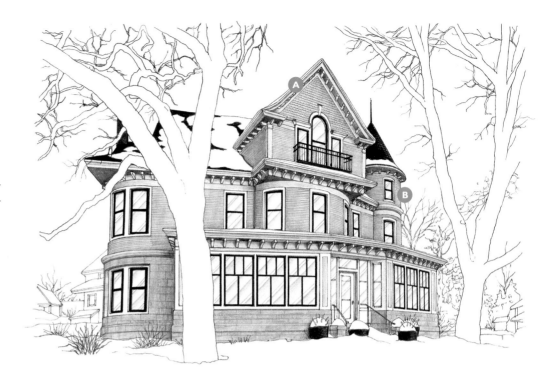

 Rhoda's Apartment

In contrast to the clean and tailored design of Mary's apartment and wardrobe, Rhoda's attic loft, with its boho-chic aesthetic and colorful drapery, was unapologetically loud and confident—just like her personality.

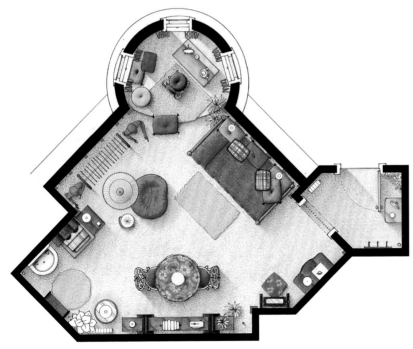

Mary's M and Rhoda's etc.

Two simple pieces of décor perfectly suited to each character's personality and apartments. During a reunion on *The Oprah Winfrey Show*, Mary Tyler Moore admitted that the iconic letter *M* was the one prop she took from the set. The cast later presented superfan Oprah with her own *O*.

KID TESTED, PARENT APPROVED

Anyone who does anything
to help a child in his
life is a hero to me.
—FRED ROGERS of *Mister Rogers'*
Neighborhood

Whether it was learning ABC's over a sugary bowl of morning cereal or waking up on Saturday mornings to catch the latest superhero action adventure, everyone has a childhood memory of watching their favorite show forever etched in their mind. Older generations had pesky cartoon animals getting hit over the head with an anvil while modern children have their talking rescue dogs. Regardless of what kids watch, or when they watch it, children's television programs, for better or worse, have had a profound impact on their developing brains.

Television has often been referred to as an electronic babysitter—a tool for busy or overworked parents to help keep their young ones occupied for hours on end. In the beginning of children's TV and its newfound popularity, advertisers took advantage of this convenient caretaker by making TV a pipeline to push products to kids, or more appropriately, their parents (the ones who bought them things), until creators realized that they could develop programs that both parents and their kids could enjoy together. This idea leapt into the mainstream, and into prime time. However, the biggest shift in children's television was the boom of educational programming that took advantage of the "electronic babysitter" needs of parents and offered an alternative— shows that were equal parts entertainment and at-home teacher, providing an enriching experience and developmental lessons hidden under bright lights, colors, and sounds. By understanding the power of television, and its power over children, groundbreaking children's television producers created a subgenre that positively impacted popular media for a generation. The following shows helped kick-start a new era of television that, despite parents' best efforts, allowed kids around the world to have their cake and eat it too. As long as it didn't spoil their dinner.

MISTER ROGERS' NEIGHBORHOOD

CREATED BY: Fred Rogers	**CHANNEL:** PBS (previously NET)
SERIES RUN: 31 seasons; 912 episodes; 1968–2001	
FILM LOCATION: WQED Studios in Pittsburgh, Pennsylvania	

The Television House Facade

The final shot of the opening credits lands on this quaint model house that, for all you model enthusiasts, is a modified Bachmann Trains Cape Cod House.

One knit sweater. One pair of sneakers. And one important message: *You. Are. Special.* Mister Rogers might not have looked like a typical superhero or talked like one, but to millions of children, over the course of fifty years, he truly became one. *Mister Rogers' Neighborhood* was an educational children's program created to provide a kinder, gentler alternative to the typical programming of the day. Written and hosted by Fred Rogers, an ordained minister with a background in early childhood education and music composition, the show premiered in the United States in 1968 on National Educational Television (NET) and then ran on NET's successor PBS until 2001. Rogers aimed to create trust with viewers—in this case, children—and slow things down from the children's television animation norm of rapid cuts and kinetic energy. Filmed in Rogers' hometown of Pittsburgh, Pennsylvania, *Mister Rogers' Neighborhood* explored new educational and mental health topics in each episode from

his fictional home in the "real world" as well as the magical Neighborhood of Make-Believe. Rogers wrote all the scripts, composed over two hundred songs and thirteen operas for the show, and voiced nearly all the puppet characters.

Mister Rogers' Neighborhood never talked down to children and encouraged them to be curious, use their imagination, and most of all, be kind. Fred Rogers was a fervent believer in providing public television access to children, recognizing early on in his career that television would help children, and fought to keep it alive by testifying in front of Congress in 1969. Just as he thought everyone deserved free educational programming, he never shied away from taking stances on equality. The same year he testified, during a particularly turbulent time for civil rights, Rogers invited his African American costar François Clemmons (Officer Clemons) to cool his feet with him in a small kiddie pool, passionately reaffirming to his audience that

we're all neighbors. While Rogers expertly crafted all aspects of the show, many of the most memorable moments were unscripted—during an interview with Jeff Erlanger, a ten-year-old boy with an electric wheelchair, Fred and Jeff talk frankly about his disability and perform an emotional rendition of the song "It's You I Like." Twenty years later, Rogers was inducted into the Television Academy Hall of Fame, and none other than Jeff Erlanger surprised him to present the award.

Fred Rogers may never have set out to become an American icon, but his legacy of compassion, empathy, acceptance, and over nine hundred episodes of TV continue to live on. Simply put, *Mister Rogers' Neighborhood* changed children's television forever while forever changing the lives of those who tuned in to hear his songs, his lessons, and most importantly, his closing message: "You've made this day a special day, by just your being you. There's no person in the whole world like you, and I like you just the way you are."

Mister Rogers' Television Home

LOCATION: Mister Rogers' Neighborhood

Mister Rogers was always clear that his "television house," where most of the action took place, was not where he lived with his family but instead a welcoming place to teach lessons and visit with his television neighbors. The series was filmed in studio A at WQED in Pittsburgh, Pennsylvania, and the studio was later renamed the "Fred Rogers Studio."

The Sweater

To convey a sense of routine and stability for his impressionable viewers, each episode memorably opened with the ceremony of Mister Rogers singing "Won't You Be My Neighbor?" as he changed out of street clothes and into one of his iconic cable-knit cardigans and a pair of sneakers. Most of his sweaters were hand knit by his mother, Nancy McFeely Rogers.

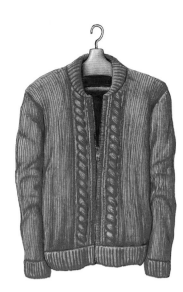

Ⓐ Won't You Pay a Visit?

Fans of Mister Rogers can view the largest collection of original items and artifacts from the show by visiting the special collections gallery at the Senator John Heinz History Center in Pittsburgh, Pennsylvania, or see scripts, clothes, memorabilia, and more at the Fred Rogers Institute in Latrobe, Pennsylvania.

Ⓑ He's Just Like Us

Fred Rogers (known to answer every piece of fan mail sent to him) once received a letter in 1986 on behalf of a three-and-a-half-year-old who was convinced that Mister Rogers didn't go to the bathroom because he never showed the room. Rogers saw this as a learning opportunity and quickly added a segment with a bathroom so children wouldn't be confused.

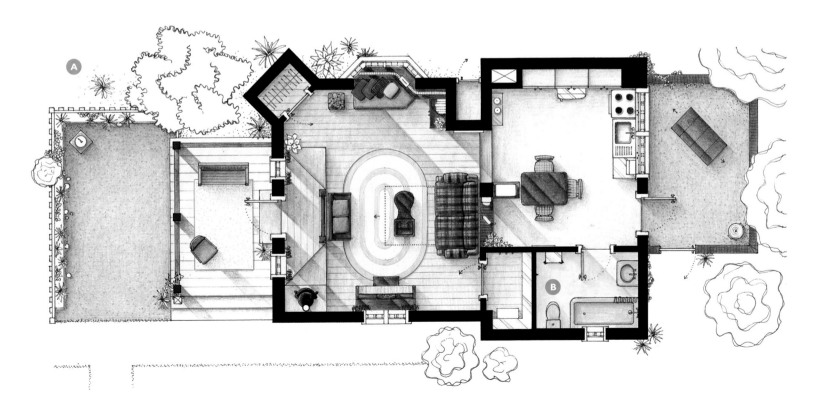

The Neighborhood of Make-Believe

LOCATION: Mister Rogers' Television Home

Accessible only by trolley, this imaginary neighborhood where anything could happen was featured on nearly every episode of the show and introduced children to such beloved characters as King Friday XIII, X the Owl, and Daniel Striped Tiger. Fred Rogers never appeared in this neighborhood in order to help children make the distinction between the "real world" and the world of Make-Believe.

Picture Picture

A favorite segment, "How people make things," was shown using Mister Rogers' trusty projector named Picture Picture.

A The Eiffel Tower

Home to the French-speaking puppet Grand-pére (full name: Henri Frederique de Tigre), who spends his time making and selling *pomme frites*. Like most of the puppets, Grandpére was voiced by Rogers, who spoke French fluently and wanted to expose children to a new language.

B King Friday XIII's Castle, I Presume

Perhaps the most recognizable landmark in all the neighborhood, this blue castle is home to King Friday XIII; his wife, Queen Sara Saturday; and their son, Prince Tuesday. On any given visit, viewers are sure to hear trumpets, big words, or guests saying, "Correct as usual, King Friday."

C Rock-it Factory

Business of Cornflake S. Pecially or "Corney" that manufactures "Rock-its" or rocking chairs of all sizes and colors as well as several other goods. The character is named after the cereal "corn flakes" because it was a favorite of Fred Rogers' son.

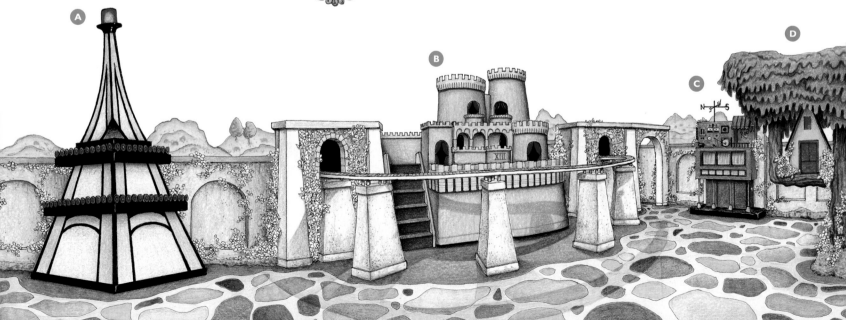

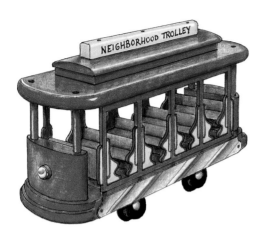

The Neighborhood Trolley

Mister Rogers would send this trolley through the tunnel and transport viewers to the Neighborhood of Make-Believe. Before he was Batman, Beetlejuice, or Birdman, Pittsburgh native and Oscar nominee Michael Keaton worked on the show as a stagehand and a member of the Flying Zookeeni Brothers. He even operated the trolley!

Traffic Light

Due to Fred Rogers' attention to detail in all aspects of his show, and his love of symbolism, many believe that the traffic light flashed yellow in many opening shots as a message and reminder to children, and adults, to slow down a little.

D The Great Oak Tree

Located in the center of the neighborhood, this massive tree houses both the meow-crazy Henrietta Pussycat, who lives in the yellow and orange schoolhouse, and her neighbor and Benjamin Franklin superfan, X the Owl.

E Museum-Go-Round

A merry-go-round museum that has everything "from dinosaurs and bones to antique telephones." It is curated by Lady Elaine Fairchilde, who lives in the museum and is often seen shouting "Boomerang-Toomerang-Soomerang" with her magic boomerang in hand.

F Platypus Mound

Home to the Platypus family that consists of Dr. Bill Platypus, neighborhood doctor of people, animals, and pets; his wife, Elsie Jean; and their daughter, Ana, who is named after *Ornithorhynchus anatinus*, the Latin scientific name for platypus.

G Grandfather Clock

Mister Rogers' most enduring character, Daniel Striped Tiger, lives in this timeless clock that has no hands. Daniel is the first puppet to appear on the show and spawned an animated spin-off in 2011 titled *Daniel Tiger's Neighborhood*.

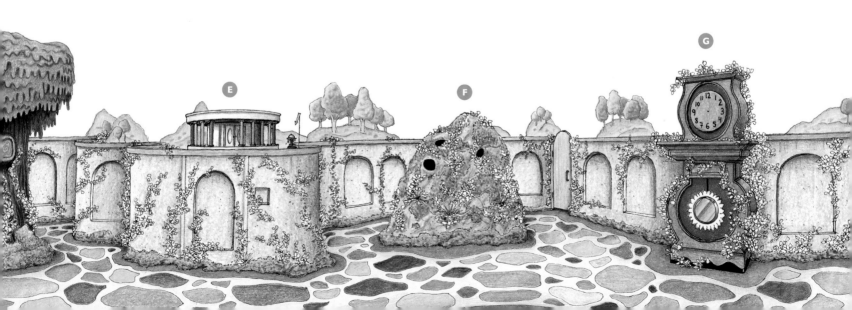

SESAME STREET

CREATED BY: Joan Ganz Cooney and Lloyd Morrisett	**CHANNEL:** PBS (1969–2015; 2016–present), HBO/HBO Max (2016–present)

SERIES RUN: 52 seasons and counting; 4,631 episodes and counting; 1969–present

FILM LOCATION: Reeves Teletape Studios, New York City, New York (1969–92); Unitel Video, Inc., New York City, New York (1987–93); Kaufman Astoria Studios, Astoria, Queens, New York (1993–present)

A Hooper's Store

Run by Mr. Harold Hooper, one of the first human characters to appear on the series, this reliable corner candy store/grocery store/newsstand was a favorite of Big Bird. Not only was it a purveyor of birdseed milkshakes, but famously, it closed in 1972 to administer measles vaccines to the neighborhood.

When it comes to the world's most famous streets, it's not hard to rattle off names like the Champs-Élysées, Park Avenue, Sunset Boulevard, and Abbey Road. But all of these landmarks pale in comparison to the most beloved and well-known street in television history, a place where the air is sweet, the neighbors are friendly, and people of all shapes, sizes, colors, and fabrics are welcome—a place called *Sesame Street*. First airing on PBS with its debut in 1969 and created by the nonprofit Children's Television Workshop (now called Sesame Workshop), *Sesame Street* is an educational children's program designed by a collaboration of writers, producers, educators, and researchers that combines reality and fantasy elements through live-action, animation, music, and puppetry. Thanks to a cast of memorable characters like Elmo, Big Bird, Cookie Monster, Bert and Ernie, Mr. Snuffleupagus, and the rest of the crew, along with a diverse group of human characters like Gordon, Maria, Luis, and Bob, and a long list of famous celebrity cameos, *Sesame Street* is not only an American institution but also a worldwide phenomenon that's still going strong after more than fifty years on the air.

Airing on the tail of the Civil Rights Movement, at the height of the Vietnam War, *Sesame Street* started as an experiment to assess the usefulness of TV technology as an educational tool at a time when children, particularly children of color, aged three to five were spending half of their waking lives watching television. Enter television producer Joan Ganz Cooney and Lloyd Morrissett, a psychologist at the Carnegie Foundation, who realized that if kids could easily sing beer commercials and memorize advertisements, the television format, and more specifically the methodology of advertising, could be used to teach reading, writing, arithmetic, and other life lessons. Cooney and Morrisett brought in writer/director Jon Stone to write the pilot script and direct the show. Stone would go on to direct and work on the show until shortly before his death, but perhaps his biggest contribution was bringing on composer/lyricist Joe Raposo and puppeteer Jim Henson, the visionary creator of the Muppets. Initially, Cooney and Morrisett researched how the program was connecting with children using test episodes and found that when only humans were on-screen, children often checked out and were disengaged. But once one of Henson's creations appeared, children were absolutely mesmerized.

Sesame Street would go on to single-handedly change the world by becoming one of the most influential programs in history, educating and entertaining generations of viewers. Of course, in the beginning of the show's run, not everyone was a fan—at one point, the state of Mississippi voted not to air it due to its racially integrated cast. Detractors aside, the show never missed an opportunity to tackle serious issues in between counting exercises, covering topics such as death, divorce, homelessness, and racial equality. *Sesame Street* is the most widely viewed children's television show in the world, operating in over 150 countries, with more than 30 international coproductions. If there's one thing in the world that's loved more than Cookie Monster loves cookies, it's *Sesame Street*—for striving to give children the tools that they need to create the world they want to live in.

Sesame Street

LOCATION: Sesame Street, New York, New York

The creators hoped that every kid felt like it could be their own street. While a street in Harlem inspired the set, the show was filmed in a studio in Queens. Fans of the most famous neighborhood on television can visit the Strong National Museum of Play in Rochester, New York, to see a life-size re-creation.

B Oscar's Trash Can

As of season 46, Sesame Street's cutest curmudgeon resides here, in front of 123 Sesame Street. Did you know Oscar's fur was orange in the first season before changing to green?

C Big Bird's Nest

Located at 123½, Big Bird has lived in this nest since he hatched. The space has gone through several makeovers, including Big Bird being relocated after a hurricane in 2001, a memorable episode that continues to replay after major hurricanes.

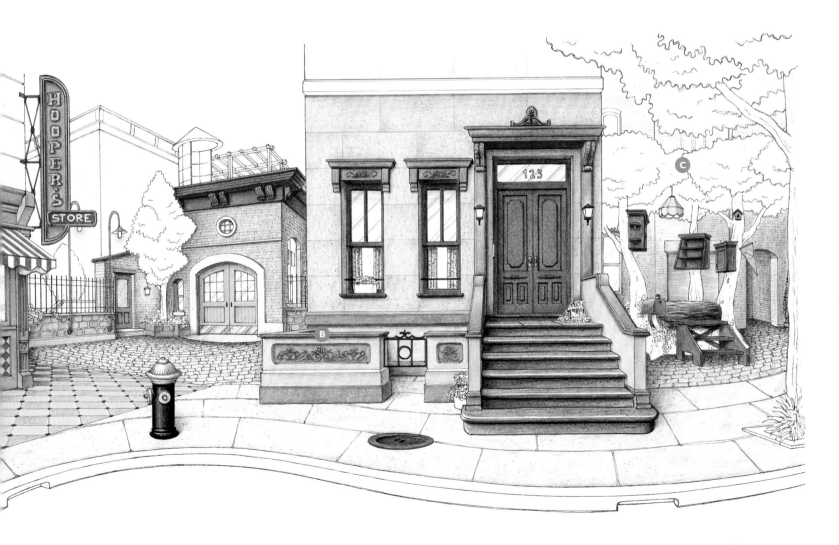

Bert and Ernie's Apartment

ADDRESS: 123 Sesame Street, #1D, New York, New York

Bert and Ernie's basement apartment was introduced in the first episode of *Sesame Street* and is the main location for most of their sketches. Bert and Ernie have had several neighbors throughout the series, most notably Gordon and Susan on the first floor and Luis, Maria, and Gabi on the top floor.

Interchangeable Rooms

Bert and Ernie's bedroom and living room sets are essentially the same and are re-dressed depending on the scene. The one constant is the framed picture of Bert and Ernie in between the windows, rendered here with similarly looking fruit.

Twiddlebugs

The Twiddlebug family (Thomas, Tessie, Timmy, and Tina) are a species of colorful insects that live in a milk carton in Ernie's window box. Debuting in season 5 (1973–1974), this fuzzy family often uses brainstorming and cooperation when difficult challenges are presented.

Rubber Duckie

This famous fictional fowl is the prized possession of Ernie and the subject of his signature song, "Rubber Duckie," which debuted on February 25, 1970. Sung by Ernie (voiced by the legendary Jim Henson), it reached number 16 on the Billboard Hot 100 chart and was nominated for a Grammy Award.

A Rosie

Ernie affectionately calls his bathtub "Rosie," explaining to Bert that every time he takes a bath, he leaves a ring around Rosie—a reference to the popular nursery rhyme.

B A Global Friendship

Bert and Ernie are well loved across the world and are known by different names internationally such as:

- Spain – Epi and Blas
- Egypt – Shadi w Hati
- Italy – Ernesto e Berto
- Norway – Bernt og Erling
- Pakistan – Annu aur Bablu
- Turkey – Edi ile Büdü

MR. BEAN

CREATED BY: Rowan Atkinson and Richard Curtis	CHANNEL: ITV
SERIES RUN: 15 episodes; 1990–1995	
FILM LOCATION: Live studio audience at Thames Television's Teddington Studios; on location in and around London	

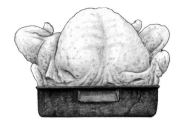

Merry Christmas, Mr. Bean

While preparing a Christmas turkey, Mr. Bean loses his watch inside the carcass. While trying to look for it, he gets his head firmly stuck inside—six years before Joey from *Friends* had a similar experience. Actor Rowan Atkinson truly suffered for his art with months of neck and back pain due to the weight of the fowl prop.

First appearing on screens in 1990, *Mr. Bean* is a British sitcom created by Rowan Atkinson and Richard Curtis (writer of *Notting Hill* and *Four Weddings and a Funeral* and director of *Love Actually*). The series followed its titular character, "a child trapped in the body of a man," who, through his unusual brand of wit, attempted to perform everyday tasks, ultimately creating trouble for himself and those around him in decidedly hilarious ways. The show consisted of fifteen episodes originally airing on ITV before spawning two feature films (*Bean* and *Mr. Bean's Holiday*), an animated spin-off, and several one-off sketches and appearances for charity or special events, including Mr. Bean's appearance during the opening ceremony of the 2012 Summer Olympics in London.

Developed by Atkinson while studying for his master's degree in electrical engineering at the Queen's College in Oxford, the character, with his trademark tweed jacket and red tie, was inspired by the likes of Charlie Chaplin, Buster Keaton, Harold Lloyd, and most notably, the films of Jacques Tati. Atkinson's near wordless character would go on to become one of the most beloved and recognizable characters around the world, striking a chord with viewers of all ages and, most importantly, all languages, due to the ingenious physical comedy that needs no translation. For over thirty years, Mr. Bean has been, and will continue to be, a British cultural icon that thankfully, and quite literally (according to the opening credits), fell from the sky for our entertainment.

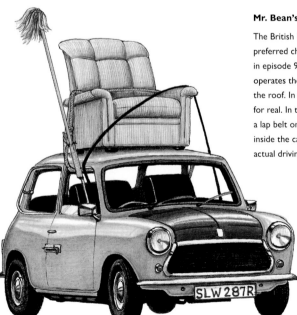

Mr. Bean's Mini

The British Leyland Mini 1000 Mark IV was Mr. Bean's preferred choice of travel. Its most famous ride occurred in episode 9, "Do-It-Yourself Mr. Bean," when Mr. Bean operates the car while sitting in an armchair attached to the roof. In most cases, Mr. Bean's stunts were performed for real. In this scene, Atkinson was held down only by a lap belt on the armchair while a crew member, hidden inside the car and navigating with a video screen, did the actual driving.

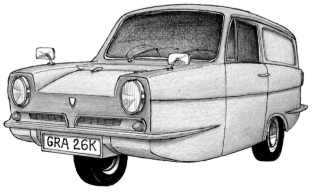

Reliant Regal Supervan III

In a running gag on the show, Mr. Bean often finds himself in conflict with this light blue, three-wheeled nemesis whose driver's identity is never revealed. The one-sided rivalry usually ends with this car being toppled over, stuck in a ditch, or having crashed into something.

Mr. Bean's Flat

ADDRESS: Flat 2, 12 Arbour Road, Highbury, London, England

First introduced in episode 4, "Mr. Bean Goes to Town," the exterior of Mr. Bean's home was located in Surbiton, a suburb of London, and the interiors were filmed before a live studio audience at Teddington Studios.

Teddy

Teddy was Mr. Bean's loyal best friend and partner in various schemes—helping him win a pet show, being used as an impromptu paintbrush, and inevitably ending up broken or in various levels of disarray. Teddy first appeared (with a smaller head) in episode 5, "The Trouble with Mr. Bean," and since became integral to the character of Mr. Bean.

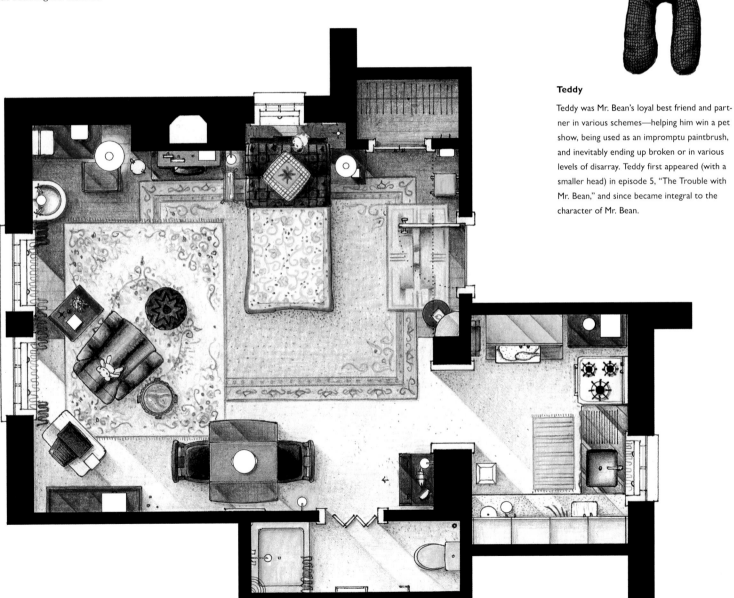

IT RUNS IN THE FAMILY

I'm sorry, Marge, but
sometimes I think we're
the worst family in town.
—HOMER SIMPSON

Maybe we should move to
a larger community.
—MARGE SIMPSON

The Simpsons

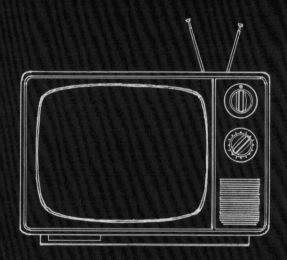

Mom. Dad. Kids. Dog. Green grass. A picket fence. The American Dream. Since the dawn of television, and especially during the postwar sprawl, sitcom families were about as cookie-cutter as the houses they lived in, but as the world evolved, so did TV viewers. Their families grew up and so did television, becoming a reflection of how real-life families changed, blended, split up, and were chosen. Despite these new television families looking, sounding, or acting different than their previous counterparts, the themes of each show remain familiar. Money troubles. Parenting troubles. In-law troubles. The always tense family dinner or holiday gathering. Or in rare cases, an otherworldly family literally just having trouble being human on earth, avoiding Jell-O. In other words, highly relatable scenarios, no?

The family sitcom has always mirrored the absurdities of modern-day life and gives much-needed perspective to viewers who love to laugh and release tension alongside a studio audience. Perhaps that's why this format of sitcom has survived. No matter how far shows get from reality, stories about family are inherently relatable. The family sitcom has stayed relevant but only because it is no longer formulaic. It's an ever-growing subgenre that has its ups and downs, but at the end of the day, as if it's family, you take comfort in knowing that it'll be there for you, through thick and thin, rain or shine, sweeps week and syndication.

THE SIMPSONS

CREATED BY: Matt Groening	CHANNEL: FOX
SERIES RUN: 33 seasons and counting; 728 episodes and counting; 1989–present	

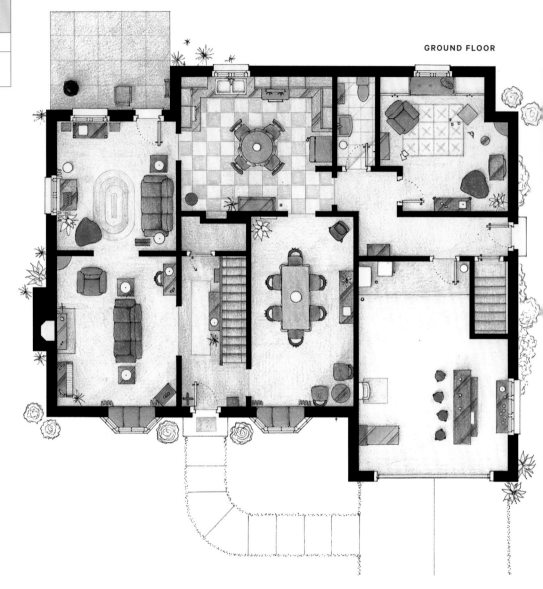

On a hypothetical basketball tournament–like bracket for "Most Popular TV Family," it stands to reason that the Bradys and the Ricardos would have a chance at winning. But when you take into consideration accolades such as longest-running American sitcom, longest-running American scripted prime-time television series, longest-running American animated series, and a cultural relevance unmatched in history, there's one clear winner: the Simpsons. Created by Matt Groening (and famously making its first appearance as a recurring series of animated sketches on *The Tracey Ullman Show* in 1987), *The Simpsons* made its network debut as a half-hour prime-time show on FOX in 1989.

Created as a social satire and parody of Middle America and family sitcoms of old, *The Simpsons* takes place in Springfield, an average-sized city in an indeterminate state, and follows the titular family consisting of Homer, a sometimes lazy and ignorant but caring father; his wife, Marge, the family's loving, blue-haired, raspy voice of reason; their son, Bart, a ten-year-old disruptive and prank-loving troublemaker; their daughter, Lisa, an accomplished, intelligent, and insightful eight-year-old; and their newborn, Maggie, who is mischievous, stubborn, and never without her trusty pacifier. Thanks to its successful combination of highbrow/lowbrow comedy, endless visual gags, parody, and satire (from a revered writers' room full of Harvard grads and comedy titans, including late-night host Conan O'Brien), *The Simpsons* has been an important and influential advance in the television art form. Featuring a cast of iconic supporting characters like Ned Flanders, Krusty the Clown, Mr. Burns, Smithers, Apu Nahasapeemapetilon, Ralph Wiggum, Moe Szyslak, Itchy and Scratchy, Barney Gumble, and a near endless list of hilarious peripheral characters and residents, *The Simpsons*' animation style allowed the creators to embrace a comedic absurdity unlike anything on TV at the time.

With the release of countless academic essays, collegiate courses, theme parks, video game franchises, and even words added to the *Oxford English Dictionary*, *The Simpsons* proves over and over that it's an unstoppable pop culture force and enduring phenomenon whose influence permeates all facets of life. Simply put, *The Simpsons* created a brand-new television medium and opened the door for animation geared toward adults (*Beavis and Butt-Head*, *South Park*, *Family Guy*, *Rick and Morty*).

No matter how many episodes of *The Simpsons* an average viewer has seen, there's always some new joke or reference to admire. Famed fictional actor Troy McClure (who you may remember from such projects

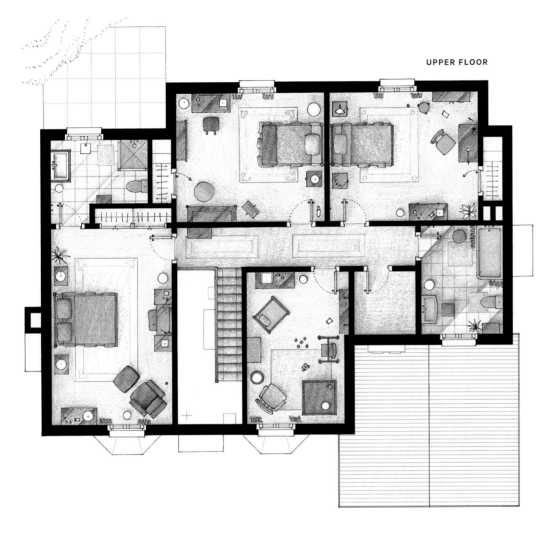

The Simpson Family Home

ADDRESS: 742 Evergreen Terrace, Springfield

After an exhaustive search and considering Horatio McCallister's houseboat, a house next to a rendering plant emitting melted hog fat fumes, and a murder house in the "Rat's Nest," Homer and Marge finally settled into their dream home. Evergreen Terrace is a reference to Matt Groening's alma mater, Evergreen State College.

"If anyone wants me, I'll be in my room."
—Lisa

"I'm Bart Simpson, who the hell are you?"
—Bart

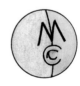

"D'oh!"
—Homer

"Hrmmm!"
—Marge

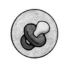

"[Pacifier sucking noise]"
—Maggie

as *Alice Doesn't Live Anymore*, *Smoke Yourself Thin*, *The Contrabulous Fabtraption of Professor Horatio Hufnagel*, and *Give My Remains to Broadway*, and from his breathtaking performance as Colonel George Taylor in *Stop the Planet of the Apes, I Want to Get Off!*—a theatrical adaptation of *Planet of the Apes*) summed up the show best during his appearance in the self-referential season 7 episode "The Simpsons 138th Episode Spectacular" when he remarked, "Right about now, you're probably saying, 'Troy, I've seen every Simpsons episode. You can't show me anything new.' You've got some attitude, Mister. Besides, you're wrong!" And wrong never felt so right.

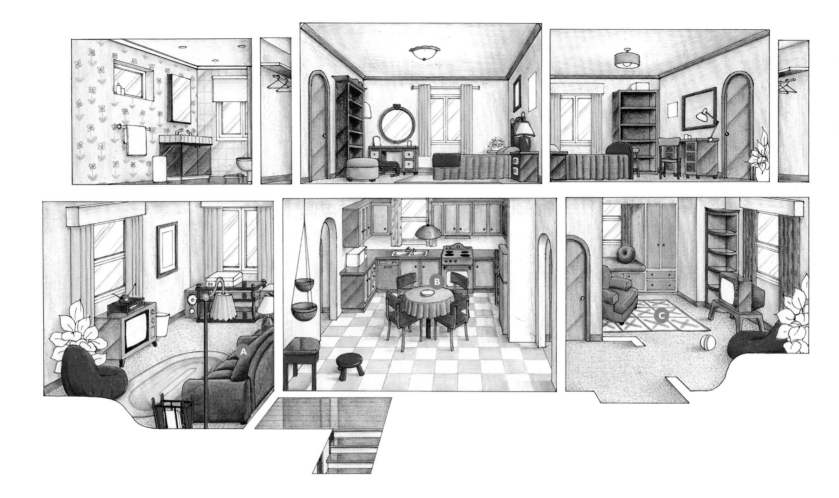

A **The Couch Gag**

Nearly every episode has a different end of the opening credits as the family races to the couch. Some notable gags include:

- The family walked in on duplicate versions of themselves already sitting on the couch.
- The family formed a chorus line that lifted the walls to reveal a full circus behind them.
- The entire town showed up and blocked the family's view of the television.

B **Predicting the Future**

The show has an uncanny knack for accidentally predicting future events such as the Siegfried & Roy tiger attack, FIFA corruption, and even a future presidency. Add artificial intelligence to the list with the Pierce Brosnan–voiced Ultrahouse 3000 smart home from "Treehouse of Horror XII" episode. After the kitchen table self-cleans, Homer boldly states, "Trusting every aspect of our lives to a giant computer is the smartest thing we ever did."

C The Mysterious Rumpus Room

Located next to the kitchen, the rumpus room, with a bean bag, armchair, and small TV, has only appeared on the show a handful of times, resulting in many fans (and perhaps some writers) not even knowing it exists. The room was mocked in "White Christmas Blues" when Marge talks about it and says, "Sometimes it's there and sometimes it isn't. Our house is very odd that way."

D Yay or D'oh!

In 1997 a real-life replica of the house was built in Henderson, Nevada, as a promotional giveaway. Builders tried to re-create the Simpsons home as closely as possible, including widening and lengthening the doors to accommodate Marge's hair and Homer's rotundness. It's safe to say that they *didn't* use "The Half-Assed Approach to Foundation Repair" like Homer did when his house began sinking.

GILMORE GIRLS

CREATED BY: Amy Sherman-Palladino	**CHANNEL:** The WB (seasons 1–6), the CW (season 7), Netflix (revival miniseries)
SERIES RUN: 7 seasons; 153 episodes; 2000–2007 (original run); 2016 (Netflix revival *Gilmore Girls: A Year in the Life*)	
FILM LOCATION: Warner Bros. Studios in Burbank, California	

Television shows come in many forms: those that make us laugh, others that make us cry, and some that even make us frightened, uncomfortable, or fall off the edge of our seats. But in 2000 a show premiered that would arguably become television's ultimate "comfort food"—a show that felt like snuggling under a cozy blanket, having a cleared calendar, or sipping hot chocolate on a cold day. That show is, of course, *Gilmore Girls*. Created by Amy Sherman-Palladino, it followed the lives of single mother Lorelai Gilmore and her daughter, Rory Gilmore, who, after moving away from the security of a luxurious life, navigated relationships with family, friends, boyfriends, and residents in their idyllic town of Stars Hollow.

As one of the most beloved towns in all of TV, Stars Hollow was based on the quaint town of Washington Depot, Connecticut, where Sherman-Palladino first got the idea for the show. Thanks to its rich and textured world, adorable town square, and diner where life's most important companion, coffee, is always hot and ready to serve, Stars Hollow became a character all its own. It was an idealized version of what small towns could be—affable but comedically nosy neighbors, no shortage of special happenings, picturesque scenery everywhere you looked, and most of all, a Rockwellian rendering of Americana that always seemed attainable and not out of reach. The town has become so well-known that each year thousands of people flock to the Warner Bros. studio tour to walk the same streets as the residents of Stars Hollow.

Initially, *Gilmore Girls* was well-known for its lightning-fast, cultural-reference-filled, wordplay-heavy dialogue echoing the screwball comedies of the '30s and '40s. Most hour-long television scripts land in the range of forty to fifty pages, but *Gilmore Girls* scripts clocked in at seventy-five or eighty pages and were performed verbatim, like a play, with little or no room to improvise. The show even had a special on-set dialogue coach, George Bell (who you might recognize as character Professor Bell at

Yale), who helped prepare all the actors and day players to deliver the lines the way they were intended. Sherman-Palladino set the tone of the writers' room, saying, "This show is about a mother and a daughter who are best friends as well as being mother and daughter, and every conflict and dynamic should ticktack back and forth on that one point."

Critics lauded the show for its cross-generational appeal, its mix of humor and drama, and most notably, the performances of stars Lauren Graham (Lorelai) and Alexis Bledel (Rory). Despite being the flagship show of the WB, *Gilmore Girls* never had massive ratings and when it came to awards was only nominated for one Emmy Award, which it won. The show amassed a cult following and eventually found its footing in syndication, DVD sales, and later, online streaming. Thanks to legions of streamers on Netflix, a miniseries revival titled *Gilmore Girls: A Year in the Life* was green-lit. The show's impact can be distilled down to a simple response Lorelai gave Dean in the first season in regard to *The Donna Reed Show*: "It's a lifestyle. It's a religion." And any religion that believes in the power of coffee and friendship as much as *Gilmore Girls* will no doubt have new converts saying, "Where you lead, I will follow."

Lorelai and Rory Gilmore's Home

LOCATION: Stars Hollow, Connecticut

Lorelai bought this house after saving money while working (and living with Rory in the toolshed) at the Independence Inn. One of the main settings of the show, it has hosted many sessions of Lorelai and Rory watching old movies together over takeout and popcorn.

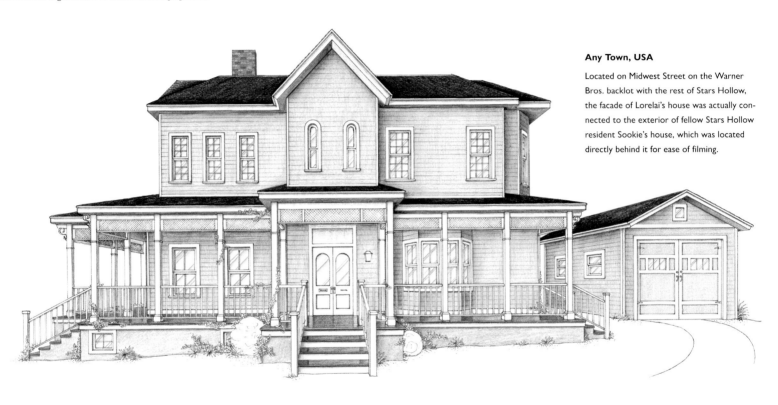

Any Town, USA

Located on Midwest Street on the Warner Bros. backlot with the rest of Stars Hollow, the facade of Lorelai's house was actually connected to the exterior of fellow Stars Hollow resident Sookie's house, which was located directly behind it for ease of filming.

Smaller in Real Life

Like the Brady's home in *The Brady Bunch*, Lorelai's house on the Warner Bros. backlot does not match the interiors we're used to seeing on TV. Can you see where fiction doesn't reflect reality?

A Friends in Stars Hollow

In season 6's episode "Welcome to the Dollhouse," Richard brought over Lorelai's childhood dollhouse as a peace offering to talk about Rory. The same prop was first used on *Friends* as Monica's childhood dollhouse in season 3, episode 20, "The One with the Dollhouse."

B Paul Anka's Favorite Spot

First appearing in season 6, Paul Anka is Lorelai's adopted dog—named after the successful Canadian singer/songwriter who wrote the song "Puppy Love."

C Pizza Money under the Singing Rabbi

The Singing Rabbi is a beloved knickknack of the Gilmore household that is often used as a paperweight for pizza money or to play a tune while searching the closet.

GROUND FLOOR

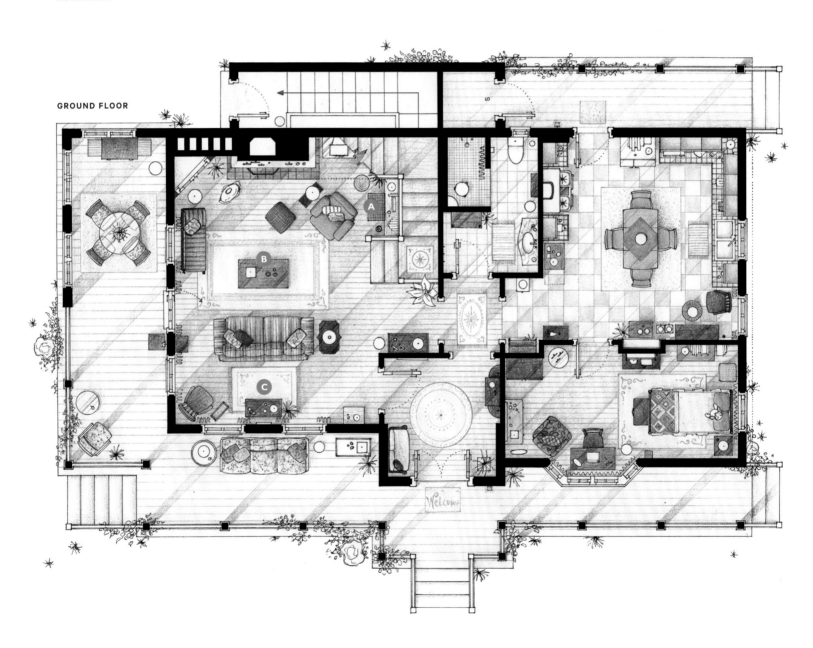

D **Lorelai's Old Bedroom**

From season 1 through part of season 6, this smaller room was Lorelai's bedroom. Many fans have scratched their heads at the fact that this giant Connecticut home had only two bedrooms.

E **Lorelai's New Bedroom**

In season 6 when Luke and Lorelai get engaged, they expand the upstairs to make a larger bedroom for Lorelai, who is too attached to the house to ever move away. This floor plan remains through season 7 and *Gilmore Girls: A Year in the Life.*

UPPER FLOOR

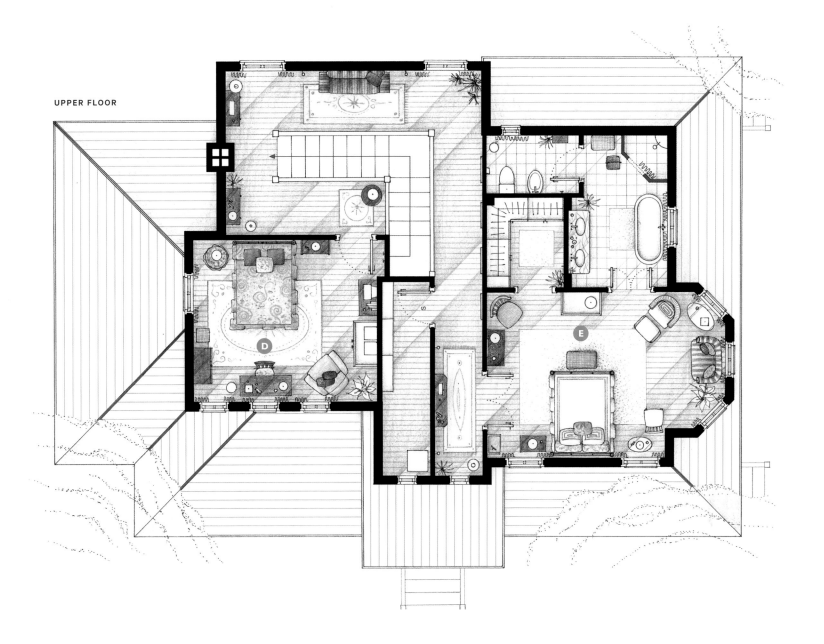

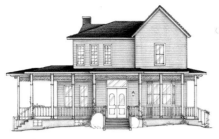

A Lorelai and Rory Gilmore's House

B Main Square and Gazebo

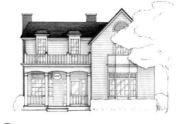

C Kim's Antiques and Lane Kim's House

D Miss Patty's School of Ballet

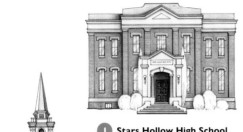

I Stars Hollow High School

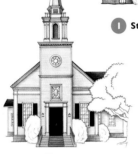

J Church

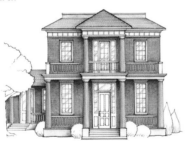

K Stars Hollow History Museum

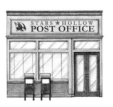

L Post Office

M Hewes Bros Gas and Service Station

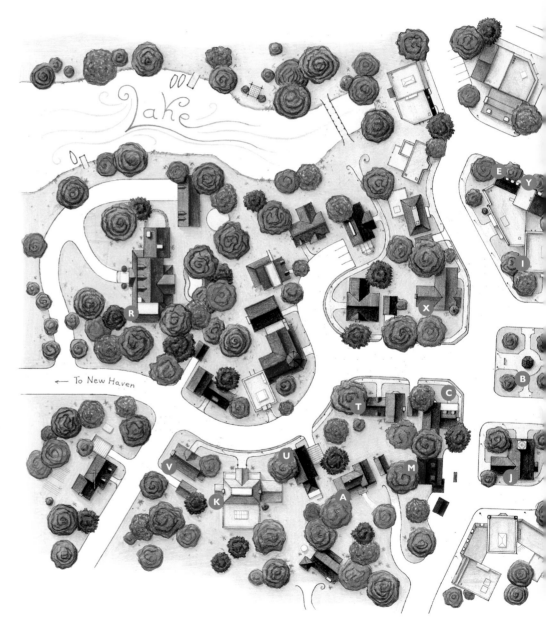

E Weston's Bakery

F Sophie's Music

G Stars Hollow Books

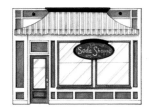

H Taylor's Olde Fashioned Soda Shoppe

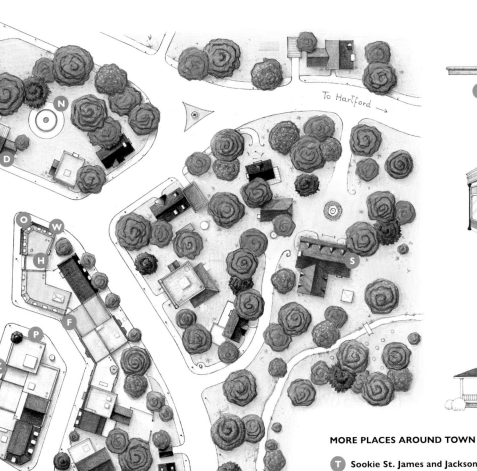

To Hartford →

To Yale →

N Public Park

O Luke's Diner/Williams Hardware

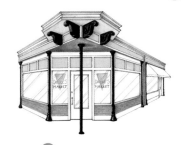

P Doose's Market

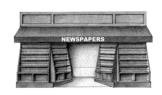

Q Bootsy's Newsstand

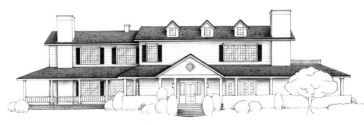

R Independence Inn

MORE PLACES AROUND TOWN

T Sookie St. James and Jackson
Belleville's House

U Babette and Morey Dell's House

V Dean Forester's House

W Luke's Apartment

X Black & White & Read Bookstore

Y Stars Hollow Video

Z Stars Hollow Beauty Supply

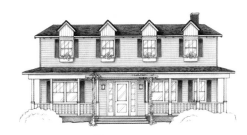

S Dragonfly Inn

ARRESTED DEVELOPMENT

CREATED BY: Mitchell Hurwitz	**CHANNEL:** FOX (seasons 1–3), Netflix (seasons 4–5)
SERIES RUN: 5 seasons; 84 episodes; 2003–2006 (seasons 1–3), 2013 (season 4), 2018–2019 (season 5)	
FILM LOCATION: The Culver Studios in Culver City, California; on location in and around California	

Cue Ron Howard voice-over and opening titles: The Bluth family, a wealthy and dysfunctional bunch surrounded by lies and some love (but mainly lies), lost everything, transforming their not-so-solid-as-a-rock family foundation into a state of, you guessed it, *arrested development*. Created by Mitchell Hurwitz, and starring Jason Bateman as Michael Bluth, *Arrested Development* premiered in 2003 on FOX. Standing in Michael's way as he tried to juggle the needs of his family and their real estate business was his father, George Bluth Sr., the sometimes imprisoned patriarch; his mother, Lucille, the manipulative and boozy matriarch; Lindsay, his materialistic and vain "twin" sister; Buster, his panic-attack-prone younger brother; George Oscar Bluth Jr. (or GOB), his older brother and a failed magician who believed he was the chosen son; Lindsay's husband, Tobias Fünke, a former therapist and analyst (*analrapist* turned *theralyst*) who believed his destiny was to be an actor; Lindsay and Tobias's sarcastic, independent, and underage movie executive daughter, Maeby; and Michael's straitlaced and awkward son, George Michael, who had a restrained attraction for his cousin.

The genesis of the project came when producer/narrator Ron Howard reached out to Hurwitz with an idea to experiment with a new kind of sitcom, one that used the visual vocabulary of reality shows and was shot on digital HD video (at a time when shows were shot exclusively on film or videotape). By using this new medium, the crew didn't have to overlight and could shoot quickly and produce more scenes, which a more traditional setup could not afford to do. It clearly paid off by making *Arrested Development* one of the defining shows of the 2000s, whose influence was apparent in future shows like *30 Rock*, *Community*, *Archer*, and even, stylistically, the American version of *The Office*. Just as much as *Arrested Development* played

with the format, it made perfect use of casting its absurd supporting characters with well-known talents like Carl Weathers, Julia Louis-Dreyfus, Martin Short, Charlize Theron, Judy Greer, Henry Winkler, and as Lucille Two (Lucille Bluth's best friend and rival, and love interest to both Buster and GOB), the incomparable Liza Minnelli, who agreed to do the show after being asked by Ron Howard, who she once used to babysit. *Arrested Development* practically created its own language of visual gags and running jokes such as the chicken dance, Tobias's attempts to join the Blue Man Group, "I've made a huge mistake," "Steve Holt!," and "pick a lane," to name just a few, cementing the show as one of the most groundbreaking comedies of the twenty-first century.

Thanks to its fresh, inventive style, *Arrested Development* was met with near universal critical acclaim. TV critic and writer Alan Sepinwall described the show as a "Rube Goldberg contraption of a sitcom" for its interlocking jokes, blink-and-you'll-miss-it gags, and numerous cleverly constructed callbacks. While *Arrested Development* was a critical darling, it lacked the extensive audience the studio expected and instead had a passionate cult following that understood and appreciated its offbeat brand of comedy. Despite the vocal fan base, it was canceled after three seasons, only to find its mainstream footing and revival six years later on Netflix. The show was nominated for twenty-five Emmy Awards, winning six, including Outstanding Writing for a Comedy Series, Outstanding Directing for a Comedy Series, and the prestigious Outstanding Comedy Series, with Jason Bateman taking home a Golden Globe Award for his role as Michael Bluth. Thanks to streaming, the show's passionate fan base of Bananagrabbers can take comfort in knowing that, like the money in the banana stand, there are always episodes to binge-watch again and again.

The Cornballer

First appearing in season 1, episode 3, the Cornballer was a Bluth family favorite since George Sr. invented it in the 1970s and hawked it on TV infomercials alongside fitness icon Richard Simmons. This faulty device (banned in numerous countries) consistently burned its users, and despite Michael advising *never* to touch it, he often burned himself too.

Model Home Exterior

Located in the Bluth family's Sudden Valley real estate development, this home design was sold to Saddam Hussein by George Sr. in an act of light treason. It features a spacious attic perfect for hiding from the law, tea parties with dolls, and storage for an Aztec tomb.

The Stair Car

After the Bluths lost everything, including their private jet, they were left with a stair car as their only means of transportation. Subjected to unwanted hop-ons, the stair car even made a cameo appearance in *Captain America: Civil War*, which was directed by former *Arrested Development* directors Joe and Anthony Russo.

Bluth's Original Frozen Banana Stand

In protest of his father George Sr.'s controlling involvement in the family business from jail, Michael burned down the banana stand only to find out his father's saying, "There's always money in the banana stand," was to be taken literally—$250,000 had lined the walls for safekeeping.

The Bluth Company Model Home

ADDRESS: 1 Lucille Lane, Newport Beach, California

The model home (a Seawind unit) that was barely functional and gradually deteriorating (poorly built by the floundering Bluth Company) served as the main setting of the show.

Never Nude

Tobias, along with *dozens* of other people in the world, suffered from a syndrome known as "never nude," a psychological affliction and fear of being naked treated by wearing cutoff jean shorts at all times, even while showering. Phillip Litt (guest star Zac Braff), producer of *Girls with Low Self-Esteem* (a parody of real-life producer Joe Francis's *Girls Gone Wild*), also suffered from the affliction.

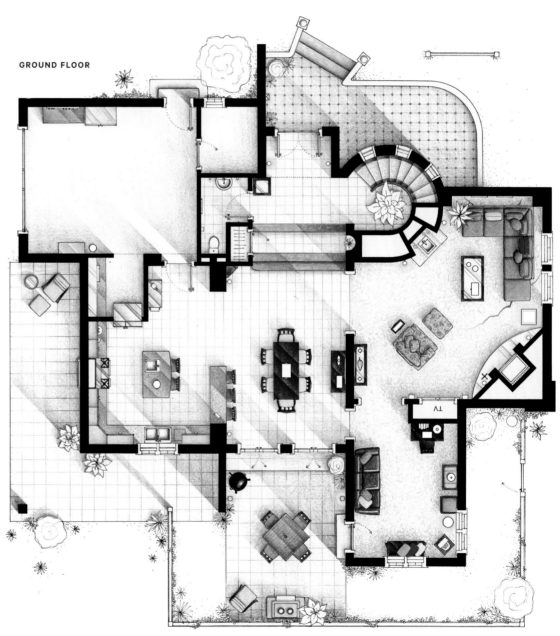

GROUND FLOOR

UPPER FLOOR

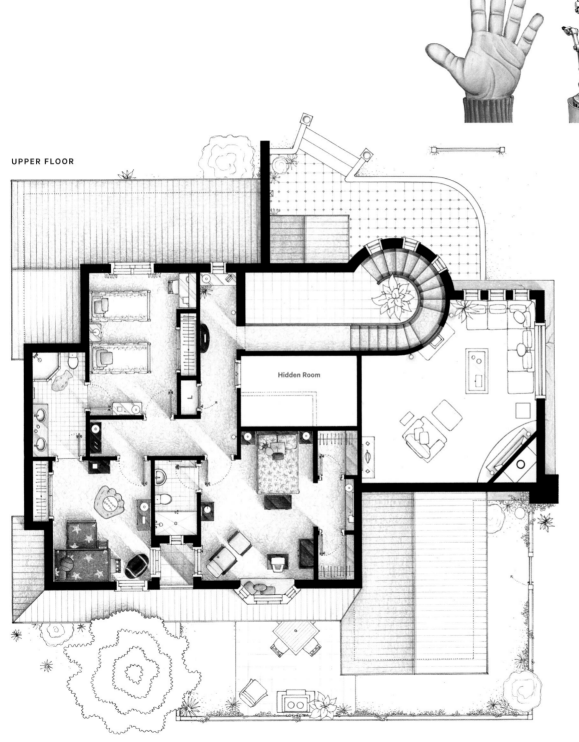

Hidden Room

Buster's Collection of Hands

Buster pursued a rite of passage by defiantly swimming in the ocean only to have his hand bit off by a "loose seal" wearing a yellow bow tie. The tragedy was comically set up several episodes before when the seal, formerly a part of GOB's illusion (*not* magic trick), was released into the wild. GOB bought the seal from his unnamed wife, a seal salesperson, who was played by the hilarious Amy Poehler, the former real-life wife of GOB actor Will Arnett.

SCHITT'S CREEK

CREATED BY: Eugene Levy and Daniel "Dan" Levy	**CHANNEL:** CBC Television
SERIES RUN: 6 seasons; 80 episodes; 2015–2020	
FILM LOCATION: Pinewood Toronto Studios, Dufferin Gate Studios, Revival Film Studios; on location in Goodwood, Brantford, and Mono, Ontario, Canada	

Created by and starring the father-son duo of Eugene Levy and Dan Levy, *Schitt's Creek* was a Canadian sitcom that premiered on CBC Television in 2015. The riches-to-rags story followed the wealthy and affluent Rose family, who suddenly lost all their money and their pampered way of life and were forced to move to their only remaining asset, the small rural town of Schitt's Creek, purchased as a joke decades ago. Upon arrival to Schitt's Creek, the desperate Rose family moved into adjoining rooms at a run-down roadside motel where they had to learn to live among the locals. The Rose family consisted of former video store magnate and mostly levelheaded patriarch, Johnny; his ambiguously accented and wig-collecting former soap star wife, Moira; their snarky, fluid, and pretentious son, David; and their spoiled socialite daughter, Alexis. Together, this constantly bickering fish-out-of-water family began their new life in a town full of colorful characters in one of the most beloved shows of the 2010s.

How did this little show that could, about a small town devoid of prejudice and full of love, go from a humble beginning with a loyal fan base to a cult following on the internet, and end up a record-breaking mainstream success? Before the season 4 premiere, the first three seasons were put on Netflix, opening up the show internationally and helping it become part of the cultural zeitgeist and daily water cooler conversations about what it means to "fold in the cheese," how to pronounce the name Herb Ertlinger, or having audiences humming "A Little Bit Alexis" on the way to work. *Schitt's Creek*, once it spread to a wider audience, ultimately captured the hearts of viewers who connected with the show's fundamental warmth and symbols of love, hope, and inclusivity that many were yearning for at the time. The show was lauded for its handling of sexuality and LGBTQ+ story lines, and after six seasons of award-wining performances, hilarious writing, one musical, a crowening, and a glorious wedding, *Schitt's Creek*, unlike many shows, got to end on its own terms.

The show made history by becoming the first TV show to win all seven Emmy Awards for comedy (Outstanding Comedy Series, Lead Actor, Lead Actress, Supporting Actor, Supporting Actress, Writing, Directing), and it set a record for most Emmy wins by a comedy series in a single season. It received three nominations and two GLAAD Media Awards, and cocreator/actor Dan Levy was given the GLAAD Davidson/Valentini Award in recognition of his contributions to promoting acceptance of the LGBTQ+ community. Instantly meme-able and expanding our lexicon in more ways than one, *Schitt's Creek* became a global phenomenon that taught us that being rich doesn't always have to be about money.

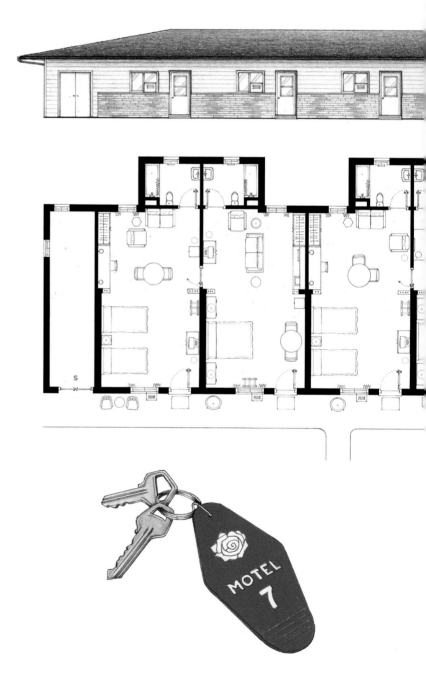

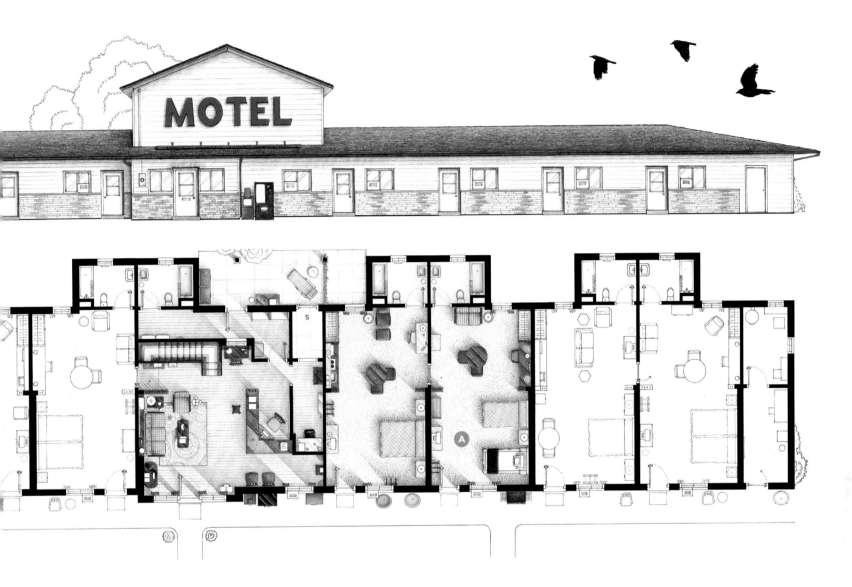

Rosebud Motel

LOCATION: Schitt's Creek, Canada

Adopted home of the Rose family, the motel was initially run by Stevie Budd—and later, by both Stevie and Johnny (after rebranding as the Rosebud Motel). The location used on the show was formerly known as the Hockley Motel, located at 308399 Hockley Road, Orangeville, Ontario, Canada. Fans of *The Umbrella Academy* may recognize it as The Rain Quail Bed & Breakfast.

 "Ew, David!"

There's a common misconception that Alexis repeatedly said this now-iconic line on the show, when in fact, she only said it in three episodes.

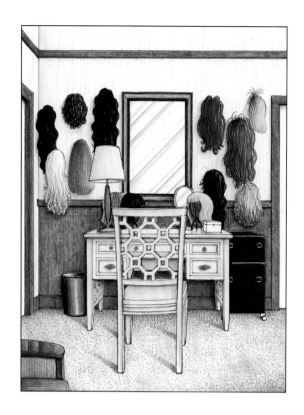

Moira's Wig Wall

Moira Rose and her affinity for wigs came from a suggestion by comedic genius and Moira actress Catherine O'Hara, who was inspired by two friends who changed wigs often. Any time Moira referenced a wig by a certain name, she was saying hello to her friends in real life, unscripted. O'Hara used English socialite and fashion designer Daphne Guinness as visual inspiration for Moira Rose.

THE MOIRA'S ROSE'S GARDEN 4856

"So, the garden is dedicated to a rose that Moira owns?" —David Rose

Small-Town Charm

Much of the sitcom's interiors were shot at various studios around Toronto, but for any superfans (or more appropriately, "Schittheads") looking to visit Rose Apothecary, Café Tropical, or Bob's Garage, you'll find them across the street from each other at the same intersection in the small town of Goodwood, Ontario, located thirty minutes outside Toronto.

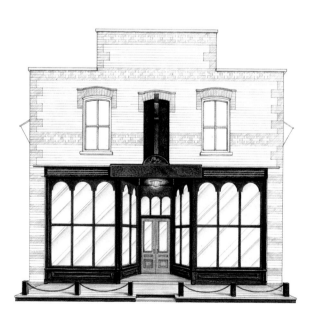

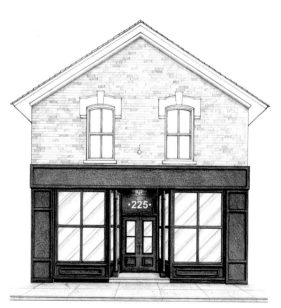

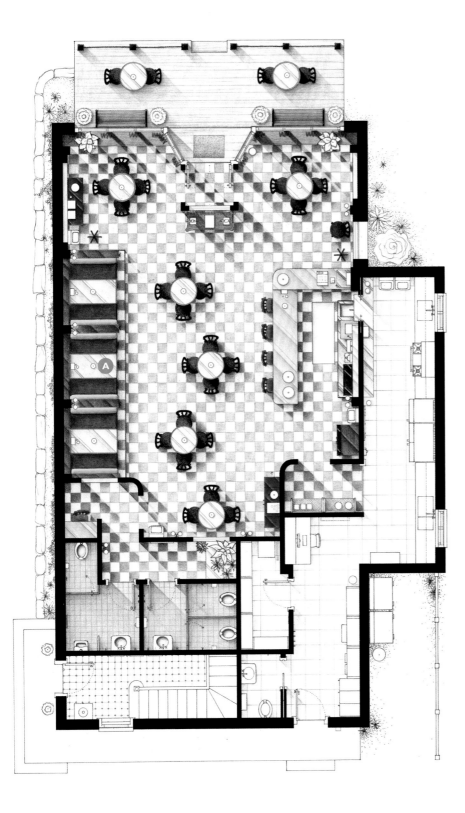

Café Tropical

LOCATION: 225 Main Street West, Schitt's Creek, Canada

Known for its gigantic multifold menu of moderately edible world-class cuisine from Mexico to the Mediterranean as well as its personable waitress (and future owner) Twyla, Café Tropical was seemingly the only restaurant in Schitt's Creek. The giant menus were Eugene Levy's idea, who thought it would be amusing to see everyone wrestle with menus that take up the full size of the table.

A "Pettifogging," "Mammae," "Bebe"

As for Moira's uniquely arcane vocabulary? During the first season, O'Hara received *Foyle's Philavery: A Treasury of Unusual Words* from makeup artist Lucky Bromhead and would replace words in the script with new favorites found in the book.

3RD ROCK FROM THE SUN

CREATED BY: Bonnie Turner and Terry Turner	**CHANNEL:** NBC
SERIES RUN: 6 seasons; 139 episodes; 1996–2001	
FILM LOCATION: Live studio audience at CBS Studio Center in Studio City, California	

"I guess not everyone likes Jell-O."
—Dr. Mary Albright

Undoubtedly a *universally* celebrated sitcom in the history of television (that specifically contains aliens hailing from the barred spiral galaxy on the Cepheus-Draco border), *3rd Rock from the Sun* first premiered in 1996 on NBC. Known for its unique blend of offbeat and eccentric humor, this celebrated sitcom was created by husband-and-wife screenwriters and producers Bonnie and Terry Turner, who worked on *Saturday Night Live*, cocreated *That '70s Show*, and wrote films such as *Wayne's World 1* and *2*, *Tommy Boy*, and *Coneheads*. The series followed the Solomons, a "family" of four extraterrestrials who beamed down (in the bodies of humans, fully formed with ten fingers and eleven toes) to the insignificant planet of Earth—more specifically, the city of Rutherford, Ohio—to study and observe

the behavior of human beings and report back their findings to their leader, the Big Giant Head. The mission was led by high commander Dick, security officer Sally, transmitter Harry, and information officer Tommy, who, despite being the oldest, was stuck in the body of a horny pubescent teen. Rounding out the cast was Dr. Mary Albright, a professor of anthropology, Dick's colleague at Pendelton State University (a third-rate university), and the high commander's immediate infatuation.

In the beginning of the show's run, critics couldn't wrap their feeble earth brains around the show's sharp writing, hilarious wordplay, physical comedy, and unique blend of lewd, and sometimes crass, innuendo-laden humor. To be fair, 108 of the show's

136 episodes had the word *dick* in them, though usually in reference to its lead character. But not long after its premiere, the show caught on with viewers, and critics and audiences agreed that *3rd Rock from the Sun* was the perfect blend of cleverly constructed jokes and memorable performances—the show was nominated for thirty-one Emmy Awards, winning eight total; somehow survived a whopping thirteen different time slots during its run (when most other shows would have crashed and burned); and still found time to penetrate the human fleshy slipcovers of millions of viewers by warming their hearts. Transmission ending in 3, 2, 1. *Achoo!*

The Gnome . . . as Himself

The gnome was one of many props scattered around the attic to reflect the alien family's eclectic taste. Often given close-ups in the show's scripts, it was listed on paper as "THE GNOME . . . as himself."

Rooftop Love

The porch roof was home to many memorable moments, but none more lustful than when Harry fell in love with a Venusian feminist named Mascha (portrayed by '90s icon Cindy Crawford).

The Solomon Family Attic Apartment

ADDRESS: 317 Pensdale Road, Rutherford, Ohio

This former rumpus room and current attic apartment was on the third floor of Mrs. Mamie Dubcek's home on Earth, a third-rate planet. Located approximately fifty-two miles (or one hour) away from Cleveland in the delightfully average city of Rutherford, Ohio, it served as home base for the Solomons.

Alien Landing

The series opened and closed with the Solomon family using this 1962 Rambler American 400 convertible to beam to and from their spaceship. The creators later donated it to the Kenosha History Museum's Rambler Legacy Gallery.

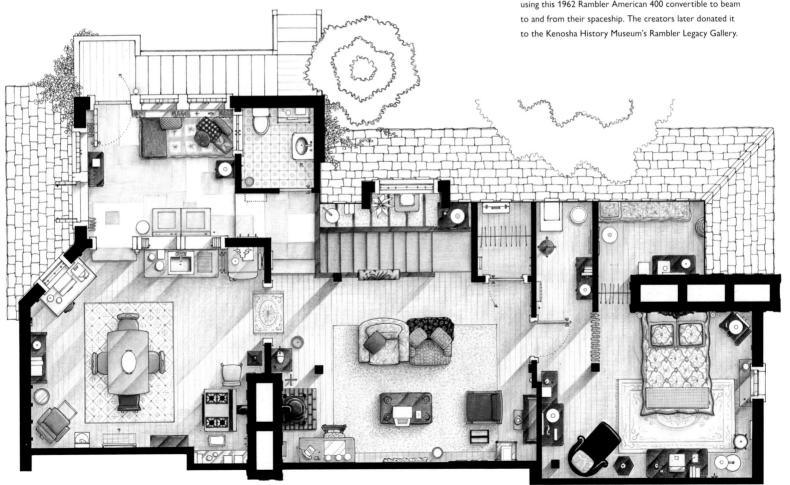

ADULT-*ISH*

I need a drink,
and I need it fast.
—ROZ

I'll get the sherry.
—FRASIER

Don't waste your time.
I've got grown-up problems.
—ROZ

Frasier

The responsibility of being a functioning adult in a sea of seemingly better-functioning adults is daunting. In the world of growing up, we often lean on family, friends, and significant others, but at the end of the day, it's up to us to learn, grow, and change. Who better to chronicle the highest of highs and lowest of lows of being an adult than incredibly witty and hilarious television screenwriters?

Enter "being an adult"—a subgenre all on its own and a framework with a bevy of storytelling possibilities that we know and love. In the reflection of our own lives, this genre is the visual equivalent of "they're just like us" tabloid articles, but with less shame on our end since we can wear pajamas and munch on food without fear of being photographed while we watch fictional versions of our lives unfold. These shows do what the best sitcoms can accomplish, which is let viewers see their own lives on-screen . . . albeit with better lighting, makeup, and apartments that seem like castles compared to normal ones. They capture the best elements from each sitcom genre, incorporating a little family, a little romance, a little humor, and a lot of adults only kind of acting like they should.

What shows about adulting do so well is take a universal kernel of truth and build around it with several more kernels of relatability (taxes, bills, first dates, simply getting out of bed in the morning), and sooner or later, it's an enticing bowl of popcorn TV where every bite is satisfying. We might not live the same bon vivant lifestyle as Frasier and Niles Crane from *Frasier*; know what it's like to empty our hearts out to a loft full of charismatic and eccentric roommates like Jess on *New Girl*; or be one of the smartest humans on the planet (except when it comes to asking someone out on a date) like Leonard from *The Big Bang Theory*, but all the same emotions are there regardless of the particulars.

Everyone wants a decent job, a good place to live, a supportive group of friends, and perhaps at some point, a fair shot at love, and what adult-*ish* shows do so well is allow us to feel comfortable laughing at situations we've painfully (and awkwardly) experienced. If sitcoms and aging remain a thing, which seems like a good bet, shows utilizing the "being an adult" format will continue to age like a fine wine, though most likely not one Frasier and Niles would ever come close to drinking.

FRASIER

CREATED BY: David Angell, Peter Casey, and David Lee	**CHANNEL:** NBC
SERIES RUN: 11 seasons; 264 episodes; 1993–2004	
FILM LOCATION: Live studio audience at Paramount Studios in Hollywood, California	

It's often said lightning doesn't strike the same place twice, but it did for the fictional character of Dr. Frasier Crane, a delightfully quirky and cultured radio psychiatrist from Seattle with an acerbic wit and a penchant for verbal wordplay. First introduced in the iconic sitcom *Cheers* as a foil to Sam and Diane's will-they-or-won't-they relationship, Dr. Crane's indelible impact and popularity awarded him his own spin-off in 1993 from creators David Angell, Peter Casey, and David Lee. In turn, *Frasier*, starring Kelsey Grammer, was born.

The continuation followed Frasier as he adjusted to life back home in Seattle, far removed from his barfly days in Boston. He provided equal parts Freudian analysis and sarcasm to wayward callers to his radio show, where he worked closely with Roz Doyle, his promiscuous and sardonically charming producer. Frasier's new personal life was quickly challenged when his younger brother, Niles, an equally pretentious and snobby psychiatrist, guilted Frasier into taking in their estranged blue-collar, former police officer father, Martin. Much to Frasier's dismay, joining Martin were his Jack Russell terrier, Eddie, and a live-in caregiver and physical therapist, Daphne Moon. Frasier's life became a series of culture clashes, whether at work, at his stunning high-rise apartment, or at his favorite coffee shop.

Frasier was one of the most critically acclaimed and decorated shows of all time, with 107 Emmy Award nominations and 37 wins (the most for a comedy series). It outperformed *The Mary Tyler Moore Show* to set the record for most wins for a scripted series until it was surpassed by *Game of Thrones*. It's also tied with *Modern Family* (which was cocreated by *Fraiser* writer Christopher Lloyd) for the most consecutive wins for Outstanding Comedy Series with five years running. Kelsey Grammer also became the first actor to be nominated for the same character on three different series (*Cheers*, *Frasier*, and *Wings*). It is ranked number 34 on *TV Guide*'s list of "50 Greatest TV Shows of All Time."

It doesn't take a rocket scientist, a psychiatrist, or even Daphne's visions to figure out why *Frasier* worked so well on so many levels. To many fans, and even Copernicus, the show became the center of the universe, a weekly refuge from daily life where audiences could watch Frasier's epic meltdowns, hear one of Niles's vicious burns, or learn about the most obscure operas, artwork, or bottles of wine. For eleven successful years, Dr. Frasier Crane said, "I'm listening," to his callers, when in fact, it was the world outside of the show that took comfort in listening and watching him.

"Dad! For God's sake, how many times do I have to tell you, my Chihuly is not a trash can!" —Frasier

Dr. Frasier Crane's Apartment

LOCATION: The Elliott Bay Towers, Apartment 1901, Seattle, Washington

Filmed on the same stage as *Cheers*, Frasier's luxury condo was the envy of any series on TV with its open floor plan featuring walls lined with artifacts and contemporary art and completely implausible (but stunning) views of Seattle. To achieve Frasier's expensive tastes, production designer Roy Christopher (*Wings*, *Just Shoot Me!*) and his team spent around five hundred thousand dollars to outfit the interiors.

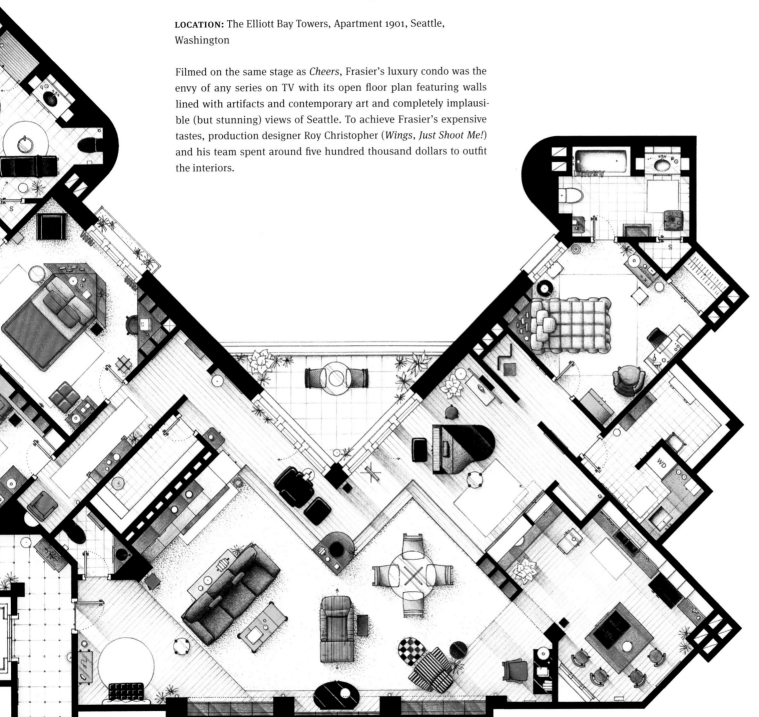

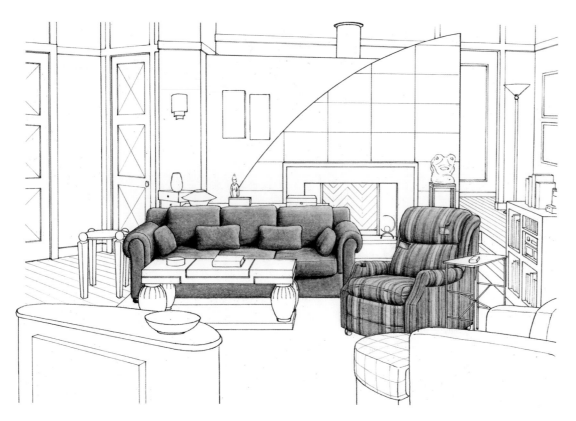

Couch Versus Recliner

No two pieces in the apartment better encapsulated the opposing relationship between Frasier and his father—for Frasier, it was an exact replica of Coco Chanel's atelier couch, and for Martin, it was a well-worn sentimental recliner that set designers created because they couldn't find anything old, used, and ugly enough.

Pewter Bear Clock

Frasier and Niles learn on *Antiques Roadshow* that this clock is a mid-nineteenth-century Andrei Kuragin made exclusively for the Romanov family. Excited by the possibility of their own Russian royal heritage, the Crane brothers investigate their family tree only to learn that their great-great-grandmother was, in fact, not royalty but a scullery maid and prostitute who smuggled this clock out of the palace.

Froggy

Displayed next to the fireplace from seasons 1–5, this sculpture was affectionately known to the cast and crew as "Froggy" and was replaced by the Chihuly vase in season 5's episode "Halloween." Froggy would later return in Frasier's office in season 11.

Café Nervosa

LOCATION: Third and Pike, Seattle, Washington

Located across the street from the KACL radio station, this regular haunt for the coffee snob Crane brothers served as a refuge for Frasier (who spent three thousand dollars a year here) and, for Niles, as a haven and cocoon. In season 10's episode "Farewell, Nervosa," Frasier and Niles rebelled against the hiring of a musician (award-winning artist Elvis Costello), whose music interrupted their conversation. The owner, Maureen Nervosa, whose character makes her first and only appearance, eventually tells them to leave.

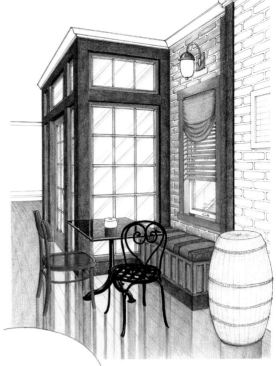

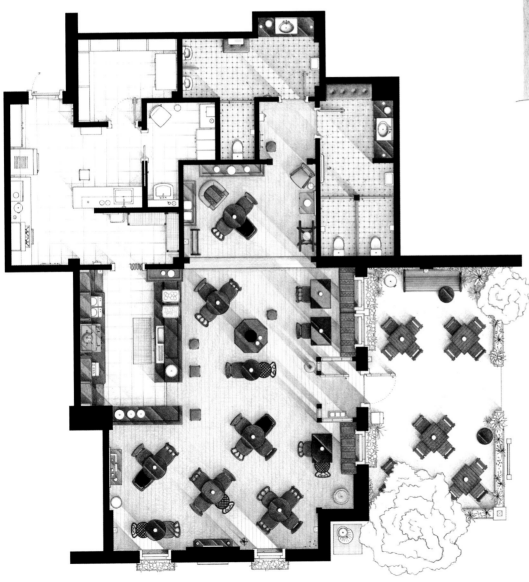

"My Coffee with Niles"

The season 1 finale took place entirely in Café Nervosa and starts with Frasier and Niles desperately trying to procure a table by the window. This highly rated episode was a play on the film *My Dinner with Andre* and the only one with Niles's name appearing in the title.

Order Coffee Like Niles

- Double decaf nonfat latte, medium foam, dusted with just the faintest whisper of cinnamon.
- Double cappuccino, half-caff, nonfat milk, with just enough foam to be aesthetically pleasing but not so much that it leaves a mustache.
- Double short, low-fat, no-foam latte. But never with nutmeg, as it inflames the stomach.

THE BIG BANG THEORY

CREATED BY: Chuck Lorre and Bill Prady	**CHANNEL:** CBS
SERIES RUN: 12 seasons; 279 episodes; 2007–2019	
FILM LOCATION: Live studio audience at Warner Bros. Studios in Burbank, California	

Who would have thought that a show about the lives of two brilliant, but socially maladjusted, Caltech scientists and their motley crew would not only run for twelve seasons on network TV but also break the record for longest-running multi-camera comedy series in TV history (previously held by *Cheers*)? *The Big Bang Theory*, created by Chuck Lorre and Bill Prady, premiered on CBS in 2007 at a time when single-camera sitcoms were making traditional multi-camera shows a thing of the past. TV was getting more cinematic and it seemed like the heyday of network sitcoms was over, but *The Big Bang Theory* saved the dying format.

The show followed the insecure but kindhearted experimental physicist Leonard Hofstadter; his roommate and stubborn, narcissistic theoretical physicist Sheldon Cooper; and their across-the-hall neighbor, the charming, outgoing Penny, who provided the nerdy friends with much needed real-world context. Rounding out the group were their friends and colleagues—mama's boy aerospace engineer Howard Wolowitz; the bashful astrophysicist Rajesh "Raj" Koothrappali; blunt but kind neuroscientist Amy Farrah Fowler; and feisty but loving microbiologist Bernadette Rostenkowski. When it's boiled down to its atomic center, *The Big Bang Theory* was about overcoming social anxiety to find happiness in life, love, and work.

The show wore its geek heart on its sleeve and became known for its cameos and guest stars, including countless figures from both the science world (Stephen Hawking, Bill Nye, Neil deGrasse Tyson, George Smoot) and popular geek culture (Mark Hamill, William Shatner, Carrie Fisher, Stan Lee). The producers even hired scientist David Saltzberg to ensure that its scripts, dialogue, and visuals accurately represented the scientific community. He would also receive support in later seasons from actress Mayim Bialik (Amy), who is a neuroscientist in real life.

The Big Bang Theory received mixed reviews, but as it progressed, the response greatly improved thanks to the inclusion of characters Amy and Bernadette, allowing more female points of view. *The Big Bang Theory* was nominated for fifty-five Emmy Awards and won four trophies. But more than awards, the show had a lasting impact on pop culture with things like Rock, Paper, Scissors, Lizard, Spock; Sheldon's catchphrase, "bazinga!"; "Soft Kitty"; board games; and even a successful spin-off prequel, *Young Sheldon*.

As the incomparable Canadian wordsmiths the Barenaked Ladies sang in their popular theme song for the show, "Math, science, history, unraveling the mysteries, that all started with the big bang," we might still be unraveling the mysteries of the universe, but when it comes to *The Big Bang Theory*, there's no secret as to why the show started, and ended, with a big bang.

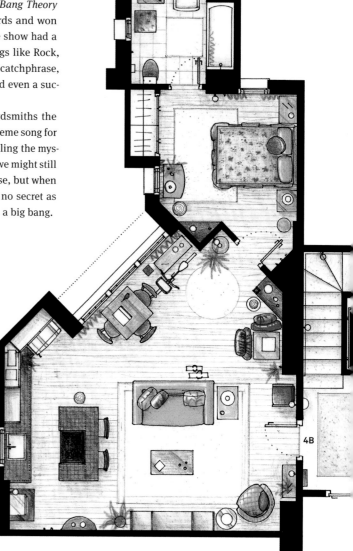

The Apartments of Penny, Sheldon & Leonard

ADDRESS: 2311 North Los Robles Avenue, #4A–4B, Pasadena, California

Equipped with an explosion of pop culture and scientific memorabilia, and even a nearly 6-foot-tall rendering of DNA, apartment 4A was the primary permanent set for *The Big Bang Theory*. Penny's apartment across the hall, 4B, was introduced in the pilot. Eventually, 4A becomes the home for Penny and Leonard, with 4B housing Sheldon and Amy after a five-week cohabitation experiment.

(A) Sheldon's Spot

Sheldon famously had "eternal dibs" on *his* spot on the couch due to its perfect temperature, air currents, and television visibility. He defined his spot as "the singular location in space around which revolves [his] entire universe."

The Official Flag of Apartment 4A

Sheldon and Leonard's official apartment flag was prominently featured in episodes of Sheldon's vexillology vodcast, *Sheldon Cooper Presents: Fun with Flags*. The show was later renamed *Dr. Sheldon Cooper & Dr. Amy Farrah Fowler Present: Dr. Sheldon Cooper's Fun with Flags*.

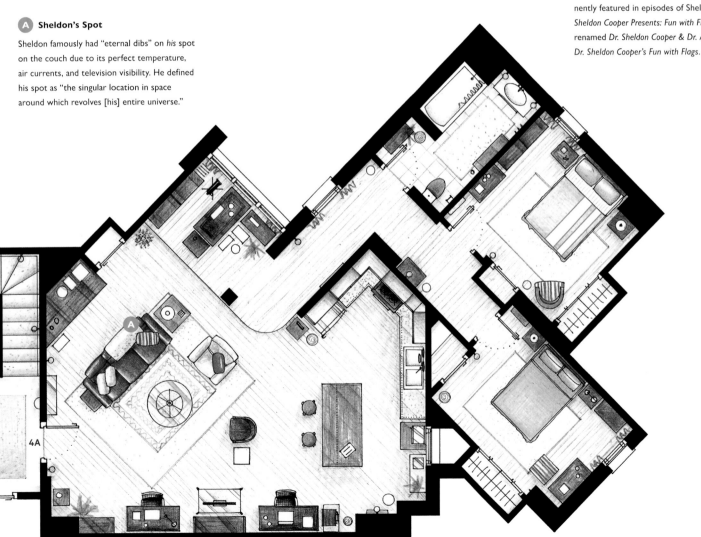

4A

Living Room

As the focal point of the apartment, it was fitting that the last shot of the series was where, like so many times before, the cast sat around the couch eating Chinese takeout and enjoying each other's company.

Klingon Bat'leth

Sheldon's *World of Warcraft* account is hacked, and he and the guys attempt to confront gamer Todd Zarnecki with his Klingon bat'leth. The plan fails, so the guys return with Penny, who solves the problem "Nebraska style" by kicking the hacker in the groin.

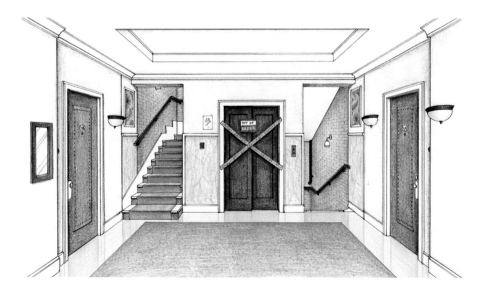

Hallway with Elevator

A running joke in the series was that the elevator was out of order, forcing the characters to walk up and down three flights of stairs. In the series finale, the elevator was finally fixed. The doors opened to uproarious applause and revealed Penny, who said, "Can you believe it? They finally fixed the elevator," sending Sheldon, who was dealing with too much change already, over the edge.

The Comic Center of Pasadena aka "The Comic Book Store"

LOCATION: East Green Street, Pasadena, California (near Caltech, according to the now-defunct store website)

Owned by Stuart Bloom, the comic book store was a frequent hangout for the guys, first appearing in season 2. It burned down at the end of season 7 when Stuart's hot plate caught on fire while he was taking a shower at the car wash. Store regulars included Lonely Larry, Captain Sweatpants, and Dale.

A Family Touch

In season 8, Stuart was finally able to reopen his store with financial help from Howard's mother, Mrs. Wolowitz, who also donated her den furniture, which angered Howard but made for a plush comics hang.

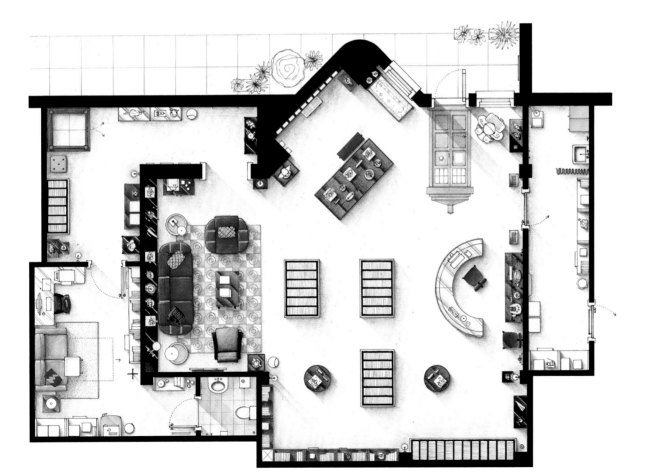

HAL 9000

Next to the entryway was a replica of HAL 9000, the artificial intelligence and main antagonist in Stanley Kubrick's *2001: A Space Odyssey*, a film adaptation of the book by Arthur C. Clarke.

THE GOOD PLACE

CREATED BY: Michael Schur | **CHANNEL:** NBC

SERIES RUN: 4 seasons; 53 episodes; 2016–2020

FILM LOCATION: Universal Studios Hollywood in Universal City, California

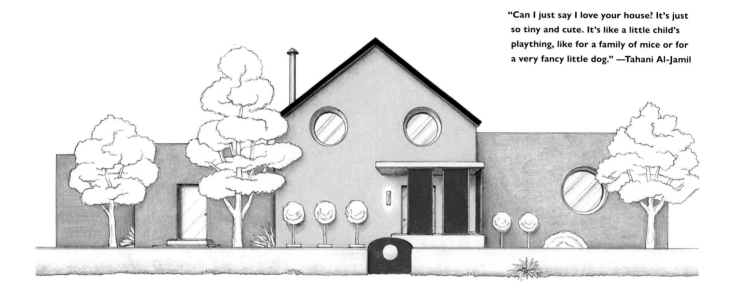

"Can I just say I love your house? It's just so tiny and cute. It's like a little child's plaything, like for a family of mice or for a very fancy little dog." —Tahani Al-Jamil

When successful writer/creator Michael Schur (*The Office*, *Parks and Recreation*, *Brooklyn Nine-Nine*) wanted to leave the world of fictional workplaces behind, he decided to take a big swing (or more aptly, a Blake Bortles–inspired Hail Mary) with *The Good Place*—a crash course in how to be adult-*ish* after life ends. Premiering in 2016, and running for four seasons, the premise of *The Good Place* was simple: A woman got put into heaven by mistake. Could she earn her place?

The story, loosely inspired by the existential play *No Exit* by Jean-Paul Sartre, followed Eleanor Shellstrop, a selfish, shrimp-loving woman with a broken moral compass who woke up in the heaven-like afterlife known as the Good Place due to an administrative error. She did her best to hide in plain sight from the town's architect, Michael, and his Siri/Alexa-inspired all-knowing assistant, Janet, before ultimately confiding in her assigned soulmate, Chidi Anagonye, an indecisive moral philosophy professor who Eleanor tasked with teaching her how to be a better person. Along the way, the duo became a quartet with Tibetan monk Jianyu, who was actually Jason Mendoza, a Jacksonville Jaguars–loving small-time crook and DJ, and Tahani Al-Jamil, a celebrity name–dropping high-society party planner. They were all tasked with learning how to become good people at the risk of being caught and sent to the Bad Place. Easy enough, no?

When the show was released, critics were quick to point out the undeniable chemistry of Kristen Bell (Eleanor) and Ted Danson (Michael), as well as the talented and diverse group of supporting performers handling the slapstick comedy, witty banter, and serious moral questions with ease. Winner of four Hugo Awards (the best in science fiction or fantasy), a Peabody Award, and three Critics Choice Television Awards, *The Good Place* received no shortage of acclaim. It even inspired several essays and books, including one from creator Michael Schur called *How to Be Perfect: The Correct Answer to Every Moral Question*.

The Good Place was a brilliant Trojan horse—comedy that pulled us in with its bright colors, vibrant world building, funny jokes, and amazing performances while subtly teaching us ethics and making philosophy cool again. At the end of the day, Eleanor, Chidi, Tahani, and Jason's story was about one thing: what it means to be a good person. And if fifty-three episodes of network TV that bravely subverted the sitcom genre can inch any of us closer to being a better person, then *The Good Place* is what Eleanor would call "forking" binge-worthy.

Eleanor Shellstrop's House

LOCATION: Neighborhood 12358W, The Good Place
(The Bad Place), The Afterlife

This quaint home, an open concept celebration of "Icelandic
primitive," was very clearly *not* the home that perfectly
matched the essence of margarita-gulping, Arizona-native
Eleanor. Meant for a different Eleanor Shellstrop who was
misplaced in the Bad Place, this house forced the real "bad"
Eleanor to live among primary colors and frightening clown
paintings in the shadow of Tahani's colossal mansion.

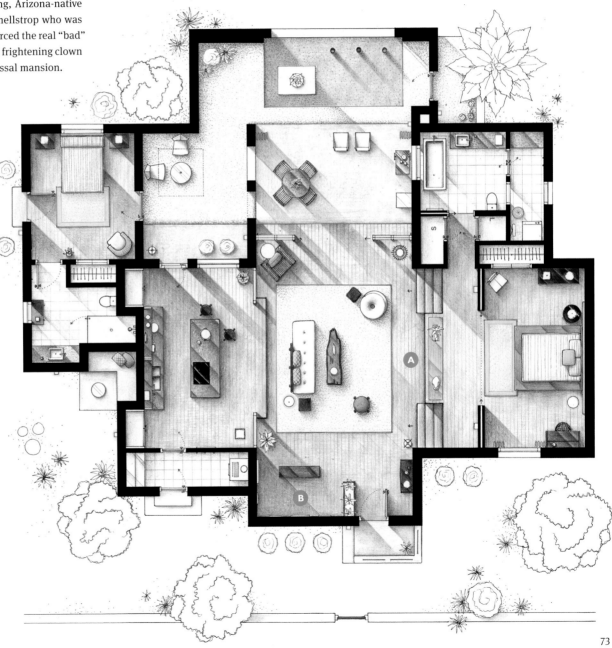

A Torturous Stairs

In Michael's continued attempts to make
Eleanor suffer in Neighborhood 12358W,
he designed hidden stairs leading to her
bedroom. Eleanor, until discovering them,
was forced to awkwardly climb up onto the
split-level platform to get from one room to
the other. Upon finding the stairs, her only
reaction was: "Son of a bench!"

B Clowning Around

Eleanor's affectionate names for the clown
paintings in her mini art gallery: Creepo,
Psycho, Crazy Head, Stupid Juggling Weirdo,
Freaky Feet, and Nightmare George
Washington.

Neighborhood 12358W

LOCATION: The Bad Place, The Afterlife

With its faux-utopian vibes, pastel hues, and seemingly end-less number of shops, this neighborhood was designed to psychologically torture Eleanor, Chidi, Tahani, and Jason. The exteriors of the town were filmed at the "Little Europe" backlot at Universal Studios Hollywood.

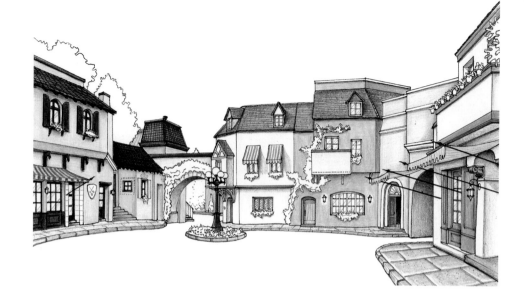

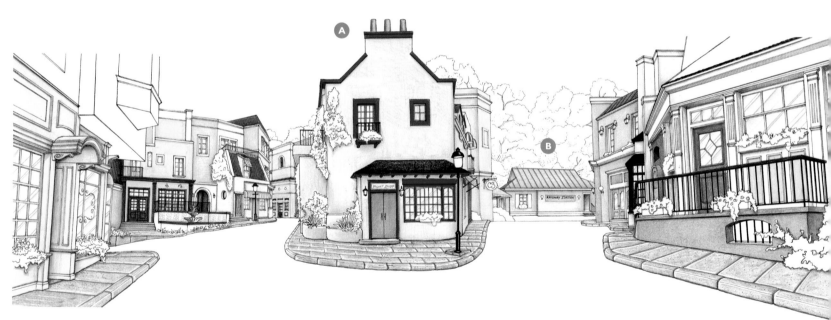

A "What's a food that people think they enjoy, but that's also kind of a bummer?" —Michael

"Frozen yogurt." —Janet

B **Railway Station**

Home to the Trans Eternal Railway that connects Michael's neighborhood to other locations in the afterlife, such as the Medium Place (created specifically for Mindy St. Claire) and the Bad Place. The train can only be summoned and operated by a Janet. Except for that one time Derek took it for a spin.

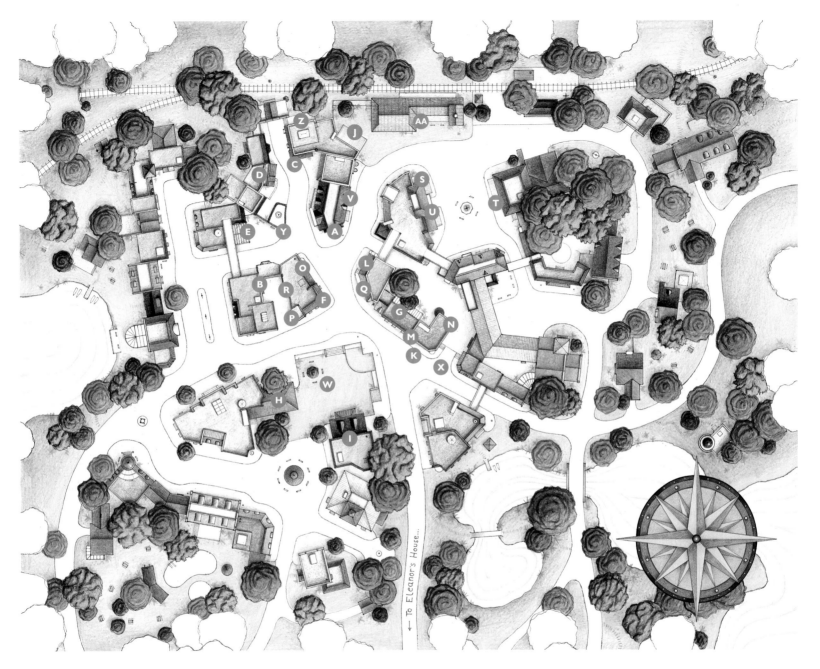

FINDING YOUR WAY AROUND NEIGHBORHOOD 12358W

(A) **Yogurt Yoghurt Yogurté**

(B) **My Big Nonfat Greek Yogurt**

(C) **Cruller Intentions**

(D) **Lasagne Come Out Tomorrow**

(E) **Foot Lager**

(F) **Infinite Light**

(G) **The Good Plates**

(H) **Tea for Two**

(I) **All Chocolate Everything**

(J) **Celestial Perk**

(K) **Joanie Loves Tchotchkes**

(L) **Knish from a Rose**

(M) **Everything Fits**

(N) **Childhood Mementos**

(O) **Warm Blankets**

(P) **All The Books**

(Q) **Your Anticipated Needs**

(R) **Oh, Gnomes!**

(S) **Jetpacks 'n' Such**

(T) **Luncheons & Dragons**

(U) **PB&J and That's It**

(V) **Scents Memories**

(W) **Presentation Lawn**

(X) **Boulevard of Resplendent Hope**

(Y) **Mmmm! Chowder Fountain**

(Z) **Michael's Office**

(AA) **Railway Station**

NEW GIRL

CREATED BY: Elizabeth Meriwether	CHANNEL: FOX
SERIES RUN: 7 seasons; 146 episodes; 2011–2018	
FILM LOCATION: 20th Century Studios in Century City, Los Angeles, California; on location in and around California	

New Girl, created by Elizabeth Meriwether, premiered on FOX in 2011 and became the network's highest-rated debut in a decade, introducing the world to the proper way to enunciate *chutney* and to True American, the greatest, most unexplainable drinking game in TV history. The series followed bubbly and adorably gullible Jessica "Jess" Day, who, after a bad breakup, searched for a new apartment and found a loft with three men: Nick Miller, an emotionally stunted and curmudgeonly law school dropout and bartender; his best friend from college, Schmidt, a fussy douchebag with a heart of gold and a touch of OCD; and Winston, a former basketball player, lover of bird shirts and cats, and purveyor of brilliantly awful pranks. The group's daily misadventures in the loft, and beyond, were joined by Cece, Jess's supportive best friend, model, and object of Schmidt's affection, and Coach, a personal trainer and the loft's former tenant.

New Girl initially revolved entirely around Jess, but quickly, Meriwether and company realized that the strength of the show was in the ensemble, so they created a space where each character was able to mature beyond their surface features. In doing so, *New Girl* portrayed young adults in a postgraduation/pre-marriage-and-children adulthood limbo figuring out who they were with the support of their "found family."

While *New Girl* wasn't exactly an award show darling, the show was embraced by audiences, and even more so a decade later when it premiered on Netflix, becoming one of the most-watched streaming titles of 2020. It had a classic will-they-or-won't-they relationship, a celebrated depiction of male friendship, and several running gags, like Nick sweating when he was lying, Outside Dave, and classic Winston and Cece mess arounds. The show had a great collection of guest stars such as Carl Reiner, Jamie Lee Curtis, Megan Fox, and of course, the High Priest of Pop, Prince.

There's no one word or phrase to describe *New Girl*'s secret sauce, but if you had to try, it would be the way Nick felt when being cradled like a baby by his elderly, oracle-like silent best friend, Tran, in a pool—awkwardly intimate at first, but then surprisingly comforting in a way that made you wonder why you hadn't experienced it before.

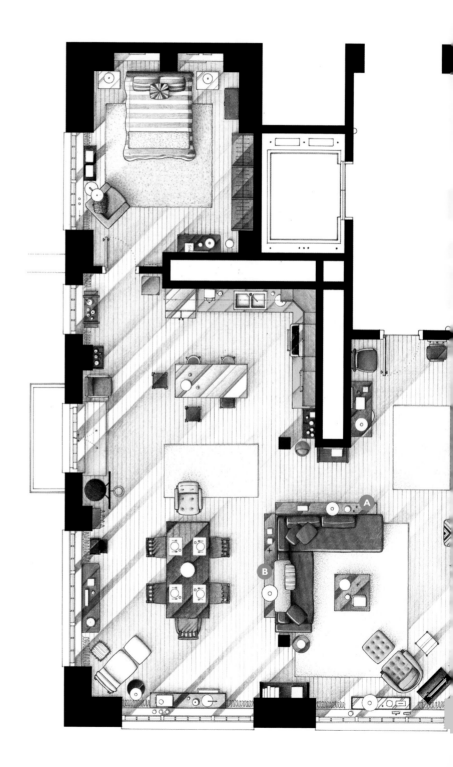

The Loft

LOCATION: Apartment 4D, Downtown Los Angeles, California

The loft was the primary location on *New Girl* and featured design elements reflecting the unique personalities of its tenants. The exterior was filmed at a commercial loft building located at 836 Traction Avenue in the Arts District neighborhood of Los Angeles. After the pilot, Winston replaced Coach after Coach actor Damon Wayans Jr.'s show *Happy Endings* was unexpectedly renewed for a second season. He would return to *New Girl* in season 3, leave at the end of season 4, and guest star for the remainder of the series.

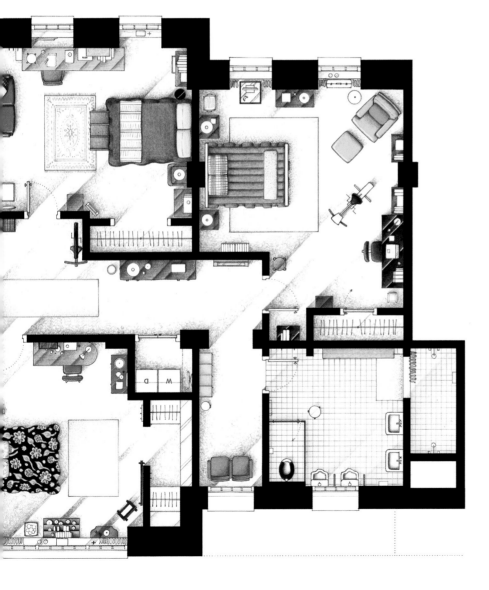

A **The Douchebag Jar**

A running gag on the show—every time Schmidt said or did something douchey, he had to put money in the jar. During Schmidt and Cece's wedding, the rabbi requested a piece of glass to be stepped on in keeping with Jewish tradition. In a tender moment, Nick revealed the jar signaling the end of Schmidt's douchebaggery.

B **The Blue Glass Grapes**

A mainstay of the loft's eclectic decor (described as Coachellaean by Schmidt), the glass grapes brought the whole loft together. When Coach moved out, he emotionally took the grapes, and other random items, to remember his friends. When the show ended, Lamorne Morris hoped to take them, but they eventually went to series creator Elizabeth Meriwether.

"I don't even like ducks that much, man."

When Schmidt catches Winston editing his own Wikipedia page to add a false fact about loving ducks, Schmidt vows to help the recently retired basketball player re-enter society. Winston may not like ducks, but he sure loves his bird shirts.

"Gave me cookie, got you cookie!"

Schmidt gave Nick a cookie (because he was thinking about him). Nick said the only time men could think about other men was when they were thinking about Jay Cutler. Schmidt's feelings were then hurt, and Nick made amends by buying him a round cookie that Nick took bites of to shape it like the star of David in honor of Schmidt's heritage.

MIRANDA

CREATED BY: Miranda Hart	CHANNEL: BBC Two (2009–2010), BBC One (2012–2015)
SERIES RUN: 3 series and 2 specials; 20 episodes; 2009–2015	
FILM LOCATION: Live studio audience at the BBC's Television Centre (2009–2013), the London Studios (2014–2015 specials)	

Comedian Miranda Hart's award-winning eponymous sitcom was developed from her semi-autobiographical BBC Radio 2 comedy *Miranda Hart's Joke Shop*. The sitcom followed Miranda, a socially awkward 6-foot-1-inch joke shop owner (who is often referred to as "Sir") desperately trying to navigate adulthood despite finding herself in embarrassing situations that comedically highlight her ineptitude for normal social interaction.

Miranda was often found cracking jokes or playing games in her shop, which was managed by her childhood friend, Stevie, whose business acumen helped the shop stay afloat. Couple all this with Miranda dealing with former boarding school friends (whom she hated but is now bonded with for life) and her futile attempts at dating (including lusting after her secret crush, Gary, a deliciously handsome chef played by Tom Ellis, the future Prince of Darkness on *Lucifer*), and you get a show anchored by a star-making and self-deprecatingly hilarious performance.

In the modern era of television where stories are being told in a more cinematic style, shying away from the manufactured joke-factory formula of the traditional multi-camera sitcom of old, *Miranda* embraced the classic style and updated it with its lead character breaking the fourth wall (predating shows like Phoebe Waller-Bridge's *Fleabag*)—which helped us connect to the character even more. For all the playful physical comedy of *Miranda* and a character that literally owned a joke shop, it was really about something we've all experienced—unrequited love. Running for three series and a two-part finale, the show reminded us that no matter how awkward or difficult life can be, we can always turn on the TV to watch a relatable character like Miranda and know we aren't alone.

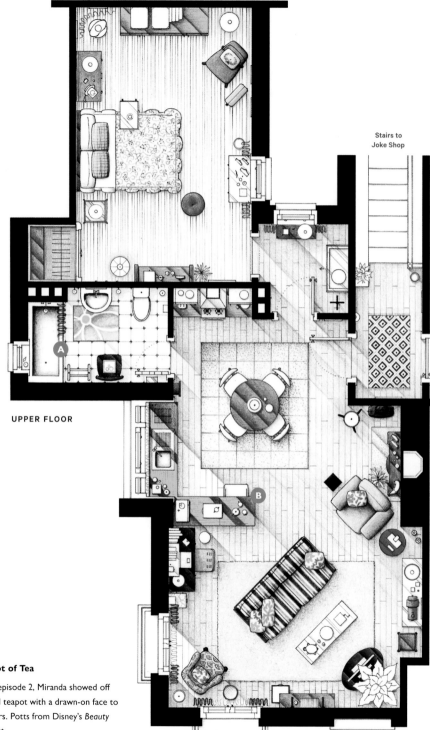

Stairs to Joke Shop

UPPER FLOOR

A "Let's Do It"

In series 2, episode 3, Miranda, while waxing, accidentally got her leg stuck to the bathtub as the comedically timed "I Want to Break Free" by Queen played in the background.

B A Spot of Tea

In series 1, episode 2, Miranda showed off her adorned teapot with a drawn-on face to resemble Mrs. Potts from Disney's *Beauty and the Beast*.

Miranda's Joke Shop and Upstairs Flat

LOCATION: Surrey, United Kingdom

Miranda's upstairs flat and joke/gift shop and boutique (that she bought with her inheritance) were the perfect backdrop for neurotic monologues, disastrous dinner parties (with foam fights), and the culmination of a will-they-or-won't-they kiss with Gary. *Miranda* was filmed in studio 8 at Television Centre, the same space used for British comedy legends *Fawlty Towers*, *Monty Python's Flying Circus*, and *Absolutely Fabulous*.

Henry Hoover

"This is not a Hoover being a man!" Miranda dressed up her Henry Hoover as "Gary," with cartoonish eyes, a mouth, and the hose connector as a nose, so she had a partner with whom to karaoke *Grease*'s "Summer Nights."

Fruit Friends

Miranda proved that living alone could be genuine fun by using googly eyes to create her own friends made of fruit. Her closest fruit friend was none other than Gordon, a bow-tie wearing grapefruit who joined her in singing "Shame" by Robbie Williams and Gary Barlow.

GROUND FLOOR

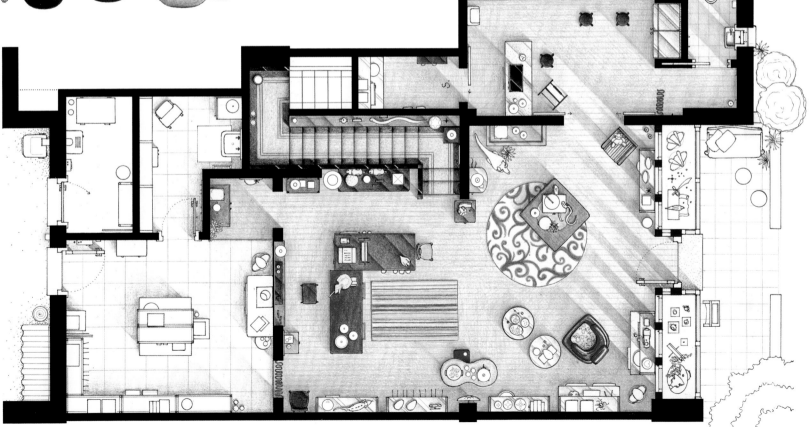

BRIGHT LIGHTS, BIG APPLE

So maybe it won't look the
way you thought it would look
in high school. But it's good
to remember love is possible.
Anything is possible.
This is New York.
—CARRIE BRADSHAW

Sex and the City

Besides the cool nicknames, jaw-dropping skyscrapers, and infectious energy, New York City has proven to be one of the best settings for a television show for one reason: proximity. Sitcoms are all about situations, hence the name "situational comedy," and in a city of over eight million people, characters are bound to bump into their friends, coworkers, and former lovers at any given moment. Unlike other cities or towns where characters could realistically leave their house, jump in the car, and get to work without interacting with anyone, it's unavoidable in the Big Apple, making it ripe for storytelling. With a vast array of confined spaces for characters to find themselves in (elevators, bars, the subway), no meet-cute or comedic debate ever feels stale. Plus, it wouldn't be a New York City–based show without characters spending time in unrealistically large, centrally located apartments that viewers agonizingly salivate over.

New York City has been used as a setting since the days of *I Love Lucy*, but no two shows have done more to highlight the allure of living in the big city than *Seinfeld* and *Friends*. One gave us a look at the hilarity of day-to-day mundane annoyances, while the other let us look at beautiful people, who were also funny, as they drank coffee in what seemed to be the coziest café in the world. Like those characters, thousands of TV fans make the pilgrimage to New York each day so they can walk the same streets as Carrie, Samantha, Charlotte, and Miranda; look for doppelgangers like Ted, Marshall, Lily, Robin, and Barney; or spend all day searching for the exterior of Will and Grace's gorgeous apartment.

On the best of shows, New York City isn't just a setting, but another character. A thriving and constantly evolving metropolis, densely packed with different cultures, races, and ideologies that consistently pushes the protagonists to grow as they navigate the charming hustle and bustle of a city that never . . . well, you get the idea.

SEINFELD

CREATED BY: Larry David and Jerry Seinfeld	CHANNEL: NBC
SERIES RUN: 9 seasons; 180 episodes; 1989–1998	
FILM LOCATION: Live studio audience at CBS Studio Center in Studio City, California	

Jerry's Stand-Up

Many episodes featured a framing device of Jerry doing his stand-up routine, telling jokes that reflected the overall themes or topics in that week's story. Following Larry David's exit after season 7 (he would return for "The Finale"), the show transitioned away from stand-up openings in favor of more traditional comedic cold opens.

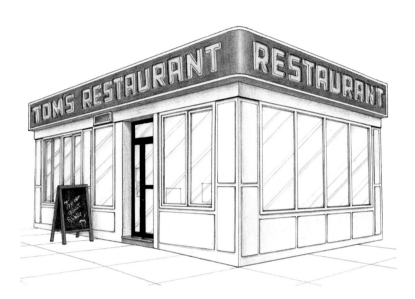

Tom's Restaurant

Tom's Restaurant (a real diner on Broadway and West 112th Street in NYC) served as the exterior for Monk's Café, the gang's favorite coffee shop. Ruth Cohen (Monk's cashier and foil to George in "The Gum") appeared on the most *Seinfeld* episodes besides the four regulars.

Seinfeld will go down as one of the most influential sitcoms to grace the small screen. Often described as a show about nothing, it was conceived by Larry David and Jerry Seinfeld as a show about how a comedian got his material. Informed by the observational humor of Jerry Seinfeld coupled with the brilliantly designed converging plots of Larry David, *Seinfeld* was a masterful exploration of the excruciating minutiae of everyday life in a postmodern world. Unlike the characters in the family and workplace sitcoms of the 1970s, enter Jerry, George, Elaine, and Kramer—four single and unapologetically cynical and self-absorbed thirtysomethings trying to navigate life in New York City while constantly battling their urban neuroses and spending far too much time in apartment 5A. Despite being filmed in Los Angeles, *Seinfeld* remains the quintessential show about New York City.

Seinfeld was designed for a contemporary audience, never dumbing down its jokes and respecting the viewers' intelligence to follow the intricate plots and punch lines. This mandate allowed the show to embrace a level of dark humor and absurdity, placing the characters in positions where they might do terrible things to each other but would return the following week as if nothing had happened.

On top of the writing, *Seinfeld* often experimented with its filmmaking techniques, pushing the boundaries of what a sitcom could be. Famously, it produced some of the most memorable "bottle episodes" (taking place in one location the entire time) with "The Chinese Restaurant" and "The Parking Space." These creative decisions led to a rocky start at first as the original pilot, "The Seinfeld Chronicles," tested poorly—though audiences ultimately responded positively by making *Seinfeld* a critical and commercial hit.

When an episode was over, George's elaborate plots to avoid responsibility, Jerry's superficial dating habits, Elaine's work conundrums, or Kramer's harebrained schemes would be discussed at length with friends, family, or coworkers at the watercooler. Soon, *Seinfeld*'s signature dialogue and catchphrases transcended the page by entering the American lexicon. Real-life conversations began featuring "yada yada," people encountered a low/high/close talker in their daily routines, and some were on the unfortunate end of a "regift." The show even created a holiday called Festivus that some people celebrate in real life with varying degrees of seriousness.

Thanks to syndication and streaming, *Seinfeld*'s devoted legion of fans continues to grow. Its influence on TV is still apparent in modern classics such as *Arrested Development*, *30 Rock*, and *It's Always Sunny in Philadelphia*, to name a few. One thing is clear: *Seinfeld* was far from a show about nothing. It has become a cultural phenomenon and taken its rightful place as the undisputed king of network television even after all these years.

Jerry Seinfeld's Apartment

ADDRESS: 129 West Eighty-First Street, Apartment 5A, New York, New York

Jerry's fictional apartment was at an actual NYC address where Seinfeld himself once lived early on in his career. To find the exterior of the apartment used on the show, you'll have to hop into a black Saab 900 and travel 2,800 miles west to 757 South New Hampshire Avenue, Los Angeles, California. Jerry's apartment number was initially 411, then 3A, and for the rest of the series, it remained 5A.

"The Puffy Shirt"

In season 5, episode 2, Jerry misunderstood Kramer's date, a "low talker," and unwittingly agreed to wear this pirate-inspired puffy shirt on *The Today Show* while promoting a Goodwill benefit for Elaine. Mocked by guest star host Bryant Gumbel, Jerry lost his cool, Elaine got fired, and in a subplot, George experienced the quick rise and fall of a career in hand modeling. The shirt and a copy of the script, written by Larry David, were donated to the Smithsonian National Museum of American History.

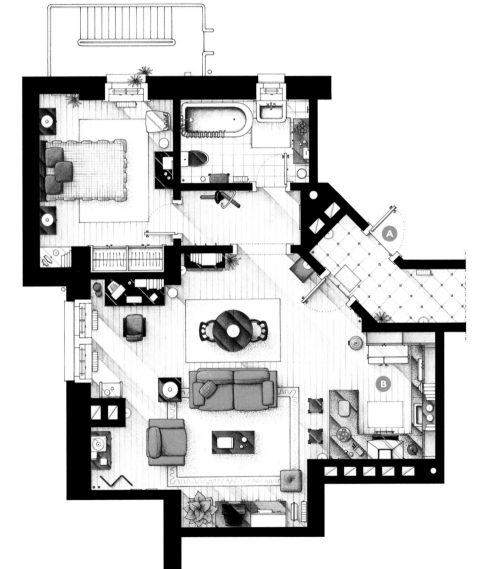

"The Fusilli Jerry"

In season 6, episode 21, when asked why Kramer chose fusilli pasta for this sculpture gifted to Jerry, Kramer replied, "Because you're silly." Three episodes later in "The Understudy," Kramer gifted Bette Midler a "Macaroni Midler" as he nursed her back to health after George ran her over in a softball game.

Ⓐ The Real Kramer

Kramer was initially named "Kessler" in the pilot episode until Larry David's friend and eccentric neighbor, Kenny Kramer, who the character was based on, gave permission to use his name. As neighbors, David and the real Kramer employed an open-door policy, often sharing food, clothes, a TV, and daily conversations on new inventions and get-rich schemes. Sound familiar?

Ⓑ One Magic Loogie Hallway

In 2021 a Reddit user posted a 3D model of the iconic set titled "Jerry's Apartment Can't Exist," showing that if 5A was a real New York City apartment, then the kitchen would have intersected with the hallway. Sure, it may have defied the laws of architecture, but as with all suspensions of disbelief, we must turn to George's advice to Jerry in "The Beard," when he said, "Jerry, just remember, it's not a lie if you believe it."

FRIENDS

CREATED BY: David Crane and Marta Kauffman	CHANNEL: NBC
SERIES RUN: 10 seasons; 236 episodes; 1994–2004	
FILM LOCATION: Live studio audience at Warner Bros. Studios in Burbank, California	

Happy Accident

The now-iconic gold picture frame was a happy accident. Before production began it was simply a mirror purchased to decorate the set, but after the glass broke, the frame was temporarily hung on the door. Set designer Greg Grande liked it so much that it stayed and eventually became a part of TV decor history.

In 1994 David Crane and Marta Kauffman introduced the world to *Friends*, a show about a tight-knit group of twentysomethings who lived in New York City and struggled to balance life, work, romance, and what it means to be an adult. For ten seasons, audiences followed these characters as they got together, broke up, had fights, made up, had babies, and above all else, supported each other.

But what set *Friends* apart from similar shows of the era? Some would argue above all else: heart. While it certainly possessed the comedic prowess of its predecessors of the '80s and early '90s, *Friends* evolved the "living in the city" genre by injecting multi-episode emotional arcs. Unlike *Seinfeld*, which famously refrained from emotion, *Friends* embraced it. For every "Smelly Cat," "Pivot!" or "How you doin'?" there was a "She's your lobster" or a "You're so wonderfully weird." *Friends* also had fun with its clever title structure of "The One . . ." that clued viewers in to the antics of that week's episode and provided a sentence structure that is now part of the cultural canon.

Throughout its run, *Friends* refused to be complacent in its tone and aesthetic choices despite sticking to the traditional sitcom formula that puts comedy above all else. What helped set *Friends* apart were the dramatic moments and season-ending cliff-hangers or twists like Ross and Rachel's will-they-or-won't-they tension (until they finally kissed at Central Perk). The cliff-hangers became a staple of *Friends* and were cultural events akin to modern audiences obsessing over *Game of Thrones* or debating the finale of *The Sopranos*. Each week fans would eagerly await the show's trademark episode titles hoping to decipher any clues to what might unfold. In an age before social media, *Friends* was genuinely masterful at keeping its finger on the pulse.

It also became known for its clever use of celebrity guest stars like Julia Roberts, Bruce Willis, or Mr. Rachel Green himself, Brad Pitt, but it was the impeccable casting of its lead characters that allowed *Friends* to unlock its own greatness. Jennifer Aniston, Courteney Cox, Lisa Kudrow, Matt LeBlanc, Matthew Perry, and David Schwimmer all brought something different to the show and gave their characters a relatability and authenticity not often found on network TV. Couple that with not just comedic but, more importantly, heartfelt writing, and there was something for everyone. Whether it was Chandler's sarcasm, Joey's childlike wonder, Phoebe's quirkiness, Monica's competitiveness, Ross's awkwardness, or Rachel's wittiness, these pitch-perfect performances and the show's intelligent writing helped catapult *Friends* to the number one show on TV, with its ratings consistently placing in the top ten. Readers of *TV Guide* voted them the best comedy cast of all time. Lisa Kudrow, Jennifer Aniston, and Matt LeBlanc would take home Emmys for playing their roles,

with David Schwimmer and Matthew Perry receiving nominations. And to everyone's surprise, the group most financially invested in the show's cultural impact was not the actors or studio, but the hairdressers of the mid to late '90s, who had customers lining up to request the latest iteration of "The Rachel."

When asked why *Friends* is still beloved by fans around the world some twenty years after going off the air, cocreator Marta Kauffman described it as the ultimate comfort food. Even in our current era of endless content, *Friends* remains the gold standard for a go-to binge (as proved by its staying power on streaming services), thanks to characters who help us celebrate the good times and support us through the bad times. As arguably the most successful Warner Bros. property ever, *Friends* still generates around one billion dollars a year in syndication alone, and thousands of people flock daily to the Warner Bros. studio tour to sit inside the beloved set from Central Perk. As Hollywood continues to try to replicate its lightning-in-a-bottle success, it's clear that *Friends* will never be replicated. Nor should it be.

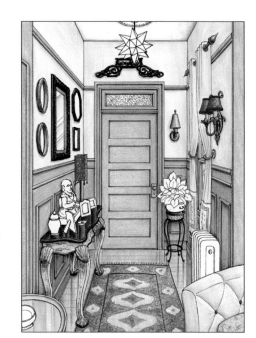

Monica's Secret Closet

The neatest of the friends, Monica's dirty little secret was this closet jam-packed with junk that Chandler discovers after using her tools to open it.

The Apartments of Monica, Rachel, Chandler & Joey

ADDRESS: 545 Grove Street, #19–20, New York, New York

The exterior shown every episode that die-hard fans flock to for pictures is in Greenwich Village at 90 Bedford Street, New York, New York. While never mentioned on the show, the fictional address was written on an envelope in "The One with the Invitation" when Ross reluctantly put Rachel's wedding invitation in the mail. At the start of the series, Monica and Rachel shared the show's central apartment, and Joey and Chandler shared the apartment across the hall. Throughout the seasons several roommate swaps occurred, though Monica and Rachel's apartment was unique in that every character except Ross at some point during the show lived at that address.

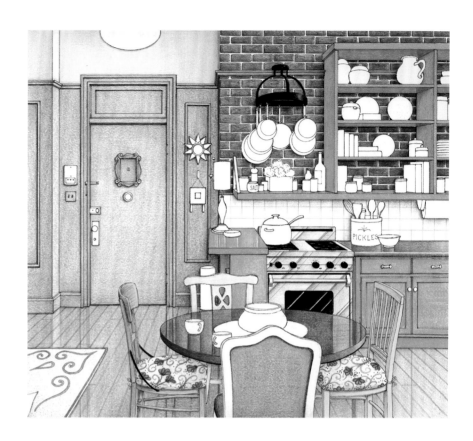

The Color Purple

Arguably the most iconic part of Monica and Rachel's apartment, the purple hue required the efforts of the show's production designer John Shaffner to convince producers it was the right choice for these twentysomethings' apartment.

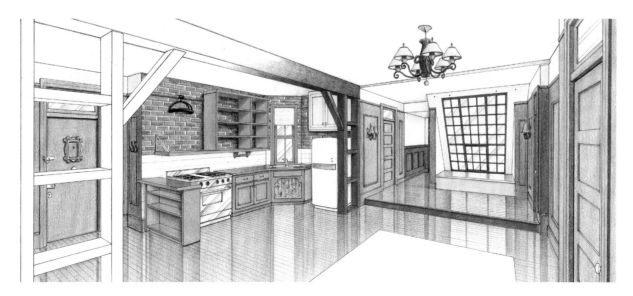

"The Last One"

Monica and Chandler's empty apartment served as the setting for the final scene of *Friends*. The group reminisced, left their keys on the table, and agreed to one more cup of coffee together. It was the fifth most-watched American series finale behind *Seinfeld*, *The Fugitive*, *Cheers*, and *M*A*S*H*.

Doodle Board

First appearing in season 3, the doodling toy was a mainstay of Chandler and Joey's apartment, often containing messages, drawings, or Easter eggs for particular episodes. Joey took the toy with him to Hollywood on his *Friends* spin-off, *Joey*.

Huggsy Penguin

Huggsy is Joey's "bedtime penguin pal." Rachel's child, Emma, becomes attached to Huggsy as he soothes her to sleep. Joey attempts to swap his Huggsy (Original) with a new one (Crappy) but fails. He also admits he got his pal by taking it from a child.

(A) Thanks for All Your Stuff!

Joey and Chandler try to sell this entertainment center built by Joey with "Italian craftsmanship." During a potential sale, Joey is locked inside while trying to prove to a buyer that a grown man can fit within. When Chandler arrives later, he walks in to find that their entire apartment has been robbed.

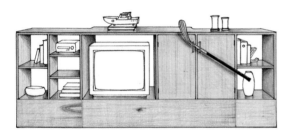

(B) Rosita

Joey revealed the name of his beloved lounge chair, "Rosita," which sat equal distance from the bathroom to the kitchen and allowed for no glare on the TV. After Rachel accidentally broke Rosita in half, she replaced it with a La-Z-Boy E-cliner 3000, which Chandler excitedly recognized as *Sit* magazine's "Chair of the Year."

The Canoe

After being robbed, and desperately wanting somewhere to sit, Joey and Chandler agree to trade all they have left (the entertainment center) for this canoe. In honor of the show's 25th anniversary, the prop was auctioned off, with proceeds going to The Trevor Project.

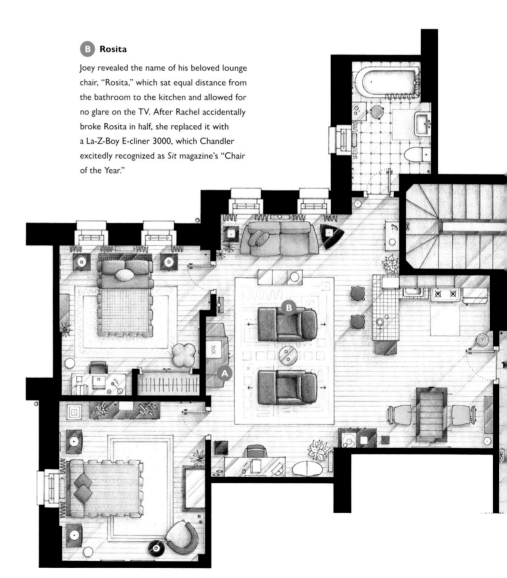

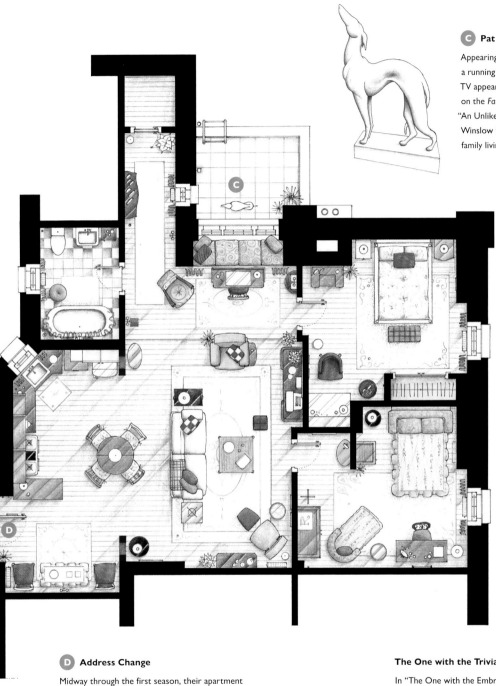

C Pat the Dog

Appearing in numerous episodes as a running joke, Pat the Dog's first TV appearance actually occurred on the *Family Matters* episode "An Unlikely Match," where Carl Winslow failed at redecorating the family living room.

"The One with All the Thanksgivings"

Chandler learns that when Monica "accidentally" severed his toe several years prior, it was because he called her fat. Seeking forgiveness, she wears a turkey on her head and does a funny dance that results in Chandler laughing and inadvertently telling her "I love you" for the first time.

"What's not to like? Custard, good. Jam, good. Beef, GOOD!" —Joey

D Address Change

Midway through the first season, their apartment numbers changed from 4 and 5 to 19 and 20.

The One with the Trivia Game

In "The One with the Embryos," the gang (sans Phoebe, who was being artificially inseminated) plays a special trivia game—the stakes: switching apartments. Questions include: "What is Monica's biggest pet peeve?" (animals dressed as humans) and "What name appears on Chandler and Joey's *TV Guide*? (Miss Chanandler Bong).

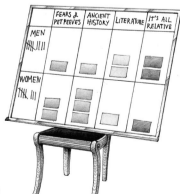

Central Perk

LOCATION: Greenwich Village, New York City, New York

Central Perk was the hip coffeehouse where the titular friends spent their free time. They were served by love-struck barista Gunther, who delivered just as much sarcasm as cappuccino while pining after Rachel. Many of the show's most memorable moments happened here, making Central Perk beloved worldwide and helping usher in modern coffeehouse culture to the '90s and beyond. The LEGO Group even made a replica of Central Perk, which is how you know you've made it.

A **"Smelly Cat"**

This area of Central Perk was where Phoebe often performed acoustic sets, including her famous renditions of "Smelly Cat" and "Two of Them Kissed Last Night." When not in use as a tiny stage, it was a seating area where Phoebe's future husband, Mike (Paul Rudd), was found by Joey in "The One with the Pediatrician."

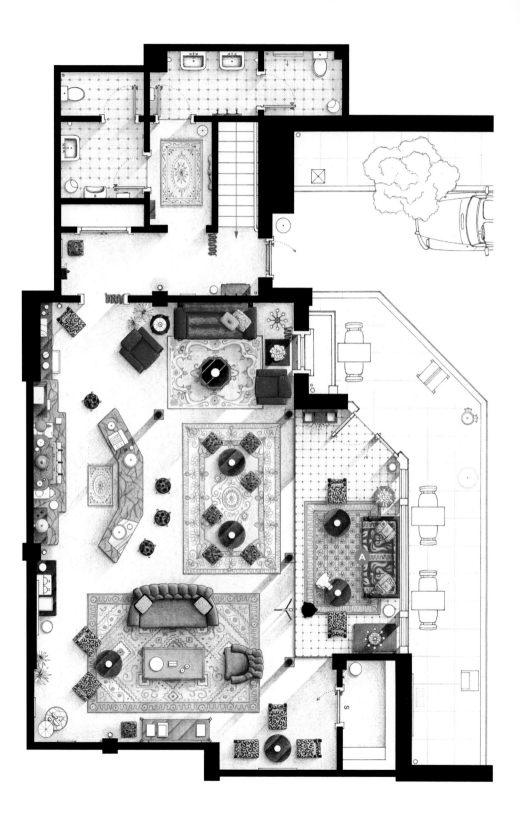

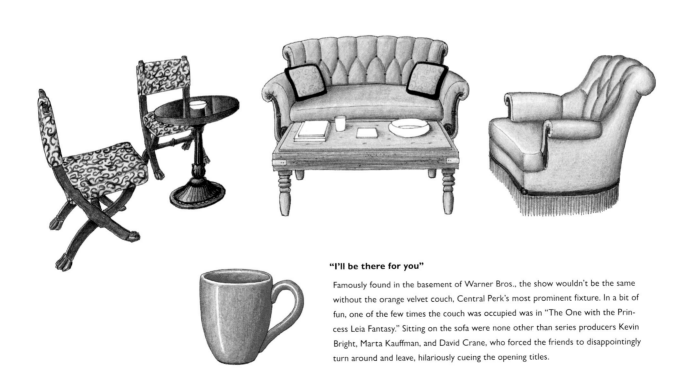

"I'll be there for you"

Famously found in the basement of Warner Bros., the show wouldn't be the same without the orange velvet couch, Central Perk's most prominent fixture. In a bit of fun, one of the few times the couch was occupied was in "The One with the Princess Leia Fantasy." Sitting on the sofa were none other than series producers Kevin Bright, Marta Kauffman, and David Crane, who forced the friends to disappointingly turn around and leave, hilariously cueing the opening titles.

Phoebe's Apartment

ADDRESS: 5 Morton Street, Apartment 14, New York, New York

Inherited, along with a taxi, from her adoptive grandmother, Frances, Phoebe's quirky abode is home to Gladys and Glinnis, a framed photo of her grandpa (aka Albert Einstein), and at one point, an unseen roommate named Denise, whose existence is continually debated among fans.

Guitar Versus Bongos

Not a big fan of playing the guitar, Lisa Kudrow at one point pitched that Phoebe play the bongos instead.

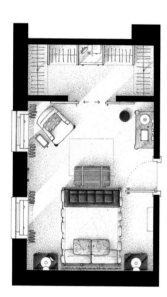

Phoebe's Bedroom Makeover

When Rachel moved in with Phoebe in season 6, Rachel's hair straightener tragically burns down both bedrooms. The result: Phoebe rebuilt the apartment with one large bedroom. *Sorry, Rachel!*

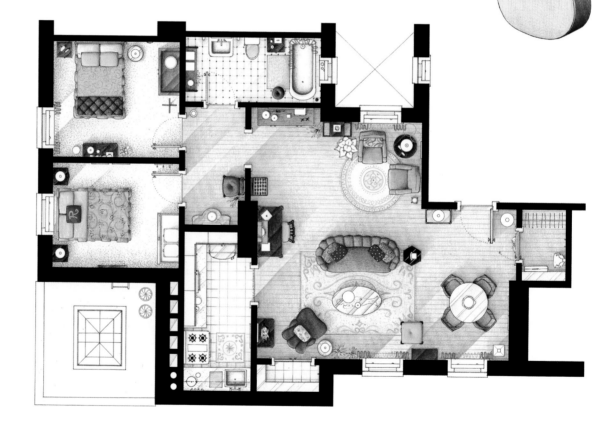

Ross's Apartment

LOCATION: The Former Apartment of the Ugly Naked Guy, New York, New York

To claim this apartment from "Ugly Naked Guy," Ross beat out hundreds of applicants by joining the former tenant for some naked bonding time. While the address is never mentioned, the apartment could be seen across the street from Monica and Rachel's balcony.

The Apothecary Table

Rachel bought an apothecary table from Pottery Barn and told Phoebe (who hated mass-produced products) that she got it at a flea market. After Phoebe saw the same table at Ross's place, they told her it was a knockoff. The charade continued until Phoebe saw her and Rachel's entire living room in a Pottery Barn window display.

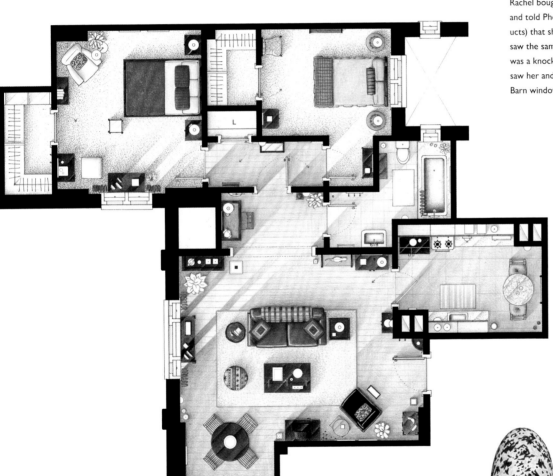

The Sentimental Tooth

During Thanksgiving dinner, Ross criticized Rachel's habit of exchanging gifts that lack sentiment. She then revealed a box containing items from their relationship that included a ticket stub from their first date, an eggshell from the first time Ross made her breakfast in bed, and this million-year-old tooth she stole from the museum the first time they "were together."

"Perhaps I can persuade you. What if you can give your son this genuine pterodactyl egg . . . [whispers] replica."
—Ross

HOW I MET YOUR MOTHER

CREATED BY: Carter Bays and Craig Thomas	**CHANNEL:** CBS
SERIES RUN: 9 seasons; 208 episodes; 2005–2014	
FILM LOCATION: 20th Century Studios in Century City, Los Angeles, California	

Have you seen . . . *How I Met Your Mother*? Created by Carter Bays and Craig Thomas, the legen-*wait-for-it*-dary sitcom suited up on CBS in 2005 and followed hopeful romantic and architect Ted Mosby who, in the year 2030, told his children the true story of how he met their mother. Ted's story began in 2005 when he was desperate to find love while living with his best friends who'd already found it—law student Marshall Eriksen and teacher/aspiring artist Lily Aldrin—all while hearing the nightly escapades of the group's brash, womanizing friend, Barney Stinson. Ted's life changed forever when he spotted reporter Robin Scherbatsky across the bar, setting in motion a nine-season-long arc of romantic twists and turns, a bevy of memorable running gags and relationships, and clever writing routinely delivered by an insanely likable cast of characters that you love to root for.

While these themes have been explored on pretty much every adult-*ish* sitcom, *How I Met Your Mother* injected new life into TV storytelling by employing a unique nonlinear framing structure and utilizing a series of imaginative flashbacks, flash-forwards, and everything in between. By playing with the idea of memory, telling a fractured story over time, and looking back on the past with renewed focus, the show was able to equally express the joy of living in the moment and the hindsight of old age reflecting on what could have been different. It proved that for all its comedy (Slap Bet, intervention, doppelgangers) it wasn't afraid to pull on the emotional heartstrings, often inserting poignant and profound dramatic moments. *How I Met Your Mother* understood that you can only get so far with a joke-a-minute format and grounded its comedy with through lines stemming from the wants and needs of the show's central quintet.

Over its nine seasons, *How I Met Your Mother* reintroduced "awesome" back into the vernacular, reminded us all how much of an earworm the song "I'm Gonna Be (500 Miles)" by The Proclaimers really is, and introduced us to Canada's most glorious pop star (and Robin's alter ego), Robin Sparkles. The show culminated in the two-part series finale, "Last Forever," that despite having the highest ratings of the series was virtually panned by most fans and critics, topped *USA Today*'s list of "Worst Series Finales of All Time," and is still a sore subject among the most loyal fans. For better or worse, it was often compared to *Friends* with its numerous similarities in structure, story, and character. However, *How I Met Your Mother* grabbed the proverbial torch—or in this case, the blue French horn—and breathed new life into the tried-and-true sitcom trope of mostly single twentysomethings navigating life, love, and success in New York City. And for that, it deserves the highest of fives.

The Swords

Representing their "brohood," these swords were one of the first pieces of decor Ted and Marshall bought for their apartment. Not just for decoration, the swords were used on many occasions to settle petty disagreements among the gang—with Lily, unfortunately, receiving the brunt of the conflicts by accident. They were first used in "The Duel," season 1, episode 8.

The Pineapple

In season 1's episode "The Pineapple Incident," Ted woke up in his bed hungover next to his one-night stand Trudy (guest star Danica McKellar of *The Wonder Years*) and this pineapple. Over the course of the series, it became a running joke that Ted and his lackluster detective skills couldn't figure out where exactly this mystery fruit came from despite an epic-looking evidence board.

The Blue French Horn

First stolen by Ted in the pilot from Carmichael's restaurant, the blue French horn became a symbol of Ted and Robin's relationship. It was primarily displayed on Robin's mantle until making its last appearance in the final scene of the series where Ted, mirroring the pilot, declared his love for Robin while holding the horn outside her apartment window. The blue French horn was actually a mellophone, a similar-looking brass instrument.

Ted Mosby's Apartment (formerly Ted and Marshall's Apartment)

LOCATION: At or near 150 West Eighty-Fifth Street, New York, New York (as seen in season 6, episode 4, "Subway Wars")

The gang's favorite hangout (outside of MacLaren's Pub) where all but Barney lived at some point. With roof access for parties (and meeting slutty pumpkins), this Upper West Side apartment was once a short-lived bar named Puzzles. Why? That's the puzzle!

The Yellow Umbrella

Often a visual device to represent the Mother (who was faceless for most of the series), this umbrella was first possessed by Ted in season 3, episode 12, "No Tomorrow," when he took it from a club on Saint Patrick's Day. He finally met Tracy McConnell (in the series finale) under the umbrella at a rainy Farhampton station while they flirtatiously debated whose T. M. initials were on the handle.

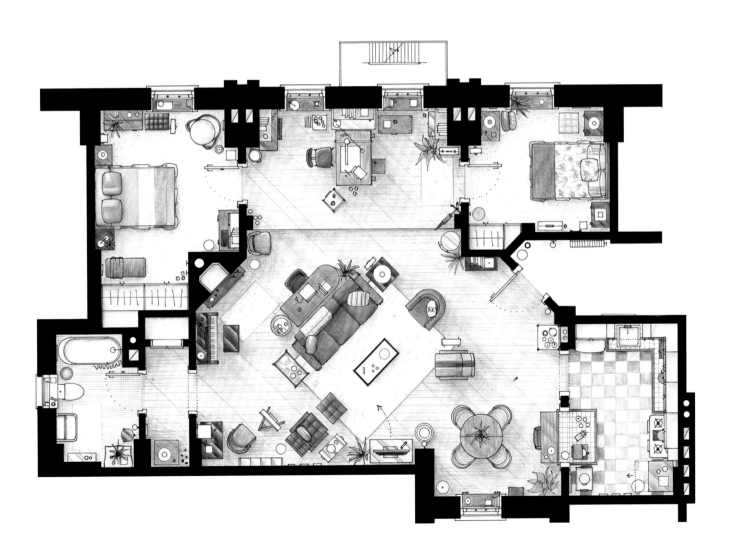

Marshall and Lily's Apartment

LOCATION: Dowisetrepla ("**dow**nwind of the **se**wage **tre**atment **pla**nt"), New York, New York

Marshall and Lily spent their entire life savings on this apartment after their wedding only to find out that the apartment floors were crooked. Fans of *Friends* will see a familiar face in season 3, episode 7, "Dowisetrepla," as Margaret, the realtor who sold Marshall and Lily their new apartment, was played by Maggie Wheeler, who portrayed Janice on all ten seasons of *Friends*.

Lily's Second Apartment

In season 2, Lily called off her engagement to Marshall to pursue a summer art course in San Francisco. When she returned to NYC, she was forced to live in this tiny temporary apartment with a pesky Murphy bed; a hybrid stove, oven, sink, and refrigerator known as a "stoveinkerator"; Lithuanian neighbors who liked to shout; and a roommate who happened to be a raccoon.

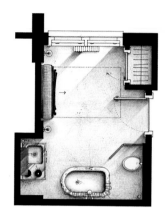

The Gouda

After several unsuccessful attempts at hosting dinner parties, Marshall and Lily throw an awkward couples' night at their apartment with Barney and Robin. Lily only allowed Marshall to do one task: pick out the cheese. Flanked by sturdy cheese-bearing crackers, Marshall excitedly tried, but failed, to hawk his beloved Gouda with phrases like, "Don't sleep on the Gouda."

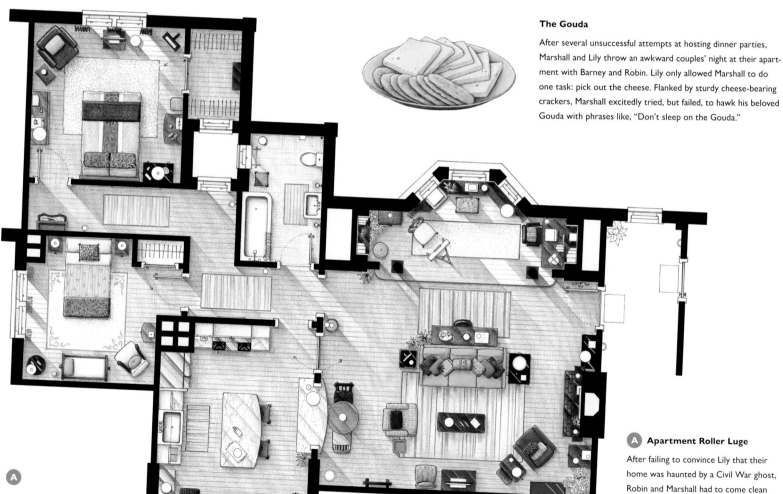

(A) Apartment Roller Luge

After failing to convince Lily that their home was haunted by a Civil War ghost, Robin and Marshall had to come clean about the floors being crooked. To cheer them up, Robin grabbed a skateboard and salad strainer and invented a new sport.

2°

Barney's Apartment

LOCATION: The Fortress of Barnitude, New York, New York

Featuring such amenities as a professionally lit porn collection, two 300-inch flat-screen TVs, a bedroom with a king-size bed and only one pillow and blanket, a bathroom with only one towel and no dryer, and several inventions (patent pending) whose sole purpose was fending off clingy women, this apartment is the Barney Stinson of apartments.

The Bro Code and the Playbook

A sacred list of dos and don'ts for bros, including such rules as "Bros before hoes" and "Bros cannot make eye contact during a devil's three-way." Its varied origins were attributed to Barney's ancestor Barnabus Stinson, as well as Broses and Christopher Brolumbus. The playbook, on the other hand, was created by Barney and first appeared in season 5; it featured a collection of scams using elaborate plots, tricks, and costumes to pick up women.

Ducky Tie

A running gag in the show and originally owned by Marshall, this tie must be worn by Barney for an entire year after he loses a bet at a teppanyaki restaurant.

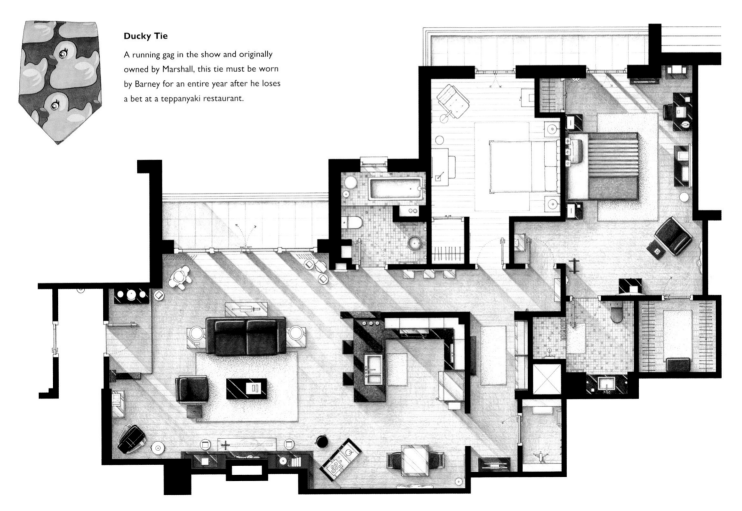

MacLaren's Pub

LOCATION: Below Ted and Marshall's Apartment, New York, New York

MacLaren's Pub was the gang's favorite hangout where many of the show's most memorable moments took place, such as Ted meeting Robin, Barney's endless conquests, and the creation of the Slap Bet. The pub and its head bartender were named after one of the associate producers, Carl MacLaren.

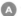 **The Booth**

The gang's favorite booth where they tell stories, plan schemes, or confide in each other. Show creators wanted the cast in a different booth each time for realism, but due to the restrictions of filming, it was much easier to have them at the same one each time.

Wharmpess Beer

In season 6, episode 7, "Canning Randy," Randy Wharmpess (Will Forte), an incompetent GNB employee and failed wingman to Barney, was fired by a remorseful Marshall, then rehired and fired again so he could use his severance to fund his dream of brewing beer. Despite the name, Future Ted notes that Wharmpess was hugely successful and was available at every bar in America.

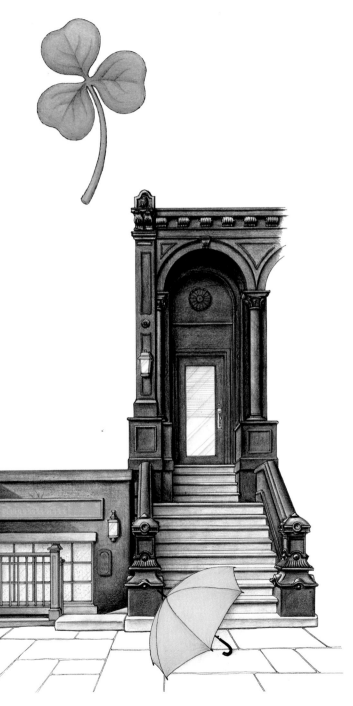

MacLaren's Exterior

The pub was based on four NYC bars (most notably McGee's at 240 West Fifty-Fifth Street) that Craig Thomas and Carter Bays frequented while writing for David Letterman. The exterior shown is located on the Fox Studios Lot.

WILL & GRACE

CREATED BY: David Kohan and Max Mutchnick	**CHANNEL:** NBC
SERIES RUN: 11 seasons; 246 episodes; 1998–2006 (original); 2017–2020 (revival)	
FILM LOCATION: Live studio audience at CBS Studio Center in Studio City, California (original); Universal Studios Hollywood in Universal City, California (revival)	

Created by Max Mutchnick and David Kohan, and starring Eric McCormack, Debra Messing, Megan Mullally, and Sean Hayes, *Will & Grace* premiered on NBC in 1998. Set in New York City, *Will & Grace* focused on the tight-knit friendship of roommates Will Truman, a lovingly uptight gay lawyer, neat freak, and fanilow (a fan of Barry Manilow), and his neurotic, food-obsessed straight best friend and interior designer, Grace Adler. Joining them both as they navigated life, work, and relationships were Grace's assistant, Karen Walker (alias: Anastasia Beaverhausen), an alcoholic and amoral gold-digging socialite (with a never-seen husband), and Will's best friend and neighbor, Jack McFarland, a gay, carefree, Cher-obsessed struggling actor and onetime backup dancer to Jennifer Lopez. From 2001–2005, the show was the highest-rated sitcom among adults aged eighteen to forty-nine and left on a high note after eight seasons. That is, until 2016, ten years after the show wrapped, when the full creative team returned for a get-out-the-vote webisode for the 2016 presidential election that reignited interest in the show and led to a revival that ran for three more seasons.

Will & Grace would go on to earn many accolades, but perhaps no accolade was as important as being the first program to have an openly gay male lead character on prime-time television. Premiering at a time when many people in the United States were in opposition to the LGBTQ+ community, the show painted a picture of two gay men living their lives and hilariously dealing with relatable problems. The show was open, proud, and unapologetic about its characters. In 2012 then vice president, and future president, Joe Biden said that *Will & Grace* probably did more to educate the American public on LGBTQ+ issues than most shows. It helped lay the groundwork for future shows such as *Six Feet Under*, *Glee*, and *Modern Family*.

In the end, the show may have portrayed two gay characters, but it wasn't explicitly about that and never claimed that to be its sole identity. Its legacy will be remembered in addition to the advances in the LGBTQ+ community as a cacophony of impeccable scripts, unforgettable performances, hilarious physical comedy (Grace's liquid-filled bra in "Das Boob"), running gags such as "Just Jack," and a slew of famous cameos. When it comes to *Will & Grace*, there are three certainties in life: Thanks to their on-screen chemistry, the cast will go down as one of the most talented groups in television history, Will and Grace's apartment is a real estate unicorn, and if you're ever in need of a drink, the odds that Karen has cleverly hidden a bottle of liquor nearby are very, very good.

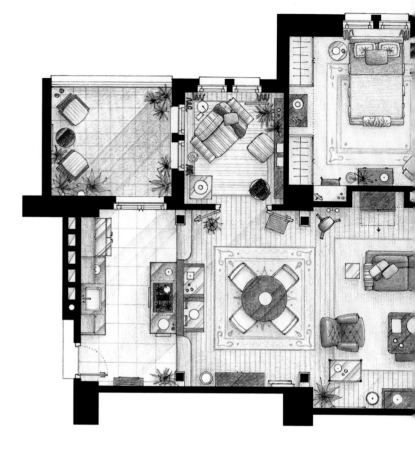

A Portrait of a Brooding Man

The portrait of the shirtless man next to the fireplace that Will called "a gaunt, dead-eyed man who never changes and looks down on everyone" was a running gag on the show and a set piece carried over from the original series to the revival. According to actor Eric McCormack, fans constantly wrote in wondering who it really was (no one knows) and where they could buy it.

B "You say potato, I say vodka." —Karen

Drink like Karen: Mix 2.5 oz. vodka, .5 oz. dry vermouth, and .5 oz. olive brine into a shaker with ice cubes. Shake well. Strain into a chilled cocktail glass.

The Apartments of Karen Walker, Will Truman & Grace Adler

ADDRESS: 155 Riverside Drive, Apartments 9A and 9C, New York, New York

Described as "the apartment that sex forgot" by Jack and a "poorly decorated crack house" by Karen, Will and Grace's trendy Upper West Side apartment was the main setting of the show with occasional glimpses into Karen's apartment where she and her no-nonsense maid Rosario swapped insults in between Karen's martinis. After the original series ended, cocreator Max Mutchnick donated the set to his alma mater, Emerson College, where it resided in Boston, and then Los Angeles, until the revival series. Unlike many shows, the fictional address matched the real exterior used in each episode. If you visit their apartment, you'll also be standing across the street from none other than Liz Lemon's apartment from *30 Rock*.

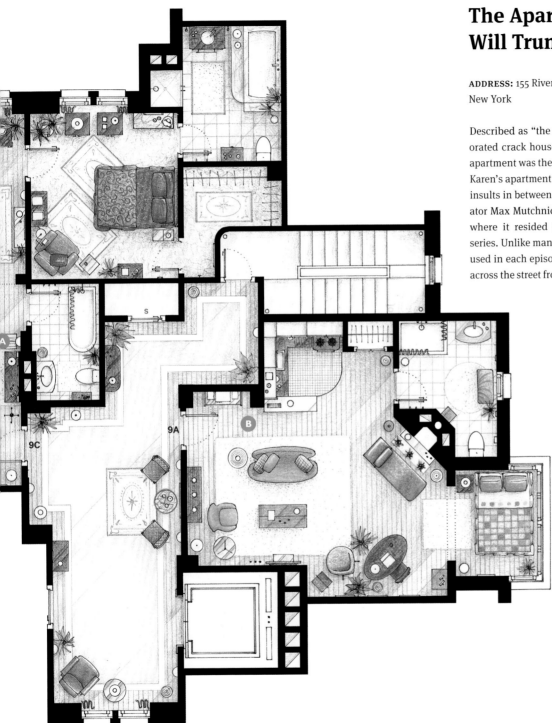

Café Jacques

Making its first appearance in season 5's episode "It's the Gay Pumpkin, Charlie Brown," Jack's "alfresco" café (located in the hallway between his apartment and the elevator) featured such delicacies as Hot Pockets for lunch, Eggo waffles for breakfast, and plenty of Jackuccinos to go around.

SEX AND THE CITY

CREATED BY: Darren Star	**CHANNEL:** HBO
SERIES RUN: 6 seasons; 94 episodes; 1998–2004	
FILM LOCATION: Silvercup Studios East in Long Island City, Queens, New York; on location in and around New York City, New York	

Based on a series of newspaper columns by Candace Bushnell, and the eventual 1996 book of the same name, *Sex and the City* premiered on HBO in 1998 and forever inspired throngs of female foursomes to dress in their best duds before weeding through duds at the bar. The show followed self-described sexual anthropologist and columnist Carrie Bradshaw as she chronicled her sexual escapades and dating life. In addition to the rotation of a visual Rolodex of sexy love interests, always at her side were her inseparable friends—hopelessly romantic perfectionist Charlotte York; uber-confident *try*-sexual Samantha Jones; and cynical and career-driven Miranda Hobbes—who collectively dished on their dating struggles and supported one another while traversing the beauty of New York City. *Sex and the City* was a first-of-its-kind show that depicted sex and relationships in a frank and honest way from the female point of view while showing women openly discussing previously taboo subjects in the same breath as their brunch order.

Sex was famously in the title, and on-screen, but the show's steamiest love affair wasn't with a sports doctor, struggling waiter-turned-actor, or major tycoon—it was with shoes. Carrie Bradshaw became a trendsetting fashion icon, never wearing the same outfit twice, and like *Friends* with the Rachel haircut sweeping the nation, Carrie's expensive tastes (and the help of famed stylist Patricia Field) inspired international closet envy. The influence didn't just end in fashion; the foursome's favorite drink, a cosmopolitan, became massively popular after appearing on the show, even garnering a line of dialogue in one of the film adaptations in reference to its popularity. Miranda asked why they had stopped drinking them and Carrie said, "Because everyone else started."

Sex and the City would be nominated for fifty-four Emmy Awards, winning seven, including Outstanding Comedy Series, the first win in that category not only for HBO but for any cable program. The show's main criticism was its lack of diversity—an issue the showrunner and producers of the HBO Max sequel series *And Just Like That . . .* tried to rectify. It premiered in 2021, seventeen years after the original series ended. *Sex and the City* may have changed the way we dress, drink, and date, but ultimately, the story was about finding yourself, loving yourself, and knowing that whatever happens, you'll always have your friends nearby.

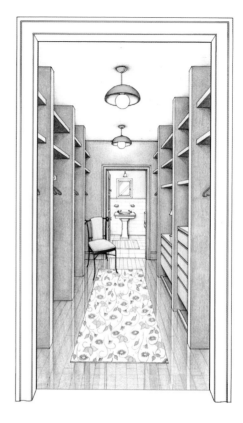

"I like my money where I can see it—hanging in my closet." —Carrie

Creating the closet to end all closets, Patricia Field was the visionary behind the quartet's epic fashion choices. Sarah Jessica Parker revealed to *Vogue* in 2021 that she still owns all of Carrie Bradshaw's clothing worn throughout the six seasons and two movies, and even some furniture, all packed away in storage according to season, episode, and scene.

Aidan's Chair

Carrie visited a furniture gallery where she met designer Aidan Shaw and his dog, Pete, who became "acquainted" with her leg. Carrie fell in love—with the chair. With a hefty price of thirty-eight hundred dollars, Carrie got the designer discount, thanks to Stanford, and the "dog humiliation factor" discount, thanks to Aidan, who then proposed a date.

Carrie Bradshaw's Apartment

ADDRESS: 245 East Seventy-Third Street, Apartment C, New York, New York

Carrie's address was on the Upper East Side, but the exteriors were actually shot in the West Village at 64 (seasons 1–3) and 66 Perry Street. Around the corner from the brownstone was the famous Magnolia Bakery where, thanks to the show and its episode "No Ifs, Ands, or Butts," you can order the "Carrie Cupcakes" and join Carrie and Miranda by indulging in delectable pink buttercream frosting as you sit on the same bench and muse about your latest crush.

A Closet Full of Manolos

Despite a closet full of shoes, these blue satin Manolo Blahniks were perhaps Carrie's most famous pair, which interestingly enough didn't appear until *Sex and the City: The Movie*.

(A) Carrie's Desk

Situated by the window with a view of her brownstone's steps, Carrie wrote her popular column and the source for the show's memorable voiceover at this desk. The black Apple PowerBook laptop Carrie typed away on resides at the Smithsonian National Museum of American History.

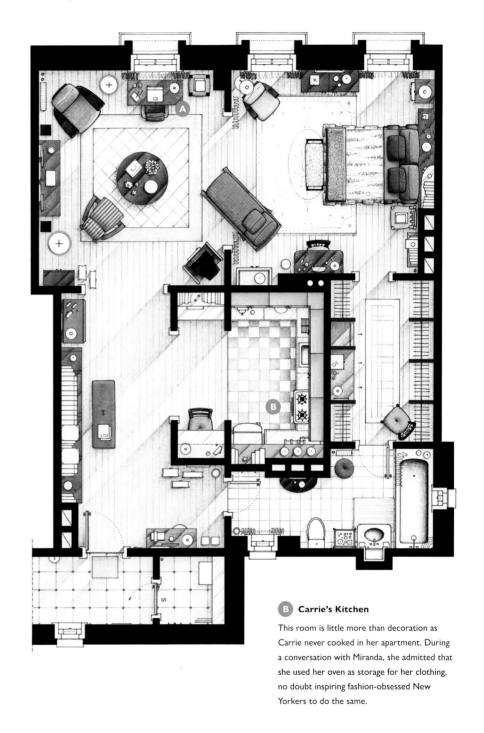

(B) Carrie's Kitchen

This room is little more than decoration as Carrie never cooked in her apartment. During a conversation with Miranda, she admitted that she used her oven as storage for her clothing, no doubt inspiring fashion-obsessed New Yorkers to do the same.

WORKING
NINE TO FIVE

I guess I've been working
so hard, I forgot what it's
like to be hardly working.
—MICHAEL SCOTT

The Office

Whether you're working hard or hardly working, there's comfort in knowing that, after the inevitable daily grind of a nine to five, your favorite TV show is waiting for you when you get home. You clock out, and your favorite fictional characters clock in, ready to provide hours of entertainment to help you forget the minutiae of your day.

For many, comfort TV is not a fantasy in a far-off land with mythical creatures, or a gripping true crime thriller, but a show about, of all things, going to work. Despite your own adventures with unruly customers, interoffice politics, or painfully troubleshooting outdated technology to complete even the simplest of tasks, watching others do the same things on TV, only funnier or more dramatic, can be awfully therapeutic. Rough days at work are a given, and yet there is satisfaction in the relatability of the many antics seen on-screen.

Hawking palettes of paper while your boss goofs around or ringing up customers in between unwanted life lessons from your dad might not sound very engaging in real life, but with the right characters and story,

it quickly becomes must-see TV. None of this would have been possible, of course, without the trailblazing efforts of *The Mary Tyler Moore Show* (refresh your memory on page 26) that premiered during a time when sitcoms were predominantly about family life and shook things up by following a young, single, career-driven character navigating relationships and the complexities of the workplace. The format took off and has endured ever since by creating an otherwise nonexistent window into small slices of everyday life.

On the following pages you can peek behind the runway to the stressful world of high fashion; enter the exquisitely designed, smoke-filled rooms of the '60s (where the cocktails and pitches are flowing); visit Toronto by way of Scranton; and exist as a fly on the wall (or more accurately, a barfly on a stool) at a place where everybody knows your name. Don't expect any PowerPoint presentations, however, because as Dwight Schrute of *The Office* says, "PowerPoints are the peacocks of the business world; all show, no meat."

THE OFFICE

CREATED BY: Greg Daniels, based on *The Office* by Ricky Gervais and Stephen Merchant	**CHANNEL:** NBC
SERIES RUN: 9 seasons; 201 episodes; 2005–2013	
FILM LOCATION: Chandler Valley Center Studios in Panorama City, California; on location in and around Los Angeles, California	

"Nobody should have to go to work thinking, 'Oh, this is the place that I might die today.' That's what a hospital is for. An office is for not dying. An office is a place to live life to the fullest, to the max, to . . . An office is a place where dreams come true."
—Michael Scott

Bears. Beets. Battlestar Galactica.

Remakes are rarely as successful as their original counterparts. Some remain too faithful to the original and never carve their own path, while others veer too far off from what made the original successful. One remake, however, managed to become one of the most iconic shows of the 2000s (and arguably more successful than the original), thanks to millions of people who made it part of their daily ritual, and the most streamed show in the world. Based on the award-winning and groundbreaking BBC series of the same name (created by Ricky Gervais and Stephen Merchant), *The Office*, created by Greg Daniels, premiered on NBC in 2005 and introduced the world to a show it hadn't quite seen before on network TV: a drab, realistic reflection of the fluorescent-lit monotony of corporate work culture.

The faux-documentary series followed the daily grind and awkward hilarity of an eclectic group of employees working at the fictional Dunder Mifflin Paper Company in Scranton, Pennsylvania. Led by regional manager Michael Scott, a dimwitted man-child who lacks self-awareness and craves friendship, employees include everyman prankster Jim Halpert, shy receptionist Pam Beesly, egomaniacal assistant to the regional manager Dwight Schrute, ambitious "wunderkind" temp Ryan Howard, and a veritable who's who of corporate coworker archetypes: Angela, Stanley, Kevin, Oscar, Phyllis, Meredith, Kelly, Creed, Andy, Darryl, and Toby.

In a TV landscape normally filled with beautiful people, lavish apartments, and high-powered careers, *The Office* went for realism by throwing out the dependable laugh track, casting "regular"-looking people, leaning into cringe humor, and most notably, adopting a reality TV, vérité-like aesthetic that would influence the next decade of television. The show received multiple awards including the Emmy Award for Outstanding Comedy Series and consistently receives high rankings in just about every best television show of all time list. During the 2020 COVID-19 shelter-in-place mandates, the show logged over fifty-seven million streams on Netflix some seven years after it left the airwaves.

Over nine seasons *The Office* resonated with audiences thanks to its ingenious writing, talented cast of improvisers, and hopefulness that grounded its characters. Without this show audiences never would have met Prison Mike, seen the conclusion of *Threat Level Midnight*, cringed at an epic dinner party, and perhaps most memorably, watched the blossoming romance of Jam. When that familiar theme song starts over a montage of sights of Scranton, Pennsylvania, the problems of your workday are immediately alleviated by the comedic problems of everyone's favorite workplace, and despite whatever is going on in the world, once you turn it on, you know it's going to be a good time. *That's what she said.*

Dunder Mifflin Paper Company, Scranton Branch Office

ADDRESS: 1725 Slough Avenue, Suite 200, Scranton, Pennsylvania

Located in Scranton Business Park and home to the "Five Families"—Dunder Mifflin, Vance Refrigeration, Disaster Kits Ltd., W. B. Jones Heating & Air, and Cress Tool & Die—1725 Slough Avenue was not a real address in Scranton, Pennsylvania, but a reference to the British version of *The Office*, after the Wernham Hogg paper company in Slough, England.

> "'You miss 100% of the shots you don't take.' —Wayne Gretzky"
>
> —Michael Scott

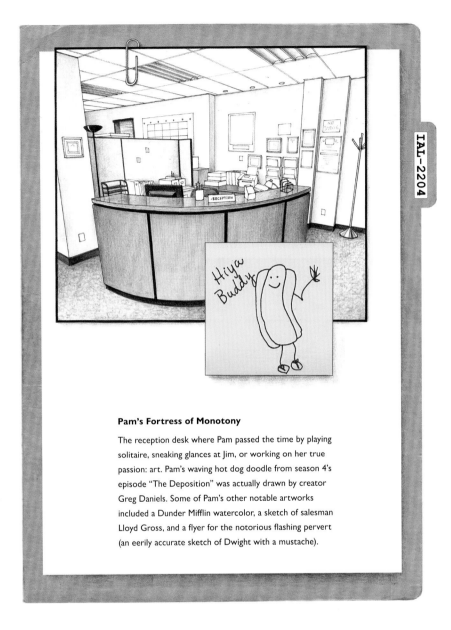

Pam's Fortress of Monotony

The reception desk where Pam passed the time by playing solitaire, sneaking glances at Jim, or working on her true passion: art. Pam's waving hot dog doodle from season 4's episode "The Deposition" was actually drawn by creator Greg Daniels. Some of Pam's other notable artworks included a Dunder Mifflin watercolor, a sketch of salesman Lloyd Gross, and a flyer for the notorious flashing pervert (an eerily accurate sketch of Dwight with a mustache).

World's Best Boss

Introduced in the pilot (and seen in nearly every episode), Michael bought himself this mug (perfect for drinking gin when feeling like a zero). Former writer for *The Office* Michael Schur (cocreator of *Parks and Recreation* and *Brooklyn Nine-Nine*, and creator of *The Good Place*) cheekily referenced the mug in *The Good Place* by giving the afterlife's head accountant (played by cocreator of the original *The Office* Stephen Merchant) a mug that said "Existence's Best Boss."

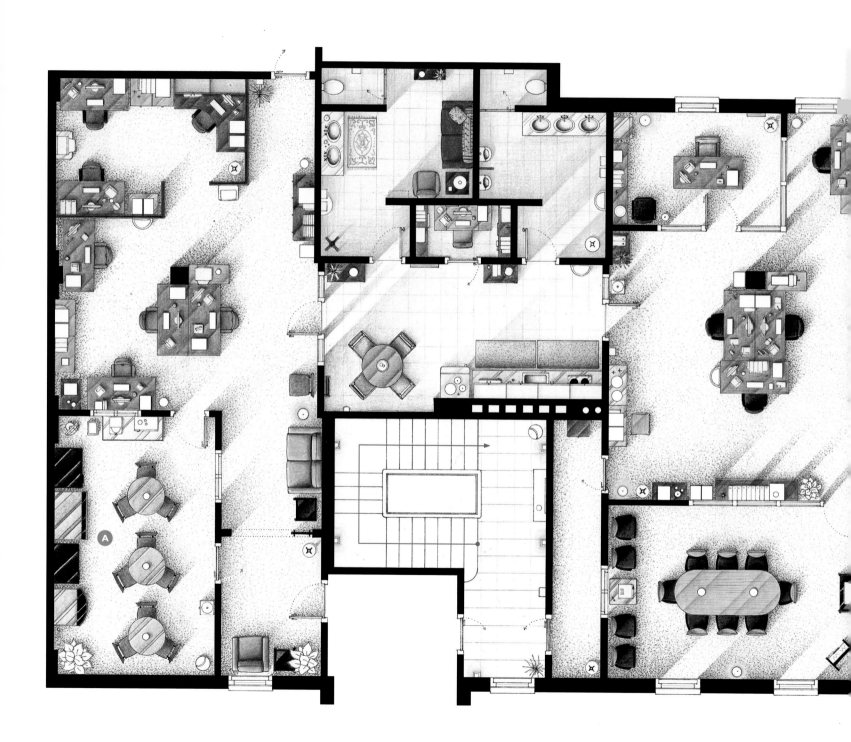

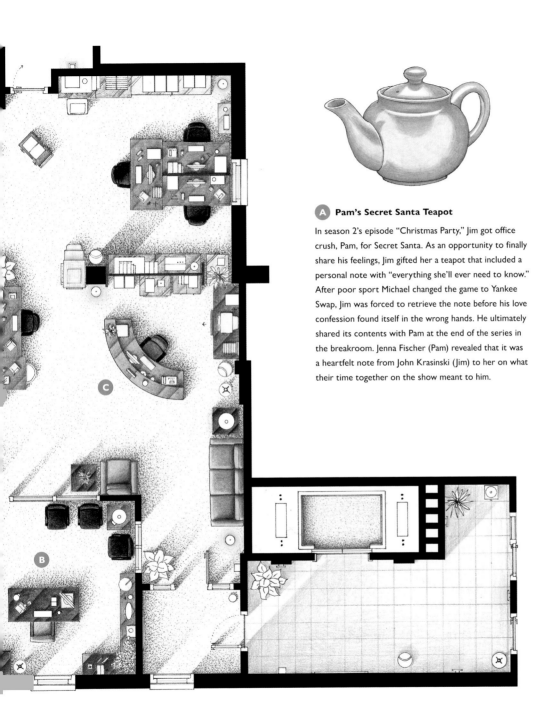

A Pam's Secret Santa Teapot

In season 2's episode "Christmas Party," Jim got office crush, Pam, for Secret Santa. As an opportunity to finally share his feelings, Jim gifted her a teapot that included a personal note with "everything she'll ever need to know." After poor sport Michael changed the game to Yankee Swap, Jim was forced to retrieve the note before his love confession found itself in the wrong hands. He ultimately shared its contents with Pam at the end of the series in the breakroom. Jenna Fischer (Pam) revealed that it was a heartfelt note from John Krasinski (Jim) to her on what their time together on the show meant to him.

B Top Five Dundie Awards

1. Bushiest Beaver Award to Phyllis
2. Hottest in the Office Award 2005, 2006, 2007, 2008, 2009, and 2010 to Ryan
3. Don't Go in There After Me Award to Kevin
4. Whitest Sneakers Award to Pam
5. Extreme Repulsiveness Award to Toby

C Kevin's Famous Chili

Passed down in the Malone family for generations, Kevin's chili made an appearance at the office at least once a year with Kevin staying up the night before pressing garlic, dicing tomatoes, and toasting ancho chiles (but the secret was undercooking the onions). The famous chili was memorably featured in the episode "Casual Friday" where Kevin accidentally spills it all over the carpet. Actor Brian Baumgartner (Kevin) captured the iconic moment in one take.

KIM'S CONVENIENCE

CREATED BY: Ins Choi and Kevin White	**CHANNEL:** CBC Television
SERIES RUN: 5 seasons; 65 episodes; 2016–2021	
FILM LOCATION: Studio City Toronto (formerly Showline Studios); on location in and around Toronto	

Kim's Convenience was a Canadian sitcom that premiered on CBC Television on October 11, 2016, and ran for five seasons. It depicted the Korean Canadian Kim family who ran a convenience store in Toronto and lived directly above it. Sounds pretty typical, eh? Perhaps on the surface, but what ensued was a hilarious blend of family, customers, and cultural differences. The titular family consisted of Mr. Kim, or Appa, the outspoken and stubborn patriarch who was never without a lesson or opinion; Mrs. Kim, or Umma, the hardworking matriarch who liked to meddle in the lives of her family in between church events; daughter Janet, a budding photographer and independent young woman; and Jung, their estranged son who worked at a car rental agency. A blend of both workplace and family subgenres, the show skillfully set itself apart from most workplace comedies by choosing the unique location of a convenience store for its primary setting rather than a sea of gray cubicles and paper pushers.

The show was based on the play of the same name written by Ins Choi, who spent five years working on the script and received financial help from his Korean church to help mount a theater workshop. This wholesome and hilarious series was a love letter to Choi's parents; Korean-owned, family-operated convenience stores (one of which his family had owned); and first-generation immigrants who call Canada home. With every hilarious one-liner or back-and-forth exchange between Appa and a customer or Umma and Janet, the show highlighted nuanced aspects of Korean culture and the experiences of immigrant families in their adopted country. As actor Paul Sun-Hyung Lee (Appa) said in his acceptance speech for a Canadian Screen Award, "I think a show like *Kim's Convenience* is proof that representation matters because when communities and people see themselves reflected up on the screen, it is an inspiring and very powerful moment for them because it means they move from the margins into the forefront. It gives them a voice. It gives them hope."

After five successful seasons the show announced that it would not continue after receiving criticism from the main cast for the lack of diversity behind the scenes and the departure of the show's two cocreators. Despite its abrupt end, *Kim's Convenience* was a landmark show whose impact on popular culture will be felt for years to come. It featured an Asian Canadian family for the first time in the history of Canadian television, and while audiences may never see or hear the familiar door of the Kim family convenience store open again, *Kim's Convenience* will always be open seven days a week for viewers to rewatch and fall in love with all over again—which Mr. Kim would appreciate as being the ultimate sneak attack. *Okay, see you!*

Mr. Kim's Pricing Gun

Appearing in the final scene of Ins Choi's original play, the pricing gun played an important role as a tear-stricken Appa gave Jung the store and handed him the gun as a symbolic gesture of passing the torch. Jung adjusted the numbers and began repricing the cans, and the play ended with the lights fading out over the sound of the pricing gun.

GROUND FLOOR

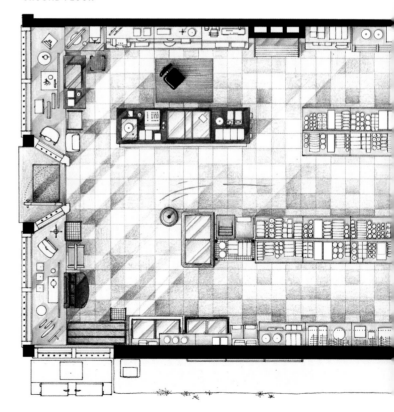

Kim's Convenience Store

ADDRESS: 252 Queen Street East, Toronto, Canada

Owned by Appa and Umma, the store had patrons who often enjoyed Appa's signature brand of humor along with a range of amenities such as greeting cards (some personally signed by Mr. Kim) and a "Best Before" two for two dollars ravioli tower. In the ravioli tower episode, actor Paul Sun-Hyung Lee said he ate five or six cans for the moment Appa defiantly ate the expired ravioli.

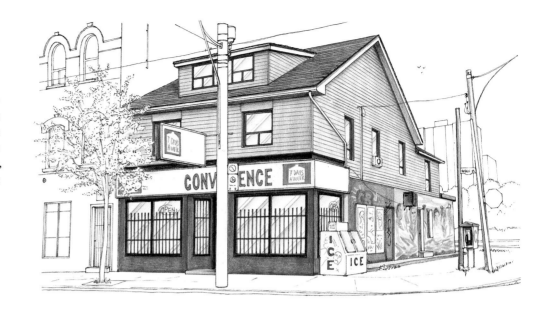

Real location of the staircase

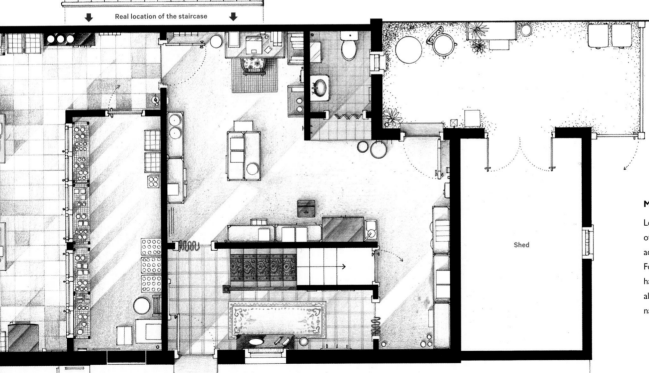

Shed

Moss Park

Located in the Moss Park neighborhood of Toronto, Kim's Convenience was an actual corner store named Mimi's Variety. For the production, the owners, who had no attachment to the original name, allowed show producers to change the name and facade of the building.

The Kim Family Home

ADDRESS: 252 Queen Street East, Upper floor and attic, Toronto, Canada

Appa, Umma, and Janet lived in the apartment directly above the convenience store. It featured a "don't touch wall" with photographs, including a photo of Umma that Gerald took and one of Appa that Janet secretly took. Writer/cocreator Ins Choi once lived with his family above his uncle's convenience store, Kim Grocery, located at 878 Weston Road in Toronto when they first immigrated to Canada.

"Elephant in the Room"

In season 3, episode 10, Janet was upset that Umma sold some of her keepsakes at the church bazaar (baby teeth, macaroni pony, *The Lion King* program signed by Appa) and retaliated by selling this golden elephant. Umma then guilt-tripped her by telling her the statue contained her grandfather's ashes. When Janet broke down after failing to relocate the heirloom, Appa confessed it was just a lie.

UPPER FLOOR

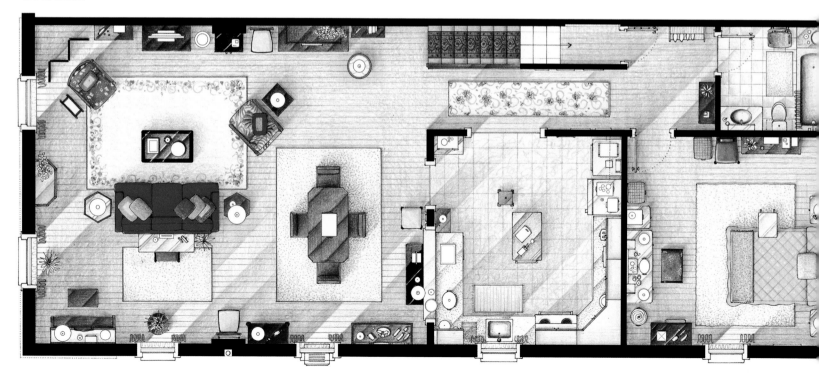

Umma's Gimbap

A favorite dish of one of Jung's best friends, Kimchee, gimbap (sometimes spelled as kimbap) is a Korean delicacy made from rice (bap) with ingredients such as cooked or preserved vegetables, fish, or meats, rolled in dried sheets of seaweed (gim), and served in a bite-size slice.

Toronto Korean East-West Presbyterian Church

The Kim family's church was the main battleground where a rivalry existed between Mrs. Kim and fellow churchgoer Mrs. Park. The rivalry came to a head in season 1, episode 13, "Family Singing Contest," when, in an attempt to outdo Mrs. Park and her daughter Jeanie's rendition of "Sixteen Going on Seventeen," Umma, Jung, and Janet sang a tearful version of "Nae Joo-Yuh Ddeut-dae-ro" (My Jesus, As Thou Wilt).

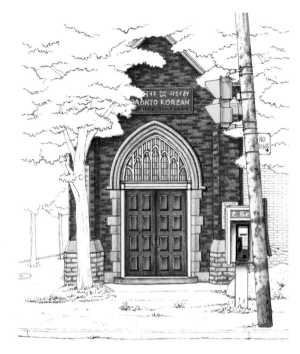

ATTIC

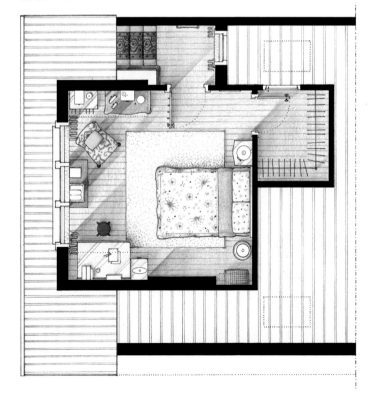

MAD MEN

CREATED BY: Matthew Weiner	CHANNEL: AMC

SERIES RUN: 7 seasons; 92 episodes; 2007–2015

FILM LOCATION: Silvercup Studios East in Long Island City, Queens, New York, and on location in and around New York City, New York (pilot); Los Angeles Center Studios, Los Angeles, California, and on location in and around Los Angeles, California (remainder of series)

Proving that nostalgia is delicate and potent, *Mad Men*, created by Matthew Weiner, premiered on AMC in 2007, and not only ushered in a modern resurgence of retro sensibilities in popular culture but also helped AMC (along with *Breaking Bad* and *The Walking Dead*) become the unofficial "HBO of basic cable." *Mad Men* was a provocative and poignant period drama taking place during the 1960s that followed the exploits of the men and women working in the highly competitive world of New York City advertising.

The title was in reference to a term coined in the late 1950s describing advertising executives of Manhattan's Madison Avenue. The show's lead character was Don Draper, a charismatic but guarded advertising executive and genius pitchman working at Sterling Cooper—he was credited on the show with inventing some of history's most famous ads. Surrounding Draper, and his existential angst and search for purpose, was a strong ensemble cast representing archetypes of 1960s culture, perhaps none more memorable than Peggy Olson, Draper's secretary-turned-mentee-turned-copywriter who rose through the ranks with hard work, perseverance, and talent, culminating in that iconic hallway scene in the show's final season.

Mad Men was critically acclaimed for its attention to detail in all aspects of production (costumes, hair, production design) and how it weaved fictional plots with the real-life transformation of the United States throughout the 1960s and early 1970s. Viewers initially were led to connect to the stylish surface of the show (the smoking, drinking, sex, music, clothing, furniture, etc.) when the show actually lived in the subtext, the tension underneath the surface depicting characters that were missing something in their lives and how they tried to attain it. Despite every character inhabiting a perfectly groomed world, like an advertisement, the show made audiences realize that the world of Don Draper, no matter how attractive it looked, was not that different from our own decades later.

The allure of *Mad Men* was really a tactic often used in one of Don Draper's pitches: smoke and mirrors. What wasn't smoke and mirrors was the response from critics to the show's visual style, acting, directing, and dedication to historical accuracy in all aspects of production. Nominated for 116 Emmy Awards, and winning 16, *Mad Men* has been regarded as one of the greatest television series of all time (which makes sense knowing Weiner's previous gig was *The Sopranos*). Don impressed several clients with a certain mantra that perfectly encapsulates *Mad Men*'s rise in TV history and the lasting impact and legacy it will have for years to come: "If you don't like what is being said, then change the conversation."

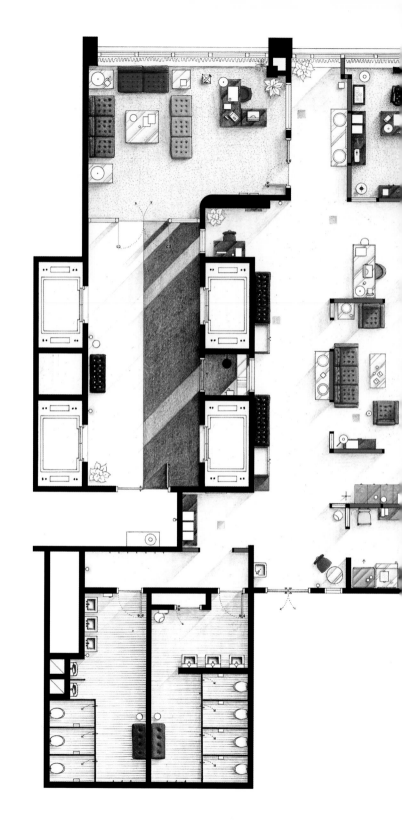

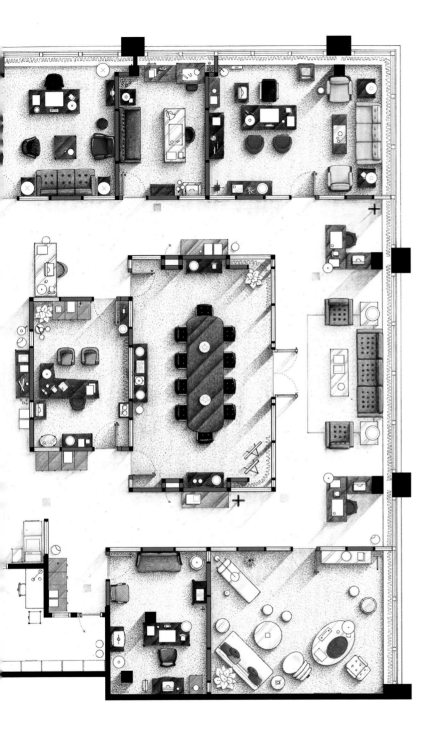

Sterling Cooper Draper Pryce Office

ADDRESS: Time-Life Building, 1271 Sixth Avenue, Suite 3750, New York, New York

Introduced in season 4, the offices of upstart agency Sterling Cooper Draper Pryce threw away the rigidity of the former Sterling Cooper and opted for an open plan, a "rabbit warren" look signifying the control of the 1950s had been broken down to make way for a youthful and colorful aesthetic that represented the revitalized lifeblood of the offices' chain-smoking copywriters.

"Everybody else's tobacco is poisonous. Lucky Strike's is toasted." —Don Draper

Equally criticized and applauded for its glorification and accuracy of cigarette use at the time, the actors luckily did not smoke real cigarettes on set, but herbal cigarettes. A fan did the math and counted Don smoking nearly seventy-five cigarettes in the pilot episode alone.

Don Draper's Apartment

ADDRESS: 783 Park Avenue, Apartment 17B, New York, New York

Don's high-rise love nest with second wife Megan, located on the Upper East Side of New York City, was a sexy and stylish upgrade from the restraints of the suburbs. Featuring a swanky sunken conversation pit perfect for entertaining (with a plush white carpet, no less), the apartment included bold colors, walnut cabinetry, and sleek modern lines fit for a philandering creative. Set decorator Claudette Didul took inspiration from the 1965 book *Decoration U.S.A.* and the 1960s books of interior designer Betty Pepis to create the contrast between Don's masculine style and Megan's youthful taste.

Mad Real Estate

In season 7, Don decides to sell his apartment with the help of real estate broker Melanie, who describes it as an $85,000 fixer-upper "that reeks of failure." This fictional abode (where Megan Draper once sang a sexy rendition of French earworm "Zou Bisou Bisou") would have existed in real life near 740 Park Avenue, known as "the world's richest apartment building."

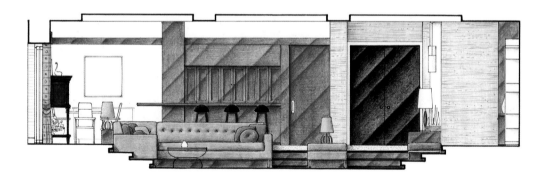

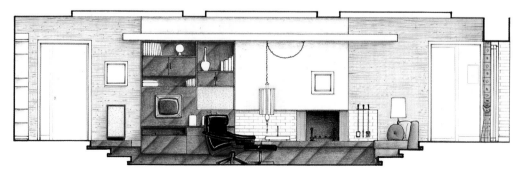

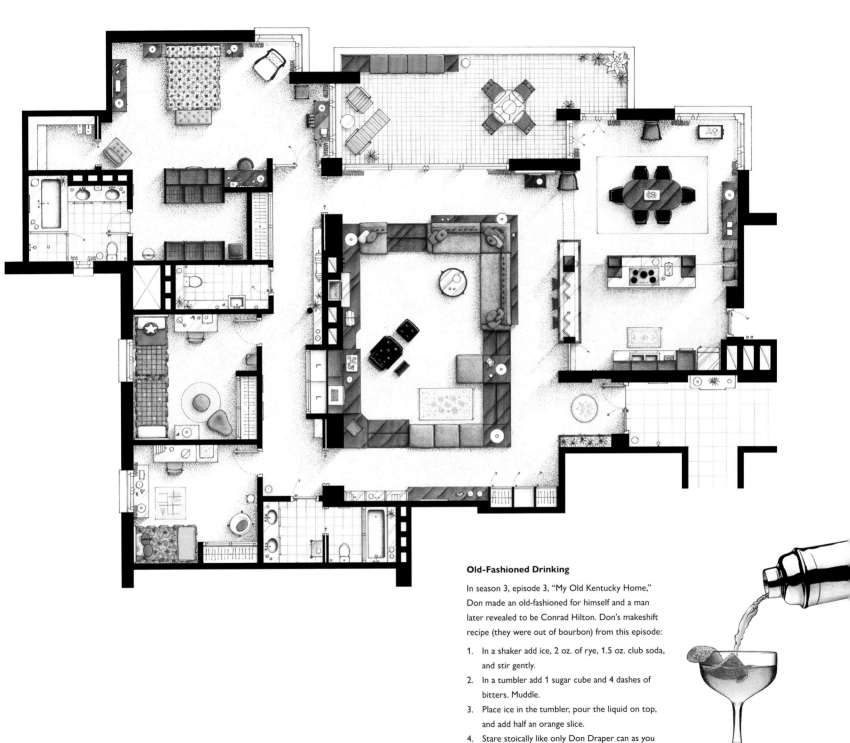

Old-Fashioned Drinking

In season 3, episode 3, "My Old Kentucky Home," Don made an old-fashioned for himself and a man later revealed to be Conrad Hilton. Don's makeshift recipe (they were out of bourbon) from this episode:

1. In a shaker add ice, 2 oz. of rye, 1.5 oz. club soda, and stir gently.

2. In a tumbler add 1 sugar cube and 4 dashes of bitters. Muddle.

3. Place ice in the tumbler, pour the liquid on top, and add half an orange slice.

4. Stare stoically like only Don Draper can as you sip and make conversation.

CHEERS

CREATED BY: Glen Charles, Les Charles, and James Burrows	CHANNEL: NBC
SERIES RUN: 11 seasons; 275 episodes; 1982–1993	
FILM LOCATION: Live studio audience at Paramount Studios in Hollywood, California	

In a historic American city like Boston, it says a lot when a little neighborhood bar becomes one of the most popular tourist attractions in the world. That's, of course, thanks to the power of *Cheers*, the sitcom about TV's most iconic bar—a hallowed hall of hops where everybody knows your name. The show featured Sam Malone, the washed-up, womanizing former Red Sox relief pitcher and recovering alcoholic; Sam's former baseball coach and now bartender (with a few screws loose), Ernie "Coach" Pantusso; sarcastic waitress Carla Maria Victoria Angelina Teresa Appolonia Lozupone Tortelli; mail carrier and know-it-all Cliff Clavin; the bar's most loyal patron, Norm Peterson; and grad student and perennial PhD candidate turned cocktail waitress, Diane Chambers. For its memorable characters (and millions of people), Cheers became that neighborhood bar where you went for the food and drink, but you stayed for the atmosphere.

While *Cheers* was always about the ensemble, no one can deny that the series' most dynamic story line was Sam and Diane's love affair. It became TV's gold standard for all on-again, off-again, will-they-or-won't-they couples. Modeled after the romantic antagonism of Spencer Tracy and Katharine Hepburn, Sam and Diane existed in a constant state of sexual tension, wrought with equal parts attraction and repulsion fueled by banter brought to life by the brilliant comedic chemistry of Ted Danson (Sam) and Shelley Long (Diane).

Over the course of its eleven seasons, *Cheers* pulled in *at least* twenty million viewers per episode—for context, smash hit *The Big Bang Theory* cracked twenty million viewers only twice. Its eventual success made way for two spin-offs, including a little show called *Frasier*. In the final episode, as Norm closed out the bar, he told Sam, "You can never be unfaithful to your one true love. You always come back to her," to which Sam replied, "Who is that?" Norm smiled and said, "Think about it." Like audiences, Sam finally came to appreciate just how much his bar meant to others and how special it was to him. Yes, it was the end of an era, but luckily for fans of the show or those just discovering it, *Cheers* will always be open.

Fortune and Men's Weight

In season 2, Coach bought an antique fortune-telling scale that had Carla convinced it could predict the future. When the fortunes eerily started coming true, it had everyone spooked. Sam and Diane even thought their destiny was contained in a fortune. Sam nervously read it only to find it said, "Machine empty. Order more fortunes today."

EST. 1895

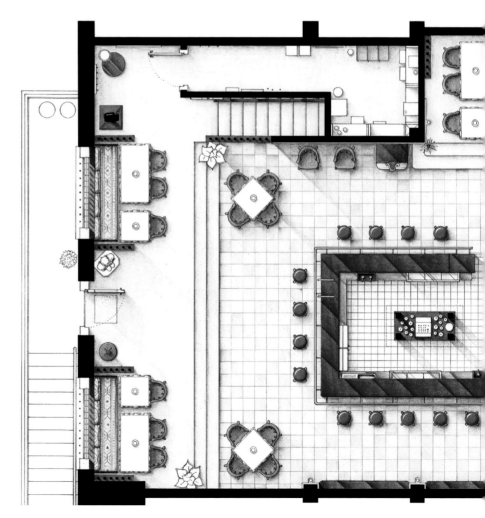

Cheers Bar

ADDRESS: 112½ Beacon Street, Boston, Massachusetts

The most famous bar on television may have been just a set, but it became another character, which is fitting considering the series opened with Sam alone in the bar and ended the same way.

A Norm's Stool

Beloved barfly Norm counted on two things when entering Cheers: a cold pint of frothy beer and the bar yelling out, "Norm!" as he walked to his favorite stool. The show's running gag even extended to children when "Norm!" became the first word ever spoken by Frederick, Frasier and Lilith's son.

Bull & Finch Pub

Cheers was filmed before a live studio audience on the Paramount lot in Hollywood, but the exteriors of the bar were filmed at Bull & Finch Pub, a neighborhood bar in Boston located at 84 Beacon Street. Due to the show's massive popularity, the bar was rebranded to "Cheers Beacon Hill" and has become a must-see tourist attraction for fans.

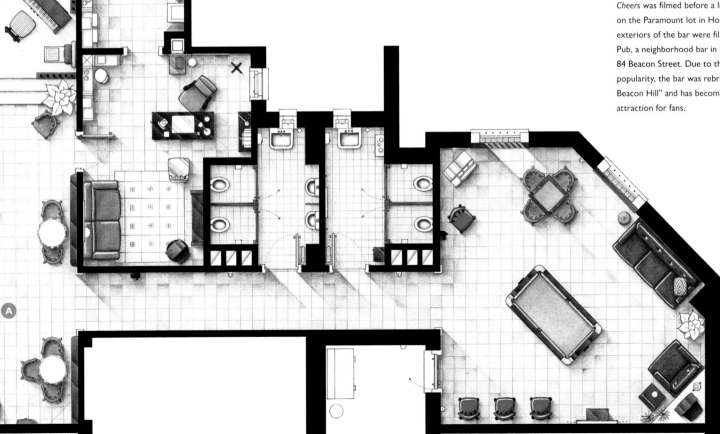

UGLY BETTY

CREATED BY: Silvio Horta, based on *Yo soy Betty, la fea* by Fernando Gaitán	**CHANNEL:** ABC

| **SERIES RUN:** 4 seasons; 85 episodes; 2006–2010 | |

| **FILM LOCATION:** Silvercup Studios East in Long Island City, Queens, New York, and on location in and around New York City, New York ("Pilot" and seasons 3–4); Raleigh Studios, Hollywood, California, and on location in and around Los Angeles, California (seasons 1–2) | |

Developed by the late Silvio Horta for ABC and premiering in 2006, *Ugly Betty* was based on Fernando Gaitán's massively popular Colombian telenovela *Yo Soy Betty, la Fea* ("I Am Betty, the Ugly"), which has been adapted internationally over ten times in countries like India, Germany, and Poland. The American version (executive produced by Salma Hayek) followed the ambitious and quirky Betty Suarez, a young, working-class Mexican American woman from Queens, New York, who, despite being in a perpetual fashion emergency, was hired by *MODE*, a *Vogue*-like high-fashion magazine. Betty was tasked with being the assistant to the womanizing editor Daniel Meade, all while trying to avoid the wrath of former model and current creative director Wilhelmina Slater. Working together to make her first job her last were Wilhelmina's equally ambitious, judgmental, and brownnosing assistant, Marc St. James, and the inept and narcissistic receptionist, Amanda.

Ugly Betty explored Betty's journey juggling her dream job, her work/life balance, the dating world, and her family—caring father, Ignacio; beautician sister, Hilda; and her nephew, Justin. Despite superficial differences with her coworkers, Betty's tenacious work ethic, empathy for others, and good heart transformed the opinions of those around her and fulfilled her wildest dreams in an industry that wears its soullessness like a couture gown. It was lauded for

its clever combination of elements from telenovelas, soap operas, slapstick comedies, and biting satire of the fashion industry.

The show was nominated for nineteen Emmy Awards, winning two, including a groundbreaking win for America Ferrera (Betty) as the first Latina to win an Emmy in a "lead actress" category. Though it was canceled due to low ratings in its final season, *Ugly Betty* amassed a cult following and paved the way for similar telenovela-inspired shows like *Jane the Virgin*. It also

laid the groundwork for more inclusivity on television in front of and behind the camera, tackling such issues as xenophobia, class, immigration, and most notably, celebrating the LGBTQ+ community. Before entering the conference room in the pilot, Betty told herself, "You are an attractive, intelligent, confident businesswoman," and for four seasons, audiences watched her remain true to herself because it was clear from the start that the beauty of Betty Suarez was inside her all along.

A Cross-Country Makeover

The blueprint on the right depicts the floor plan of the original *MODE* office in seasons 1 and 2. The office received its own fashion makeover after filming moved from Los Angeles to the Big Apple for seasons 3 and 4.

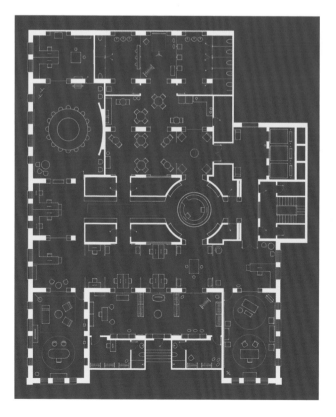

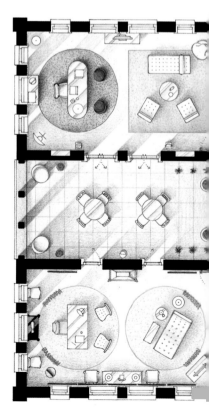

MODE Office

ADDRESS: Meade Publications, 100 Meade Plaza South, 28th Floor, New York, New York

The *Vogue*-inspired offices of *MODE* magazine are composed of stark white spaces with clean lines and pops of bright saturated colors such as orange and light blue. Designed by Mark Worthington, the space features circular designs alongside long open concept work areas, or as season 1's fictional designer, Oshi, would say, "Round. White. Minimal."

Graduation Bunny

A graduation gift from her sister, Hilda, this pink bunny appeared on Betty's desk in nearly every episode and was often terrorized by Betty's coworkers, resulting in its disheveled appearance.

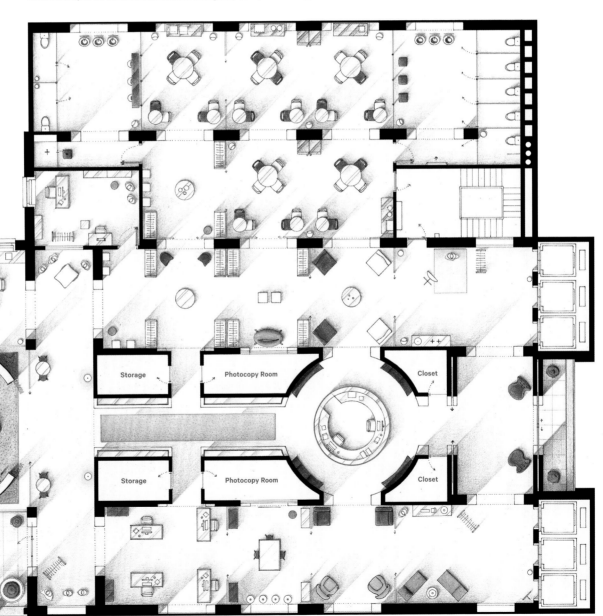

Storage

Photocopy Room

Closet

Storage

Photocopy Room

Closet

The Suarez Family Home

ADDRESS: 37-27 Ninety-Second Street, Queens, New York

Home to the Suarez family and the site of Hilda's Beautilities Plus salon, this Jackson Heights home was owned (or rented, depending on the season) by Ignacio for over twenty-five years. Taking place in the high-pressure world of fashion, *Ugly Betty* was unmistakably a New York show, which is why it might be surprising to learn that only the pilot and seasons 3 and 4 were filmed in the city, while seasons 1 and 2 were creatively shot in Los Angeles.

Betty's Glasses

On the show, Betty's "ugly" uniform mostly consisted of the holy trinity of eyeglasses, a frizzy, unstructured hairstyle complete with bangs, and of course, metal braces. Over two hundred pairs of glasses were tested before landing on glasses owned by the show's famed costume designer and stylist, Patricia Field (*Sex and the City*), who was wearing them during the wardrobe test.

GROUND FLOOR

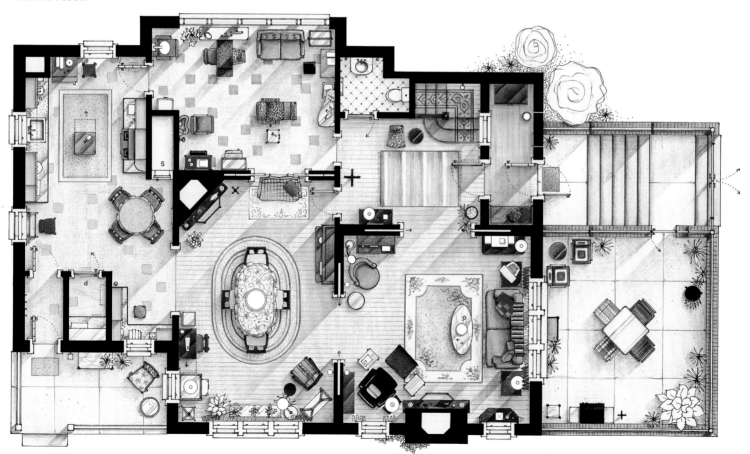

The Other *B* Girl

One of Betty's signature pieces of fashion was a Tudor pearl necklace. History buffs may have noticed that the necklace first appeared almost five hundred years ago around the neck of Queen Anne Boleyn in her official portrait, which makes Betty the other *B* girl.

Guadalajara Poncho

This now iconic piece of colorful wardrobe became a series-long recurring joke after Betty wore it on her first day at *MODE*. She eventually frames it for her office in season 4.

UPPER FLOOR

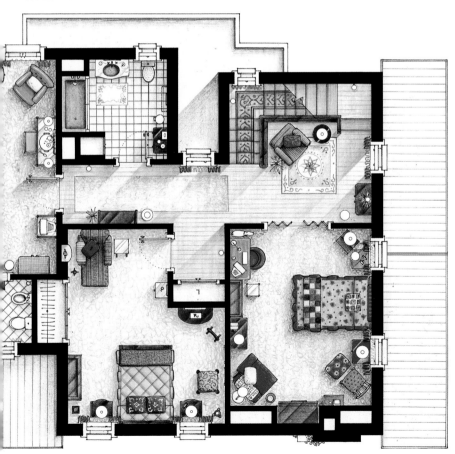

ATTIC

MURDER, MYSTERY, AND MAYHEM

A nice murder.
That'll cheer you up.
—MRS. HUDSON

Sherlock

Even before Sir Arthur Conan Doyle and the Queen of Crime, Dame Agatha Christie, society has had a fascination with murder, mystery, and mayhem. It doesn't matter if it's true crime, fictional crime, puzzle mysteries, or whodunits . . . we read them, we watch them, and we listen to them as part of our daily routine. Why? Because a good mystery always delivers on the promise of keeping us on the edge of our seats. No medium has embraced this beloved genre more than television since it gets a free pass to outwit and deceive audiences on a weekly basis while showcasing the deepest, darkest corners of the human condition.

When television embraced this beloved genre, a myriad of storytelling possibilities became available to tell a mystery in one episode of television. The baseline format is your standard procedural, or "body of the week," show where a victim is presented, the cast follows the clues, the crime is solved, and the credits roll until the next episode. In recent years, there's also been an interest in true crime–inspired stories centered around a real-life case or serial killer where one case may take an entire season to solve.

If dissected even further, many recognize the main difference between British and American mystery/thriller television: order versus justice. British shows traditionally chose a more serialized format (one main story told over several episodes) that dealt with a crime affecting a tight-knit community such as a quaint village or a family country estate where the detectives on the case must restore order to the local way of life. American shows, on the other hand, were much more focused on justice—more specifically, the demons within the lead character that drive the crimefighter to bring someone to justice and in turn redeem themselves.

As the genre has evolved, these generalizations, however, are constantly turned on their heads—whether that's blending a procedural with a high-concept hook, like a private detective who can gather clues by speaking to the dead or where we first meet a protagonist only to have them descend into darkness and become the antagonist. The beauty of these shows is that you don't need a famous detective solving the crimes for them to be entertaining because the crimes themselves, and the journey toward solving them, are the true reward.

SHERLOCK

DEVELOPED BY: Mark Gatiss and Steven Moffat	**CHANNEL:** BBC One (United Kingdom), PBS (United States)
SERIES RUN: 4 series and 1 special; 13 episodes; 2010–2017	
FILM LOCATION: Upper Boat Studios in Cardiff, Wales (series 1–3); Pinewood Studio Wales in Cardiff, Wales (series 4); on location in and around Cardiff, Wales, and London, England	

Reimagining an iconic character like Sherlock Holmes, undoubtedly the most well-known detective in pop culture history, is a tall order. Especially considering that the Guinness World Records declared Sherlock Holmes the most portrayed literary human character in all of film and television history. In 2010 former *Doctor Who* writers Steven Moffat and Mark Gatiss took on the Herculean task of introducing a fresh and modern retelling of the famous sleuth starring Benedict Cumberbatch as Sherlock Holmes, consulting detective and self-described "high-functioning socio-path," and Martin Freeman as John Watson, his only friend, his moral compass, and the voice of reason for the audience.

The creators chose to revitalize Sir Arthur Conan Doyle's celebrated stories by writing them in a contemporary setting to, as Gatiss says, "fetishize modern London, the way the period ones fetishize Victorian London." Moffat and Gatiss took the hallmark traits of Sherlock Holmes (powers of deduction, skills of observation, and 221B Baker Street) and uniquely placed them in an era of advanced technology. Gone were the deerstalker hat and Inverness cape widely associated with the character in favor of a fashionable overcoat, scarf, and flowy head of hair. This was a Sherlock for a new generation.

Why, in this day and age, would the police need a genius consulting detective to solve crimes? Because telling a story where his unmatched intellect works hand in hand, instead of at odds, with modern sciences created a fresh new take. But what set the show apart from other adaptations was the visual language created for the Peabody Award–winning pilot by director Paul McGuigan. The "A Study in Pink" episode (loosely based on Holmes's first adventure in *A Study in Scarlet*) brilliantly integrated text messages on-screen that interacted with characters and setting, allowing viewers to see both the messages and reactions of characters in real time. *Sherlock* also became an invigorating departure from previous iterations of the character by giving us a front-row seat to his mind palace through the words displayed on-screen.

The show was a massive hit when it premiered and was celebrated for its new visual style, writing, and chemistry between actors, leading to multiple BAFTA and Emmy Awards. The show reportedly inspired a 180 percent rise in the sales of the original stories and created an entirely new subsection of fandom within the passionate Sherlockian community. As Sherlock remarked to Watson while on the hunt, "That's the frailty of genius, John. It needs an audience." For all its genius, *Sherlock* certainly found its audience and showcased once again the many talents of Sherlock Holmes.

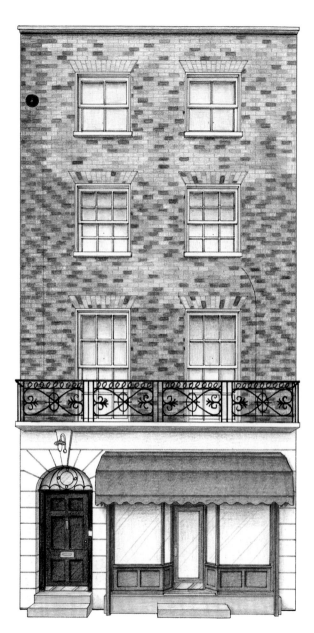

Baker Street

This exterior location is situated approximately one mile away from the real Baker Street. It was used as a stand-in for 221B to avoid tourists, busy streets, and museum patrons that now occupy the original 221B Baker Street. Sherlockians can visit Speedy's as it's a real sandwich bar and café welcoming fans and locals alike for a meal, even including a Sherlock breakfast!

Sherlock Holmes's Apartment

ADDRESS: 221B Baker Street, London, England

Residing at this real address since 1990 is the Sherlock Holmes Museum, which attracts thousands of visitors from all over the world. The building itself actually lies between 237 and 241, but thanks to the City of Westminster, it was allowed to keep the famous address.

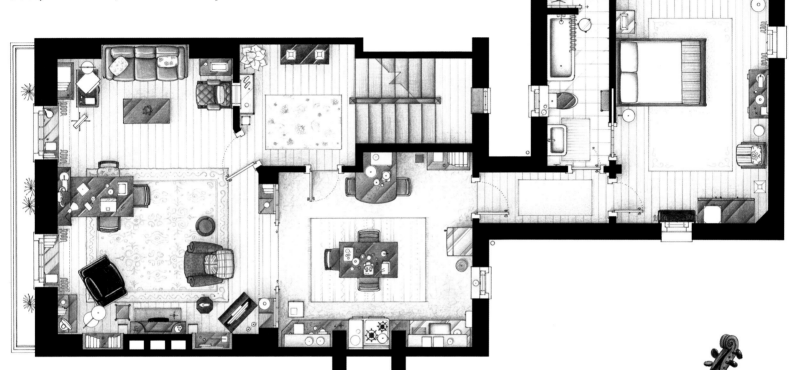

Magnifying Glass

Sherlock never leaves home without this pocket-size foldable magnifying glass. The first appearance of a magnifying glass being used as an investigative tool (which has now become a trope) was, you guessed it, a Sherlock Holmes story. It appeared in **1887**'s *A Study in Scarlet*.

Sherlock's Violin

Sherlock, an accomplished violin player, learned to play from his sister, Eurus Holmes (unique to this adaptation and the main antagonist of series 4), whose intellect was conveyed as magnitudes beyond Sherlock's.

PUSHING DAISIES

CREATED BY: Bryan Fuller	**CHANNEL:** ABC
SERIES RUN: 2 seasons; 22 episodes; 2007–2009	
FILM LOCATION: Warner Bros. Studios in Burbank, California	

"Pie is home. People always come home." —Ned

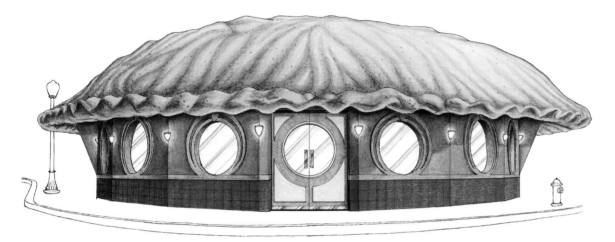

Pie Hole Facade

The exterior of Ned's shop fittingly resembled a pie and was even equipped with a quaint crust roof. Situated under the apartment building where Ned, Chuck, and Olive live, the exterior was shown using CGI for most of the series but appeared as a real set a handful of times. The cost for a slice of decadent pie? $5.95.

From the deliciously devious mind of celebrated writer Bryan Fuller (*Dead Like Me*, *Wonderfalls*, and *Hannibal*), *Pushing Daisies* followed Ned, a talented baker and owner of The Pie Hole, who learns at a very young age that he was endowed with a special gift—bringing life back to the dead with a simple touch. The rules of Ned's powers were simple: first touch, life; second touch, death. Anything dead he touched instantly came back to life. But if he touched it again, it died. And finally, cosmic compensation—if the revived life-form was alive for more than a minute, something else of equal size or "life value" must have taken its cosmic place. After harnessing this power as an adult, Ned was joined by a private investigator named Emerson Cod, who teamed up with him to solve cases with the help of Ned's necromancing skills. However, life got complicated when one of the bodies turned out to be his childhood sweetheart, Charlotte "Chuck" Charles. Enthralled by Chuck, Ned let her live past 60 seconds, which caused another life to be taken in her place. Ned may have had the love of his life next to him, but he could never touch her again, or she'd die forever.

Billed as a "forensic fairy tale" due to the playful juxtaposition of the macabre and the lighthearted, *Pushing Daisies* was known for its eccentric production design and wardrobe, and took the tried-and-true police procedural format, combined with a high-concept/highly stylized Tim Burton–like fantasy world, and pulled it together with a simple love story. Like many of Bryan Fuller's shows, it ended prematurely, with the first season only lasting nine episodes (due to the Writers Guild of America strike interrupting production) and the second season only receiving a thirteen-episode order after ratings began to dip. For such a small run, it became a cult classic, with *TV Guide* including it in the 2013 list of shows "Canceled Too Soon." It was nominated for five Emmy Awards, winning two, including an Outstanding Supporting Actress in a Comedy Series award for triple-threat Kristin Chenoweth, who played Olive Snook, an employee of The Pie Hole who pined after Ned in the shadow of Chuck.

Like a well-balanced pie, *Pushing Daisies* contained several ingredients that, while tasty on their own, truly elicited a harmonious explosion of flavor when combined. It has stood the test of time thanks to the love shown on-screen and, even more, the love for the show off-screen.

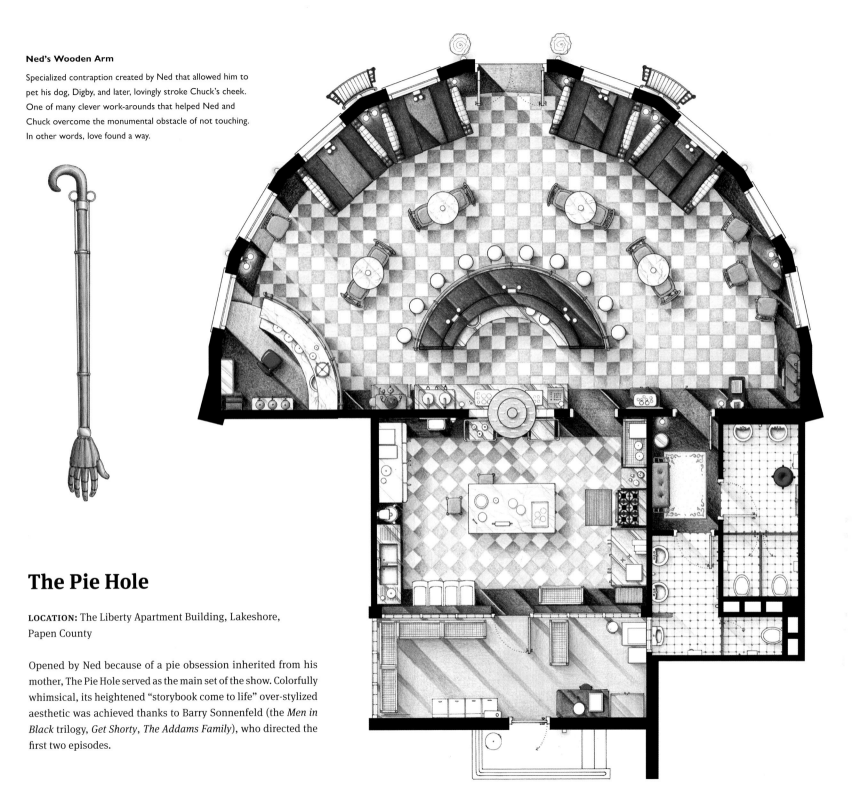

Ned's Wooden Arm

Specialized contraption created by Ned that allowed him to pet his dog, Digby, and later, lovingly stroke Chuck's cheek. One of many clever work-arounds that helped Ned and Chuck overcome the monumental obstacle of not touching. In other words, love found a way.

The Pie Hole

LOCATION: The Liberty Apartment Building, Lakeshore, Papen County

Opened by Ned because of a pie obsession inherited from his mother, The Pie Hole served as the main set of the show. Colorfully whimsical, its heightened "storybook come to life" over-stylized aesthetic was achieved thanks to Barry Sonnenfeld (the *Men in Black* trilogy, *Get Shorty*, *The Addams Family*), who directed the first two episodes.

KILLING EVE

DEVELOPED BY: Phoebe Waller-Bridge, based on the Villanelle novel series by Luke Jennings	**CHANNEL:** BBC America
SERIES RUN: 4 series; 32 episodes; 2018–2022	
FILM LOCATION: West London Film Studios; on location in and around London, England, and Europe	

Killing Eve followed bored MI5 security officer and desk jockey Eve Polastri as she tracked the murder of a sex-trafficking Russian politician and championed the unpopular theory that the killer was a woman. Proved correct, Eve was tasked with tracking the killer down. Enter Villanelle, a flamboyant and frightening psychopathic assassin (with a childlike wonder and naivete) who fetishized her fashion choices and possessed a warped sense of humor about her work. Almost immediately, in between all the murder and chasing, Eve and Villanelle's adversarial beginnings developed into a mutual romantic and sexually charged obsession for each other that, thanks to the talent and chemistry of the lead actresses, was nothing short of magnetic.

 Killing Eve brilliantly chose to throw away the traditional blueprint of a female assassin (devoid of personality, defined by their sex appeal, or dependent on a male partner). Instead, the show made Villanelle a compelling, at times hilarious, and ultimately tragic character who allowed herself to be thrust into a game of cat and mouse (or more appropriately, a game of cat versus cat) after being captivated by Eve. Jodie Comer dominated in her star-making turn as Villanelle and would go on to win two Emmy Awards for Outstanding Lead Actress in a Drama Series, with Sandra Oh (Eve) receiving equal praise and several nominations, and winning a Golden Globe Award for Best Television Actress-Drama Series. The series has been applauded for having a different female head writer at the helm for each series, led by the ever-so-talented Phoebe Waller-Bridge (creator of *Fleabag*). While the first two series found more critical success than later series, viewers remained on the edge of their seats for the culmination of Eve and Villanelle's relationship. In the end, *Killing Eve* burst onto screens, introducing a queer will-they-or-won't-they romance in the world of espionage and delivered a stylishly violent and wickedly funny thriller that's just plain fun to watch.

Villanelle's Weapons

Some of the many weapons in Villanelle's arsenal: This knife was used in season 1, episode 3, "Don't I Know You?," when she mortally stabbed Eve's boss, Bill, inside a crowded Berlin nightclub. The other, a tuning fork with a sharpened point that Villanelle used to dispatch a pesky pianist.

Overtures of Love?

After Eve and Villanelle confessed their obsessions with each other in the season 1 finale, the second season found Villanelle trying to woo Eve in unconventional ways only a serial killer would attempt. In "Desperate Times," Villanelle staged a public murder in Amsterdam's red-light district to get Eve's attention, inspired by a painting while wearing this cherubic pig mask and a pink traditional Bavarian dirndl.

Villanelle's Apartment

LOCATION: Paris, France

"Chic as shit" was how Eve bitterly explained Villanelle's season 1 Parisian apartment. Stocked with just as many guns and weapons as haute couture dresses and wigs, it was a chaotic yet glamorous abode perfect for a psychopathic assassin and stylish femme fatale whose identity was constantly in flux. With its peeling wallpaper, art deco pink-tile bath, and large windows overlooking Sacré-Cœur de Montmartre, it was a killer apartment. Literally. Though the address was never stated, the exterior of the apartment was filmed near 16 Rue de Lancry, 75010 Paris, France.

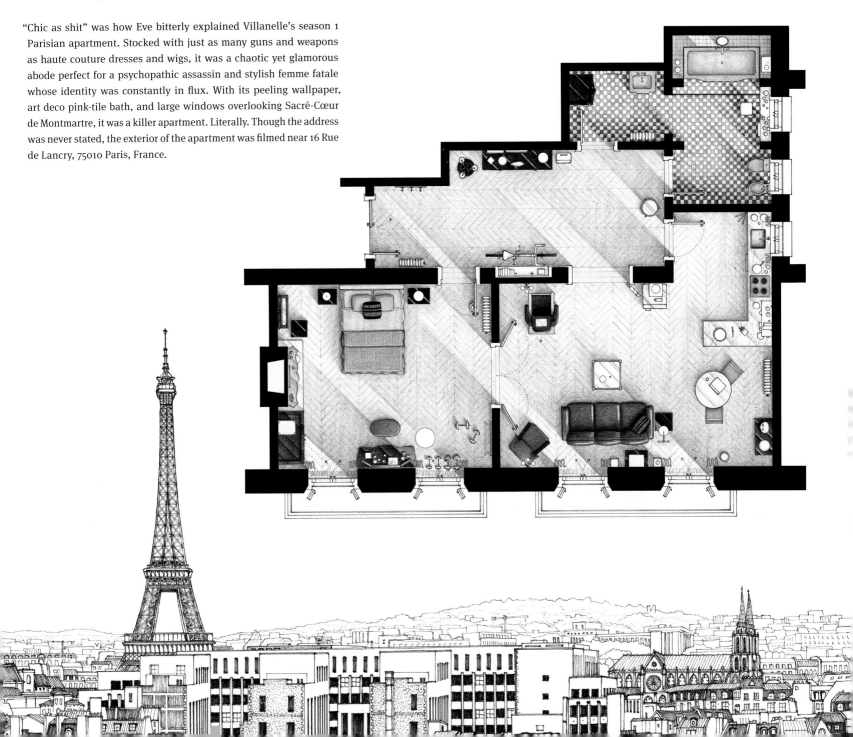

BROADCHURCH

CREATED BY: Chris Chibnall

CHANNEL: BBC America (United States), ITV (United Kingdom)

SERIES RUN: 3 series; 24 episodes; 2013–2017

FILM LOCATION: Vision Studios, Waterloo Film Studios; on location in and around Dorset, Somerset, Bristol, and in and around England

Britbank

Sitting on the bank of the River Brit on Dorset's Jurassic Coast and built in 1900, this detached timber bungalow known as Britbank was the shooting location for DI Alec Hardy's home. Accessible only by foot, the home was first seen by *Broadchurch* creator, Chris Chibnall, while he was working out the story for the show in a local café nearby. Chibnall looked to Dorset once more for inspiration in naming the series—"Broadchurch" comes from combining the hamlets of Broadoak and Whitchurch.

Broadchurch, created by writer Chris Chibnall (known for his work on *Torchwood* and *Doctor Who*), followed a small town grappling with the murder of eleven-year-old Danny Latimer, whose body was found on the beach, sending shock waves through the working-class citizens of a picturesque but isolated community. The show carried on the time-honored tradition of prestige British crime dramas and gripped a nation as the series 1 finale, at the time, became the most-tweeted-about UK TV drama ever and caused power surges during commercial breaks before the killer was revealed. Combining top-tier mystery elements and socially conscious themes, the show shone a light on how suspicion, accusations, and attention from the media can transform a tight-knit community overnight. Putting aside their differences to find justice were Detective Sergeant Ellie Miller, a local detective and friend of the victim's family, and Detective Inspector Alec Hardy, a new resident of Broadchurch, haunted by the past and carrying a secret.

Unlike most standard American police procedurals that utilize a "murder-of-the-week" story approach, *Broadchurch* flipped the script by employing a "suspect-of-the-week" season-long arc where everyone, even the plumber's assistant, was a suspect. Choices like this are one of many that set American and British crime thrillers apart. While most American network police procedurals have a case neatly solved within the hour, British mysteries, of which *Broadchurch* was a shining example, take their time before solving a case, spreading out the investigation and allowing more time to deepen the grief, guilt, and complexity of the crime and its outcome. The show becomes emotion over action. British police mysteries rarely include guns in their story lines, instead focusing on adding tension to mundane tasks like interviewing suspects, clue gathering, and reviewing CCTV footage, which highlight how the crime affects everything around it as opposed to just catching the criminal.

Along with its lead actors, *Broadchurch* was praised for its cinematography, realism, and handle on themes such as loss, grief, and redemption—winning several BAFTA Awards, a Peabody, and more. Despite attempts at remakes of *Broadchurch* in other countries, nothing beats the real thing. British crime thrillers reign supreme thanks to streaming and the never-ending supply of fascinatingly gruesome stories, complex characters, and cold, dark, and stormy settings—of which the United Kingdom is in no short supply. *Broadchurch*, its predecessors, and those that will come after, prove that unlike the poor souls starring in them, murder mysteries will never die.

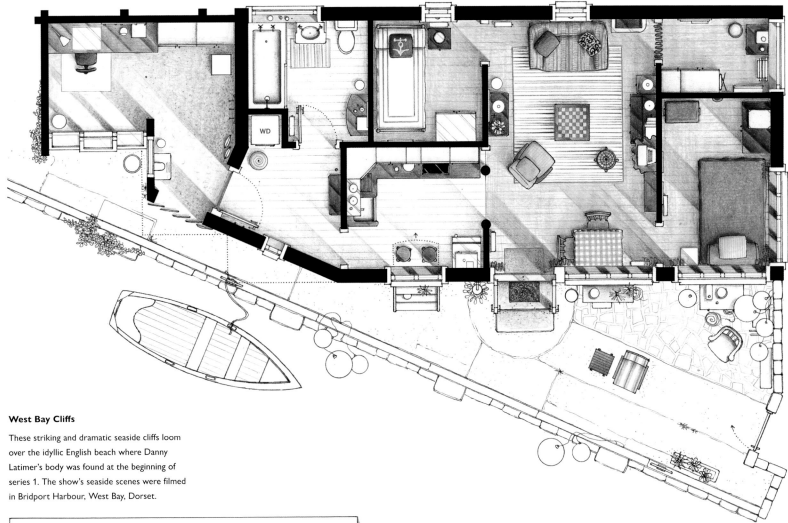

West Bay Cliffs

These striking and dramatic seaside cliffs loom over the idyllic English beach where Danny Latimer's body was found at the beginning of series 1. The show's seaside scenes were filmed in Bridport Harbour, West Bay, Dorset.

GREETINGS FROM **BROADCHURCH**

DI Alec Hardy's House

ADDRESS: 3 Seafront Lane, Broadchurch, Dorset, United Kingdom

Home of DI Alec Hardy in series two, which took place seven months after the events of series one when he was discharged from the force. This nautical-themed blue chalet served as a respite for Hardy to ponder his gruesome murder cases, reflect on his complex work/life balance, and treat his medical issue while navigating the challenges of a case. Hardy was named in homage to Dorset-born poet and author of *Far from the Madding Crowd*, Thomas Hardy.

BREAKING BAD

CREATED BY: Vince Gilligan	**CHANNEL:** AMC
SERIES RUN: 5 seasons; 62 episodes; 2008–2013	
FILM LOCATION: Albuquerque Studios; on location in and around Albuquerque, New Mexico	

Critically acclaimed as one of the greatest television shows of all time (even awarded a Guinness World Record in 2013 due to the reviews), *Breaking Bad*, created and produced by Vince Gilligan, premiered on AMC, further solidifying the cable network among the likes of premium cable channels.

Set in the desert landscape of Albuquerque, New Mexico, *Breaking Bad* was a neo-Western crime drama that followed the disgruntled high school chemistry teacher Walter "Walt" White, who reevaluated his life after receiving a terminal cancer diagnosis. To financially provide for his wife, Skyler; son, Walt Jr.; and soon-to-be-born daughter, Holly, Walter tapped into his science background to create 99.1 percent chemically pure crystal methamphetamine, nicknamed "Blue Sky," with the help of former student Jesse. Due to the quality of their recipe, Walt and Jesse found themselves the envy of local gangs, on the radar of the Mexican drug cartels, and under the watchful eye of the Drug Enforcement Administration (led by Walt's suspicious brother-in-law, Hank), collectively putting everyone's lives at risk. The epic story of antihero Walter White showcased a rich, textured, but intrinsically dark and flawed human being who lived in the realm of Greek tragedy—a modern morality play of pride, power, ego, and masculinity following one man's gradual evolution from meek and mild mannered to unflinching and reprehensible in the shadow of his former self.

Most shows gradually lose their audience over time, but *Breaking Bad* bucked the trend by increasing viewership with each subsequent season. It's a show that benefited (perhaps more than most) from catch-up viewing thanks to Netflix carrying the first four seasons ahead of the release of the final season on AMC. The show was no stranger to awards, winning sixteen Emmys from fifty-eight nominations, and spawned an equally successful spin-off/prequel, *Better Call Saul*. *Breaking Bad* taught audiences many things: Heisenberg wasn't just an uncertainty principle anymore, cooking doesn't necessarily mean food, and never ask Walt who knocks because he'll certainly tell you.

The Crystal Ship

Walt gave Jesse his life savings (about seven thousand dollars) to purchase this motor-home-turned-meth-lab so they could cook their Blue Sky. In season 3, a flashback to the pilot revealed Jesse blew almost all of Walt's money at a strip club with Skinny Pete and Combo. Being the true friend he was, Combo made a "no-paperwork-type-deal" with Jesse and sold him his mom's RV for the remaining fourteen hundred dollars.

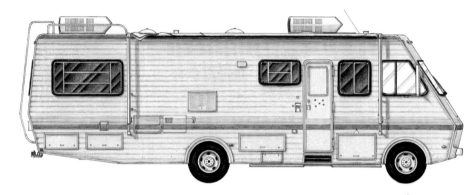

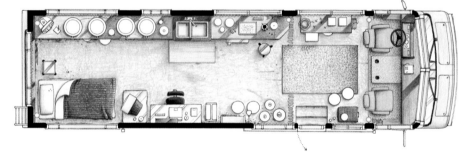

The White Family Home

ADDRESS: 308 Negra Arroyo Lane, Albuquerque, New Mexico

Home to Walt, Skyler, Walt Jr., and Holly, exteriors of the White house were filmed at 3828 Piermont Drive NE, Albuquerque, New Mexico. A fan-favorite moment of the show is when Walt threw an entire pizza on the roof of the garage in frustration, which fans tried to re-create in person at the real location, prompting series creator Vince Gilligan to plead that they stop.

Car 1

Car 2

The Pink Teddy Bear

This bear was a piece of debris from the deadly midair collision indirectly caused by Walt's actions and a recurring motif in the second season. Its true meaning is still debated, but many fans and critics have agreed that the bear's charred appearance and missing eye referenced the future fatal injuries of fan-favorite series antagonist Gustavo Fring.

SCANDAL

CREATED BY: Shonda Rhimes	**CHANNEL:** ABC
SERIES RUN: 7 seasons; 124 episodes; 2012–2018	
FILM LOCATION: Sunset Gower Studios in Los Angeles, California; on location in and around California	

Affairs. Blackmail. Sex tapes. Kidnapping. Murder. Audiences expected nothing less from an addictive political crime drama and thriller named *Scandal* when it was released in 2012. The show was created by powerhouse showrunner Shonda Rhimes, the first African American woman to create a top ten network series (*Grey's Anatomy*) and the first woman to create three television series (*Grey's Anatomy*, *Private Practice*, *Scandal*) to reach the hundred-episode milestone. *Scandal*, over the course of its seven seasons, became must-see TV just as much as it became must-tweet TV, often called the show that Twitter built.

Starring Kerry Washington (the first black woman to be the lead of a network drama since 1974), *Scandal* followed Olivia Pope, a former White House staffer turned "fixer," who, along with her capable team of former lawyers, hackers, and impressionable go-getters (affectionately referred to as Pope's "Gladiators"), handled all the scandals of DC's elite. Throughout the course of the show, Olivia also struggled to keep hold of her own personal scandals, including a fraught relationship with her manipulative father and an incredibly steamy on-again, off-again affair with the president of the United States.

In a way, *Scandal* was the antithesis to *The West Wing*, focusing on the dark and cynical side of our nation's capital over a more idealistic rendering. While similar fast-paced dialogue existed in both series, *Scandal* exchanged the dependable hopeful endings for edge-of-your-seat action, heartbreak, and palpable on-screen sexual tension thanks to the undeniable chemistry of its leads. Despite the show's melodramatic plotlines that could often venture into over-the-top territory, the show was partially based on the real-life work of Judy Smith, a former George H. W. Bush press aide who ran her own crisis-management company.

Adding *Scandal* to her already stacked credits, Rhimes has become a creative force in Hollywood through her production empire, Shondaland, and made it her mission to make the world of TV look like the world outside of it, both on- and off-screen, ensuring writers' rooms and casts were more diverse and inclusive. *Scandal* made it clear that not everyone can be a power player who dismantles secret government organizations in a white hat—then again, there's only one Olivia Pope. But if we want her, we have to earn her.

The Oval Office and the Truman Balcony

ADDRESS: 1600 Pennsylvania Avenue NW, Washington, District of Columbia

Thanks to a talented production crew and some visual-effects wizards, the cast of *Scandal* (minus a few key scenes in the final season) never set foot in the nation's capital, including these storied White House locations that were the backdrops to Olivia Pope and President Fitzgerald's steamy love affair.

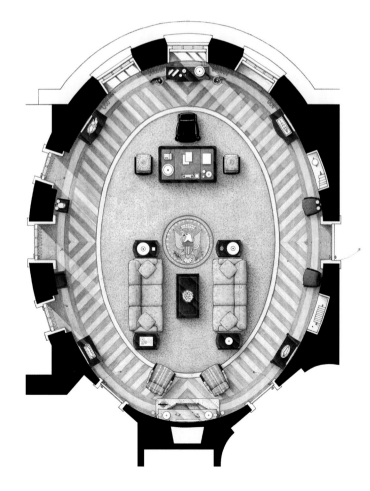

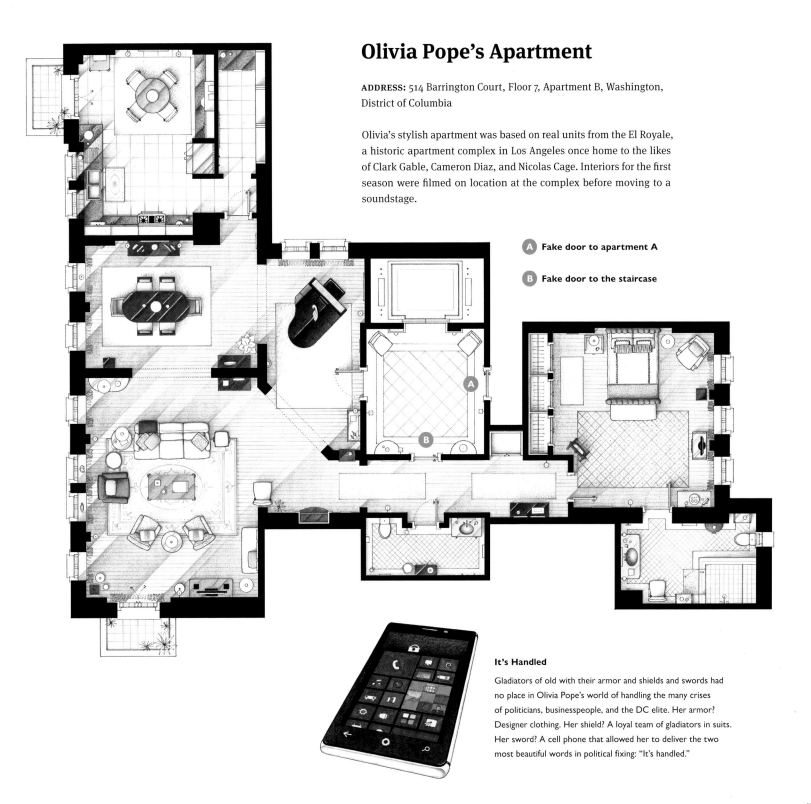

Olivia Pope's Apartment

ADDRESS: 514 Barrington Court, Floor 7, Apartment B, Washington, District of Columbia

Olivia's stylish apartment was based on real units from the El Royale, a historic apartment complex in Los Angeles once home to the likes of Clark Gable, Cameron Diaz, and Nicolas Cage. Interiors for the first season were filmed on location at the complex before moving to a soundstage.

A Fake door to apartment A

B Fake door to the staircase

It's Handled

Gladiators of old with their armor and shields and swords had no place in Olivia Pope's world of handling the many crises of politicians, businesspeople, and the DC elite. Her armor? Designer clothing. Her shield? A loyal team of gladiators in suits. Her sword? A cell phone that allowed her to deliver the two most beautiful words in political fixing: "It's handled."

Acknowledgments

I am one of those children who grew up in front of a television. My upbringing was given to me by the fluffy puppets who lived on *Sesame Street* and *Fraggle Rock*. Then came other television series and movies that taught me other things, including an interest for interior design, which eventually became a profession. In a time of anxiety, both these worlds came together again and creating floor plans for TV series and movies became a therapy and a kind of yoga of the brain. I discovered that there were people who also enjoyed these floor plans, and their positive feedback and generous words gave me confidence. I would like to thank those kind people who have lent me their support during the years and whose encouragement has helped me come this far. And now, from here, I would like to thank Maddy Wong Huff and Wynne Au-Yeung and the rest of the team at Chronicle Books—Neil Egan, Heather Fisk, and Perry Crowe—for being my hands, and Neal E. Fischer for being my voice from across the pond. I have always depended on the kindness of strangers, and because of this project, now I know why . . .

Library of Congress Cataloging-in-Publication Data

Names: Aliste Lizarralde, Iñaki, author illustrator. | Fischer, Neal E. co-author.
Title: Behind the screens : illustrated floor plans and scenes from all of your favorite TV shows / Iñaki Aliste Lizarralde with Neal E. Fischer
Description: San Francisco : Chronicle Books, 2023.
Identifiers: LCCN 2023005983 | ISBN 9781797219431 (hardcover)
Subjects: LCSH: Television programs--United States--Miscellanea.
Classification: LCC PN1992.3.U5 A455 2023 | DDC 791.45/750973--dc23/eng/20230309
LC record available at tps://lccn.loc.gov/202

Manufactured in China.

MIX
Paper | Supporting responsible forestry
FSC™ C008047
www.fsc.org

Text by Neal E. Fischer.
Design by Wynne Au-Yeung.

10 9 8 7 6 5 4 3 2 1

Chronicle books and gifts are available at special quantity discounts to corporations, professional associations, literary programs, and other organizations. For details and discount information, please contact our premiums department at corporatesales@chroniclebooks.com or at 1-800-759-0190.

Chronicle Books LLC
680 Second Street
San Francisco, California 94107
www.chroniclebooks.com